THE ART OF FOOTBALL

THE ART OF

FOOTBALL

The Early Game in the Golden Age of Illustration

Michael Oriard

Includes Edward Penfield, J. C. Leyendecker, Frederic Remington, Charles Dana Gibson, George Bellows, and Many Others

University of Nebraska Press | Lincoln & London

Library of Congress Cataloging-in-Publication Data
Names: Oriard, Michael, 1948–, author.
Title: The art of football: the early game in the golden age of illustration /
Michael Oriard; includes Edward Penfield, J. C. Leyendecker, Frederic
Remington, Charles Dana Gibson, George Bellows, and Many Others.
Description: Lincoln: University of Nebraska Press, [2017] | Includes
bibliographical references and index.
Identifiers: LCCN 2016044859
ISBN 9780803290693 (cloth: alk. paper)
Subjects: LCSH: Football in art. | Football—United States—History—19th
century. | Football—United States—History—19th century—Pictorial
works. | Art, American—Themes, motives.
Classification: LCC N8217.F665 O75 2017 | DDC 704.9/49796332—dc23
LC record available at https://lccn.loc.gov/2016044859

Designed and set in Arno Pro by L. Auten.

For Colin, Kelly, and Aidan, and Alan and Bree

CONTENTS

ILLUSTRATIONS

INTRODUCTION

"AMERICAN FOOTBALL ART" can be no older than "American football," whose origins, unlike baseball's, have never been lost in antiquity or embroiled in rival creation myths. On November 6, 1869, Rutgers played Princeton in what everyone has long agreed was the first American intercollegiate football contest. The game played, however, was the soccer version rather than the rugby one that American collegians later adopted and adapted. Both were developed by British schoolboys in the middle decades of the nineteenth century. Before that, American boys and young men engaged in various kinds of informal "football," including slightly more organized interclass contests and varieties of the annual "rush," by which sophomores initiated freshmen at Harvard (on "Bloody Monday") and Yale. (The "cane rush" at Princeton and Columbia was a similar wild melee fought over a cane, not a ball [see fig. 1].)

The action was rough—more shins than balls were kicked—and frowned on by faculty but beloved among students. These opposing desires collided in 1860, when the Harvard faculty banned Bloody Monday, prompting a mock burial for "Football Fightum," prematurely deceased at the age of "LX Years." (In 1872 the faculty relented and reinstated the annual contest.)[1]

Thomas Hughes, the celebrated author of *Tom Brown's School Days* and *Tom Brown at Oxford*, sacred texts for sports-minded American schoolboys, described "the primitive and unscientific" state of interclass football he saw being played at Cornell on a visit to the United States in 1871:

It having been settled after a good deal of confused talking that the class of '72 should play those of '73 and '74, all

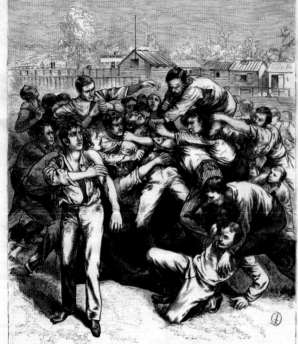

FIG. 1. A cane rush at Columbia. *Frank Leslie's Illustrated Newspaper*, October 21, 1882.

who cared to play collected into two irregular crowds, unorganized and leaderless, and stood facing one another. Most, but not all, of the players took their coats off. Then a big, oddly-shaped ball arrived, somebody started it with a kick-off, and away went both sides in chase, wildly jostling one another, kicking, catching, throwing, or hitting the ball, according to fancy, all thoughts more bent, seemingly, upon the pure delight of the struggle than upon any particular goal.[2]

These college rushes and interclass contests were adaptations of games that had been common enough in some colonial New England communities to warrant legal bans on the Sabbath or within town limits to prevent property damage. "Mob football," played with an indeterminate number of players on each side—sometimes village against village, guild against guild, or single men against married men—and with the simple object of kicking a ball across the other side's goal line (and, along the way, as many opponents as required), can be traced back to the Middle Ages in Britain, ultimately perhaps to the ball game *harpastum*, which may have been adapted from the Greeks' *episkyros* or *phaininda* (see fig. 2) and brought to the British Isles

by Roman soldiers in the first century AD. The origins of football as a world sport *are* lost in antiquity.

But *American* football, the kind played in this country and almost nowhere else, dates not from 1869 but from a meeting on November 26, 1876, of representatives from Harvard, Yale, Princeton, and Columbia to create the Intercollegiate Football Association and agree on a game based on the rugby-type rules favored by Harvard (and, belatedly, by Yale), rather than the soccer style preferred by the other schools. American collegians' style of English rugby then evolved into the distinctive American sport through a series of rule changes chiefly engineered by Yale's Walter Camp, recognized even in his own time as "the Father of American Football." In 1880 Camp persuaded his fellow rule-makers to award possession of the ball to one team at a time, putting it in play through a "scrimmage" rather than the more random rugby "scrummage" (today's scrum). Two years later, Camp's second foundational rule required the team possessing the ball to advance it five yards (or lose ten) in three tries. These two rules began the transformation of English rugby into American football.

An 1807 lithograph of seven young men engaged in an informal ball game on the New Haven Green that is some-

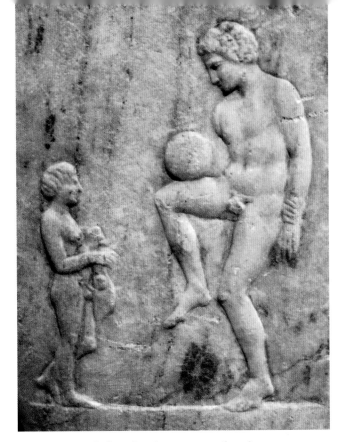

FIG. 2. Grave stele from fourth century BC, found near Piraeus, possibly representing an ancient ball game. National Archeological Museum, Athens.

times identified as the earliest illustration of American football (fig. 3) represents football in America but not "American football." The earliest wood engravings of "foot-ball" appeared in *Harper's Weekly*: the first, in 1857, of a Bloody Monday at Harvard by Winslow Homer (plate 1) and then two of contests among soldiers in camp during the Civil War in 1861 (plate 2) and 1865 (plate 3, again by Homer). All show Americans playing a kind of mob football that was not yet American football.[3] Engravings in *Harper's* in 1878 by J. Davidson (plate 4) and in 1879 by A. B. Frost (plate 5) illustrate an American game, but one still in its rugby form. Two illustrations from 1881—a second one by Frost in *Harper's* (plate 6) and one by Charles Upham in *Frank Leslie's Illustrated Newspaper* (plate 7)—and an unsigned one in *Harper's* in 1883 (plate 8) are the earliest to represent true American football.

The illustrated weeklies of the late nineteenth century, led by *Harper's*, were the first of four tributaries to a mainstream of American popular football art (see chapter 1). The other three quickly followed. As large-circulation metropolitan newspapers, beginning with Joseph Pulitzer's New York *World,* became illustrated in the mid-1880s, cartoons satirizing the oddities of the new collegiate game soon began popping up regularly on the sports pages. By the end of the decade the great humor magazines of the era—*Puck, Judge,* and *Life*—began paying attention, often with a brilliantly colored lithograph on the front or back cover or as the double-page centerfold (see chapter 2). By the end of the 1890s, a poster craze had spawned football posters, which were then adapted as magazine covers, where they flourished for decades (chapter 3). Finally, the inevitable emergence of football fiction in response to the new sport meant the appearance of halftone illustrations to accompany stories in popular magazines (see chapter 4). These remained a fixture in our visual landscape until television killed off the last of the great general-interest weeklies in the 1960s.

Among the more than two hundred reproductions of engravings, drawings, and paintings reproduced here, a few are regarded as minor works by major artists like Winslow Homer and George Bellows, or as works by lesser but still important artists such as A. B. Frost, Frederic Remington, Charles Dana Gibson, William Glackens, George Luks, and N. C. Wyeth. Some of the artists—Edward Penfield and J. C. Leyendecker—are remembered as great commercial artists of their era who made no contribution to "fine art."

FIG. 3. A. B. Doolittle. *A View of the Buildings of Yale College in New Haven.* 1807. Yale University Archives.

Most of the images were produced by illustrators and cartoonists who were prominent in their time but have long been forgotten: Thure de Thulstrup, W. T. Smedley, W. A. Rogers, E. W. Kemble, Grant Hamilton, R. F. Outcault, John E. Sheridan, Hibberd V. B. Kline, Howard Giles, Sidney H. Riesenberg, and many others. Nearly all of the leading illustrators of the period tried their hand at depicting football at one time or another, simply as working artists plying their trade during the two months of football season.

Artists in this early period developed conventions for the four different kinds of football art in these chapters. Once the conventions were in place, the artists' challenge (and the challenge for those to follow) was to create novelty within them, in order to give viewers the pleasures of both the familiar and the new. That mandate is true for all popular art. For popular football art, novelty often meant finding some new way to capture the sport's distinctive excesses.

Football was conspicuously "excessive" from nearly the beginning. Its players were "giants" (six-footers, tops, but size is relative), swooned over by lovely maidens, and glorified by an over-lively press. Their sponsoring colleges, elite institutions of higher learning, seemed engaged in something closer to managing a Circus Maximus than

to training the nation's scholars and leaders. Above all, a supposed game played by sons of gentlemen often looked more like an organized brawl, punctuated occasionally by a thrilling kick or a run down the field. Artists attuned to this strangeness had to find ways to represent it in their art. A common solution was to employ elements of distortion and exaggeration—what could be called an "aesthetic of excess"—that pushed against the boundaries of straightforward representation more typical of popular illustration. Not all of the art reproduced in this book exemplifies such strategies, but many of the most distinctive, powerful, and imaginative works convey an aesthetic of excess that has continued to characterize much football art to our own day. Our recent discovery that football's most fundamental excess, the violence of its collisions, has more serious consequences than we ever imagined gives this aesthetic of excess a relevance today that transcends art.

The four streams of football art developed during a Golden Age of Illustration in the United States which has been variously dated from 1850 to 1925, from the 1870s to the 1920s, or from 1900 to 1950. This book opts for 1880 to 1920, the four decades that neatly coincided with the appearance

of American football art and the development of its early conventions. The Golden Age of Illustration was a golden age of popular football art, too. How much of it is "art," in the honorific sense, others can decide. Here I take it on its own terms.

Published before 1923, the images reproduced here are in the public domain, a fact that makes including over two hundred of them possible. Most are from my personal collection, supplemented through the dedicated efforts of Deborah Carroll and her colleagues in Interlibrary Loans at Oregon State University's Valley Library, for which I'm grateful, as always. Some of the posters and illustrations were available from the Library of Congress. For others I am thankful to librarians and archivists at Harvard University, Yale University, Ohio State University, Syracuse University, the University of Notre Dame, and the Smithsonian Institution, with special thanks to Ed White for sharing one of his paintings with me and to Robert Mann for sharing a rarely seen Bellows work from his personal collection. I am also grateful to Linny Frickman, director of the University Art Museum at Colorado State University, for an invitation to contribute to her groundbreaking exhibition of football art at CSU in 2015, which prompted me to follow through on what at the time was a loosely defined project.

At the University of Nebraska Press, Rob Taylor approved the project and with Courtney Ochsner oversaw its assembly; Ann Baker provided expert copyediting; and numerous others unknown to me handled design and production. To all, I express my thanks.

I have several hopes for this book. For readers interested in football history, I hope that it helps explain the game's distinctive place in American culture and how it got there during its formative decades. For readers interested in the history of illustration, I hope that the focus on the single subject of football captures the breadth of popular graphic art during four decades of its "golden age." For all readers I hope that the images are a visual feast, as enjoyable to pore over as they were to collect and assemble.

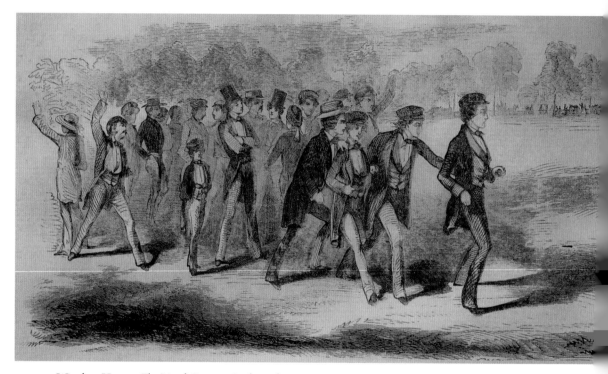

PLATE 1. Winslow Homer. *The Match Between Sophs and Freshmen—the Opening. Harper's Weekly,* August 1, 1857.

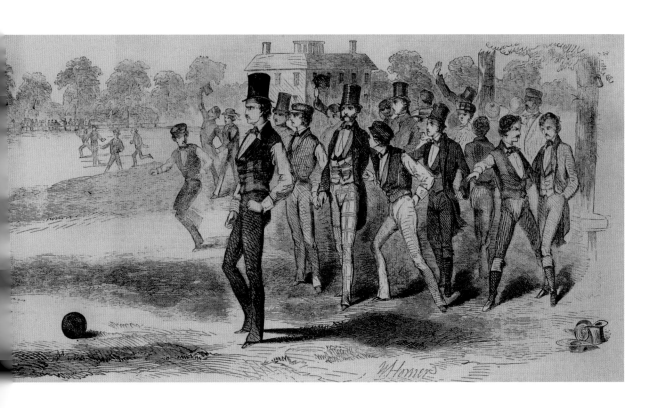

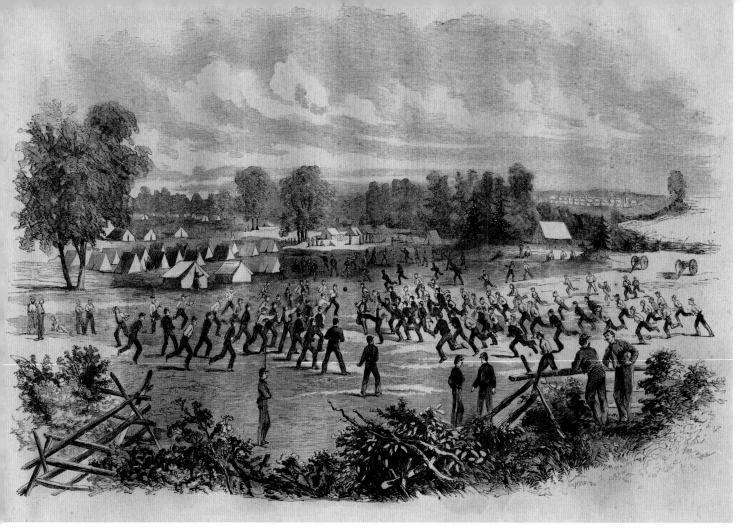

PLATE 2. *Camp Johnson, Near Winchester, Virginia—the First Maryland Regiment Playing Foot-Ball Before Evening Parade. Harper's Weekly*, August 31, 1861.

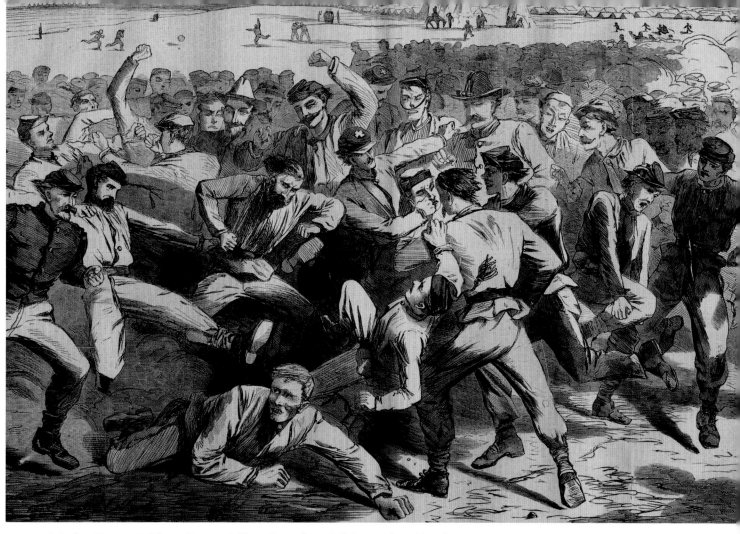

PLATE 3. Winslow Homer. *Holiday in Camp—Soldiers Playing "Foot-Ball." Harper's Weekly,* July 15, 1865.

PLATE 4. J. Davidson. *A Game of Foot-Ball. Harper's Weekly*, December 7, 1878.

PLATE 5. A. B. Frost. *Foot-ball Match Between Yale and Princeton, November 27. Harper's Weekly,* December 20, 1879.

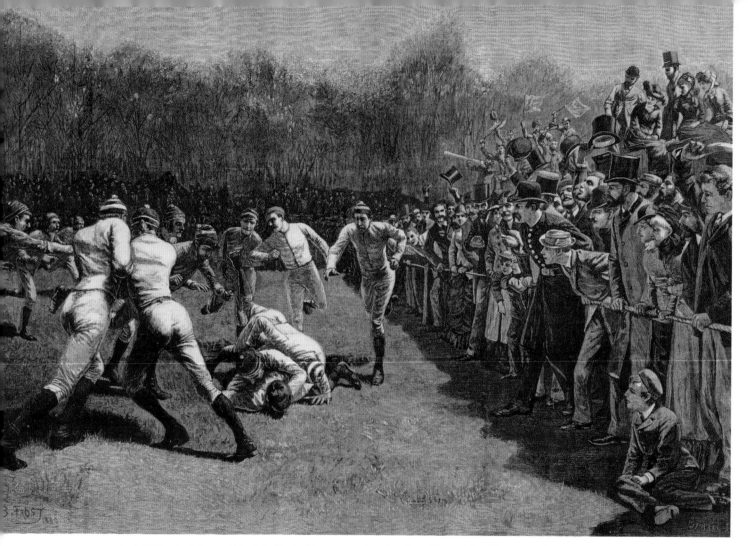

PLATE 6. A. B Frost. *A Game of Foot-Ball—A "Scrummage," at the Close. Harper's Weekly,* November 5, 1881.

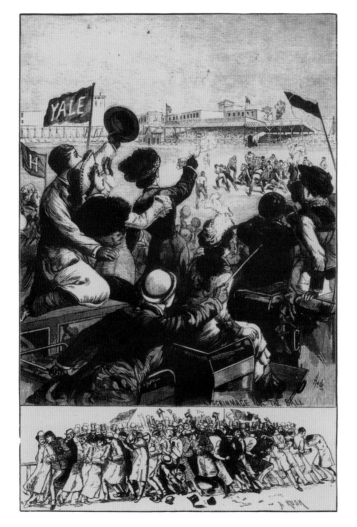

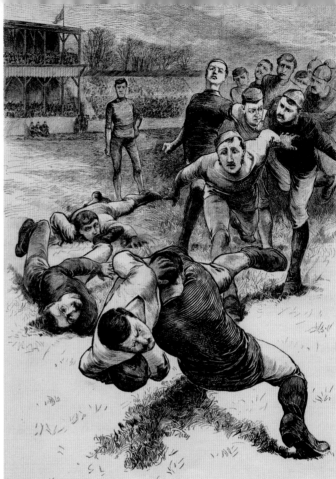

PLATE 7. C. Upham. *Great Game of Football Between Players of Yale and Princeton Colleges, on The New York Polo Grounds, Nov. 24th. Frank Leslie's Illustrated Newspaper*, December 17, 1881.

PLATE 8. *Foot-Ball—Collared. Harper's Weekly*, December 1, 1883.

1

HARPER'S WEEKLY AND THE BEGINNINGS OF AMERICAN FOOTBALL ART

IN DECEMBER 1878 a brief article accompanied J. Davidson's drawing, *A Game of Foot-Ball* (plate 4), when it appeared in *Harper's Weekly*:

> Our picture on page 969 represents a point in the game when one side has forced the ball almost to the opposite goal, and both teams, excepting goal-keepers, close in and try to force the other back by main strength. During this struggle the opponents can not be touched with the hand, except the one holding the ball. In our illustration the lad holding the ball has succeeded (at the expense of a shirt) in wriggling out of the "scrimmage," and is handing the ball to one of his "half backs," who will "touch it down" behind the goal for a safety, thus securing a breathing-space and a new trial.

The writer was obviously describing a game unfamiliar to readers who would otherwise have had no idea what they were seeing. The account was technical rather than interpretive, with the exception of a final sentence that appears profoundly ironic in retrospect: "The game requires speed, wind, and judgment, and if properly played, according to the revised rules, it is not dangerous."[1]

The weekly magazine launched by the Harper brothers in 1857 was not the first but it was the most successful and respected of the American illustrated weeklies that appeared

in the 1850s, all of them modeled on the *Illustrated London News* (1842), with its abundant large and small wood engravings. The first, in 1851, was *Gleason's Pictorial and Drawing-Room Companion*, followed a month later by the *Illustrated American News*. The *News* lasted just six months, then reappeared in 1853 as the *Illustrated News* published by the showman P. T. Barnum, which merged with *Gleason's Pictorial* within the year. The *Pictorial*, in turn, was sold in 1855 and renamed *Ballou's*; it lasted until 1859, the year that yet another short-lived paper, the *New-York Illustrated News*, first appeared (and then folded in 1864).[2]

A major figure in several of these short-lived enterprises was born Henry Carter but went by "Frank Leslie" when he worked as chief of the engraving room for the *Illustrated London News*. After emigrating to the United States, Carter/Leslie worked successively for *Gleason's Pictorial*, the *Illustrated American News*, and the *Illustrated News* before founding in 1855 his own weekly, *Frank Leslie's Illustrated Newspaper*. This one survived, and it became the principal rival that *Harper's Weekly* took on when it entered the field two years later. *Leslie's* and *Harper's* went on to thrive as the two great illustrated weeklies of the late nineteenth century: *Harper's* more respected and proper, *Leslie's* more sensa-

tional and lively.[3] The two papers lasted until 1916 (*Harper's*) and 1922 (*Leslie's*), but by then they had been eclipsed by the next generation of general-interest illustrated magazines that had emerged early in the new century, led by *Collier's* and the *Saturday Evening Post*. By this time technical advances and corresponding economic advantages allowed halftones to supplant wood engravings and photography to replace most artwork of any kind. (Daily newspapers underwent the same transformation.) Both the great era of wood engravings in the popular press and the beginnings of American football art belong to a brief period from around 1880 into the early 1890s.

The beginnings of American football art belong mostly to *Harper's*. All of the illustrated "miscellanies" (as opposed to the specialized journals) included pastimes and amusements among their subjects. In the 1850s this did not mean athletic games (with the exception of cricket) but trotting or yachting races in the summer, ice skating or sleighing in the winter, and the occasional prizefight or horse race whenever it occurred.[4] Barnum's *Illustrated News* favored the sensational or exotic: cockfighting in Havana, bull and bear fighting in New Orleans, wrestling in Japan.[5] *Ballou's* printed homely scenes of parlor games, husking parties, and

winter sledding ("coasting") drawn by a young Winslow Homer at the beginning of his career.[6] The rise of athletic sports came later, after the Civil War.

Illustrating timely news instead of scheduled pastimes, particularly with full- or double-page engravings, was an enormous challenge, not just because of the delay in getting a sketch artist to the scene but also because of the further delay in processing the wood blocks on which the sketches had to be carved. Frank Leslie pioneered a process for cutting large blocks into as many as thirty-two sections that were assigned to a team of engravers and then reassembled, with a master engraver knitting the separate sections together. More timely publication became possible but with an obvious drawback inherent in the process: the varied engravers, often working from just a rough sketch, had to follow common rules and conventions for the final image to cohere—a certain kind of line for ground, another for foliage, another for flesh, another for drapery. Some engravers became specialists, with mildly disparaging nicknames: *pruners* (sky and foliage), *tailors* (drapery), *butchers* (flesh). The result could only be a generalized version of the scene, with no claim to faithful recreation and no individual style—"second- or third- or fourth-hand accounts, or even badly jumbled accounts by many different people, of what things were supposed to look like," as one particularly severe critic put it. Engravers were reduced from artisans to mechanics, while artists with talent and aspirations hated losing control of their images. (Winslow Homer was among those who solved the problem by becoming his own engraver.)[7]

The new process made possible the double-page prints of Civil War battles for which *Frank Leslie's Illustrated Newspaper* and *Harper's Weekly* both became famous. It also made possible more timely coverage of major horse races and championship prizefights, the two mid-nineteenth-century sports of greatest popular interest. The first full-page engraving of a sporting event published in *Leslie's*, in October 1858, pictured the ballyhooed prizefight between John Morrissey and the "Benicia Boy," John Heenan (fig. 4). Two years later, when Heenan traveled to England to challenge Tom Sayers for the putative championship of the world, three months of astonishingly extravagant coverage climaxed in a four-page foldout of the championship bout itself.[8] *Leslie's* sent its own staff writer and artist to England for what the distinguished historian of the popular press, Frank Luther Mott, calls "one of the greatest feats of journalistic enterprise" of

Frank Leslie's career. And it was profitable too—sales for this issue more than doubled regular circulation.[9]

For the Heenan-Sayers bout, *New-York Illustrated News* matched *Leslie's* blow for blow, with an "extra" edition devoted entirely to the fight plus its own special correspondent to provide drawings: a young Thomas Nast, before he became the scourge of Tammany Hall as a political cartoonist for *Harper's Weekly*, plus an "Extra" edition devoted entirely to the fight.[10] *Harper's Weekly*, on the other hand, published just one double-page engraving of what it called the "Brutal, Bloody, and Blackguard Prizefight."[11] In its disdain *Harper's Weekly* spoke for the "respectable" classes, while *Frank Leslie's* and the *New-York Illustrated News* appealed more to the masses (though *Leslie's* also denounced the bouts in 1858 and 1860 even while extravagantly illustrating them). Prizefighting was illegal everywhere in the United States (Morrissey and Heenan fought in Canada) and it continued to offend middle-class sensibilities until the 1920s. Heenan-Sayers was the last prizefight covered by *Leslie's*, until John L. Sullivan took on "Gentleman Jim" Corbett in 1892 with gloves rather than bare knuckles, still with some explicit nose-holding over the "demoralizing 'profession.'"[12]

In those intervening years, *Leslie's* published roughly a dozen large illustrations of sporting events every year, predominantly rowing (nearly ninety illustrations) and horse racing (about fifty). There was very little baseball coverage before the 1890s—twice as much yachting and nearly as much cricket—and even less football. After its first notice of the new college sport in 1881 (plate 7), *Leslie's* did not publish its next football illustration until 1886, another full-page rendition of the season-ending championship contest that took place in driving rain, by Charles Upham (plate 9). A cover by John Durkin and a double-page centerfold by Upham in 1889 (plates 10 and 11) marked the beginning of more regular football illustrations, with B. West Clinedinst replacing Upham as the principle artist. Reasons for the relative delay, compared to its rival *Harper's Weekly*, can only be surmised. Frank Leslie died in January 1880, leaving the paper to his wife, who, after not quite a decade as the "Empress of Journalism," sold it to the publishers of the humor magazine *Judge* in 1889.[13] It was more likely football's tremendous growth as a spectator sport rather than changes in ownership that led to the increased coverage. Football was an elite collegiate sport from its beginnings, and *Harper's Weekly* was more attuned to the activities of

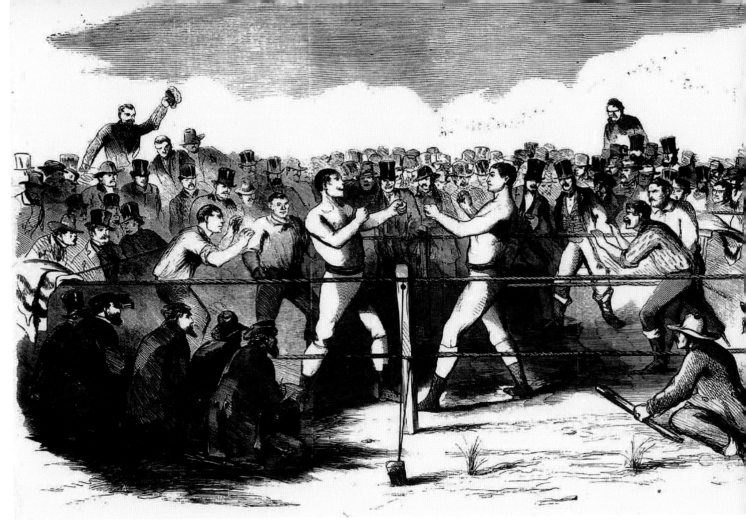

FIG. 4. *The Great Prize-Fight Between Morrissey and the Benicia Boy at Long Point, Canada West. Frank Leslie's Illustrated Newspaper,* October 30, 1858.

the elite. By the end of the 1880s it had become the premier American spectator sport in its season with an audience extending into the middle classes. For whatever reason, *Harper's*, not *Leslie's*, took the lead in developing conventions for illustrating football in the 1880s.

FOOTBALL AS CONTEST AND SOCIAL EVENT

The popular enthusiasm for the wood-engraved sporting prints of the 1850s and 1860s is hard to fathom, given the fact that all prizefights and prizefighters looked alike, as did all horse races, cricket matches, and boat races. New printing processes and technologies changed this. The football illustrations that appeared in *Harper's Weekly* in 1878, 1879, and 1881 are significantly different from the ones published in the 1860s. For example, compare Frost's in 1881 (plate 6) to Homer's in 1865 (plate 3). Homer's has more white space, less fine detail, and a more simply sketched background; Frost's figures (both players and spectators) are more individualized. The faces of the men in Homer's football-as-slugfest are expressive, but all have essentially the same expression. The facial expressions in Frost's 1879 rendering of the Yale-Princeton game (plate 5) are still fairly uniform but more lifelike, while the players' bodies

are more varied, contoured, and dynamic, and the background is more detailed and layered.

All of these are wood engravings from drawings done by two of the era's foremost illustrators early in their careers. (The artworks are attributed exclusively to the artists because the engravers rarely signed them, but in fact every wood engraving was a collaboration between artist and engraver.) The differences derive less from either the engravers' skills or the artists' styles than from the development of a new process for transferring the drawing or painting onto the woodblock by photograph rather than by hand. Engravers now worked from a detailed copy of the artist's original, rather than a rough approximation. Engravers also devised ways to capture the tones and textures of the original, even the illusion of brushwork, through techniques such as stippling, cross-hatching, and pricking.[14]

Among engravers, this "new school" was controversial: the goal was speedy and economical reproduction of original art for large print runs, rather than to be an art form in itself, as the best wood engravings had been viewed for centuries. Engravers of the old school disparaged the new's use of tricks and complained about a loss of clarity and definition. Old school engravers had interpreted or translated

an original artwork, often just a sketch, transforming it into art. New school engravers, striving to reproduce the original as accurately as possible, were supposedly mere "copiers."[15]

With this new approach, wood engraving may have declined as a fine art but popular illustration improved dramatically. For enthusiasts, the new school launched a veritable "textural revolution" whose leaders for once were American, not British. Some of the best were employed by the firm of Harper & Brothers, which also had "nearly all of the important illustrators of the last quarter of the nineteenth century" on staff.[16] With its primary commitment to more faithful reproduction, new school engraving was inevitably a brief stage in the transition to photography, but from the late 1870s to the early 1890s it marked a high point for illustration in popular magazines. Football art was a beneficiary.[17]

Under the supervision of one of the era's leading art editors, Charles Parsons, Harper & Brothers began shifting to new school engraving in the late 1870s for its three major periodicals: a weekly and a monthly for adults and a monthly aimed at young people.[18] Following the full- or double-page football engravings in the *Weekly* in 1878, 1879, 1881, and 1883, the next, a cover by Frederic Reming-

ton (plate 12), did not appear until 1887. (The absence of Thanksgiving Day championship games in New York in 1885 and 1886 likely accounts for part of the gap.) The next four years then saw full- or double-page engravings of drawings by Frederick Barnard (plate 13), Thure de Thulstrup (plate 14), Charles S. Reinhart (plate 15), Remington (plate 16), William A. Rogers (plate 17), and William T. Smedley (plate 18). The five years from 1887 through 1891 mark the pinnacle of football illustration in *Harper's Weekly*.

While only Frederic Remington is remembered today, all of these men were among the era's major illustrators. Thirty-four of Reinhardt's drawings are held by the Smithsonian's Archives of American Art, though not *Foot-ball at Tuxedo*, a simple line drawing of spectators at an early season contest. In contrast, Thulstrup's renown for rendering crowds is well justified by his richly textured portrait of the spectators at the Yale-Princeton Thanksgiving Day Game.[19] Thulstrup was a prolific illustrator of sports for *Harper's Weekly*—lacrosse, croquet, yachting, polo, sleighing, baseball, rowing, badminton, horse racing, curling, tennis, archery, water polo, and ski-jumping, in addition to football. Overall, in subject matter Thulstrup paid roughly equal attention to spectators and the sporting action. In the case of football,

the subject he chose—the well-dressed crowd observing the game rather than the game they were observing—reflected and contributed to one of the defining aspects of the new intercollegiate sport.

The Ardor and the Joy of a Game at Foot-Ball (plate 13), by Frederick Barnard in 1888, also depicted elite spectators rather than young athletes. Walter Camp's accompanying article described the scene:

> Our artist has evidently selected the front seats of the grand stand from which to make his sketch, and in the excited faces of the two men in the foreground one easily recognizes the old undergraduate enthusiasm stirred into new life by the excitement of the game. Youth shines once more in their faces almost as strongly as in the bright face of the boy behind them. He perhaps is exulting in the prowess of an elder brother "on the team," and looking forward to the time when he too shall be representing his university.[20]

Football had become fundamentally a spectator sport within a decade of its beginning, initially appealing to only certain social classes. Over the 1880s and early 1890s

the Thanksgiving Day championship game in New York in particular became a major event on the social calendar of the city's elite, equivalent to a fashionable tennis tournament, the opening of the racing season at Jerome Park, the annual horse show, or the opening of the opera season (fig. 5).[21] With audiences in the foreground, illustrations of these events made it clear that the point was who attended more than what they saw. That a football game was deemed comparable to these major social events speaks volumes about the game's distinctive place within the larger American sporting culture. As college football spread from a handful of leading northeastern universities to state colleges throughout the country, these illustrations marked it in a way that drew the elites of communities everywhere, as well as those from the middle classes with social aspirations. (Professional football remained a largely working-class sport into the 1950s, mostly ignored by the middle and upper classes outside the handful of cities that fielded teams in the National Football League.)

Leslie's illustrated the Thanksgiving Day championship game in this way as early as 1881 (plate 7), when the crowd of ten thousand at New York's old Polo Grounds was unprecedented. It was the second contest played in New York,

following games in Hoboken in 1878 and 1879, years when the new intercollegiate sport was little known beyond the campuses and alumni of Harvard, Yale, and Princeton. Moving the Thanksgiving Day game to New York was the catalyst for the game's discovery by a broader audience. By the early 1890s the ten thousand at the Polo Grounds grew to forty and fifty thousand at Manhattan Field, as football became a great spectacle and a subject for full-page, double-page, and cover illustrations in virtually all of the illustrated weeklies, not just *Leslie's* and *Harper's* (plate 19).

What quickly became celebrated as the "traditional" season-ending Thanksgiving Day championship game in New York lasted only through 1893 (with no games in the city in 1885, 1886, and 1888), after which school authorities moved the contests back to their own campuses to curb students' postgame carousing in the dance halls and saloons of the Tenderloin District. The three games at Manhattan Field in 1891, 1892, and 1893 marked the pinnacle of football's impact on the city and the city's on football, and they had a huge impact on football illustration as well. In addition to the fashionable spectators, another distinctive contribution to college football's emerging iconography was the horse-drawn coach spilling over with students heading uptown to

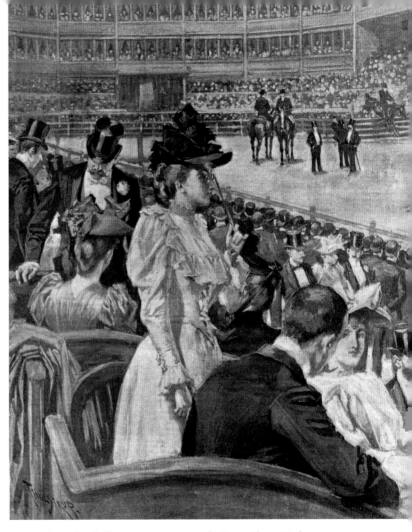

FIG. 5. Thure de Thulstrup. *An Evening at the Horse Show, Madison Square Garden, New York. Harper's Weekly,* November 19, 1892.

Manhattan Field from their midtown hotels (plate 20). As other colleges and universities followed New York's example, football became permanently linked to the national holiday (just as college football bowl games would later lay claim to New Year's Day). Aided by graphic artists, college football's role as spectacle and social event made it fundamentally different from baseball, the people's game and national pastime.

The fashionable crowd's centrality to football's place in American life is no more clearly evident than in two double-page centerfolds drawn by W. T. Smedley for *Collier's* in the early 1900s. Both images adopt the same perspective he used for his 1891 illustration for *Harper's Weekly* (plate 18). In the *Collier's* illustrations the game itself has receded deeper into the background (plate 21) or out of the picture altogether (plate 22). Only the upper-class spectators matter. Smedley was known as a pictorial chronicler of the lives of the social elite, praised by one contemporary for his "keen eye for the individualities which the monotonous sameness of fashionable attire often veils," as well as for his "sympathetic and subtle psychological analysis penetrating the social attitude of well-mannered people."[22] His football illustrations pose a fundamental question for anyone curi-

ous about the sport's remarkable ascendance in just two decades: which mattered more, the watching or the playing?

Yet the game itself did matter—a great deal. A third centerfold in *Collier's*, by T. Dart Walker at the turn of the century (plate 23), captures the dynamic action of a well-coordinated play. Advocates championed football as a link to the heroic ages of Greece and Rome for a modern world desperately needing to recover a lost warrior spirit. Illustrators from nearly the beginning tried to portray this visually. The unsigned engraving in *Harper's Weekly* from 1883 (plate 8), despite its relative simplicity, is historically important for capturing the fierce struggle of the new sport in the frantic expressions on the players' faces. To appreciate the novelty of this drawing, recall Walter Camp's description of Frederick Barnard's 1888 illustration: "Our artist has evidently selected the front seats of the grand stand from which to make his sketch." Artists sketched from the bleachers or the sidelines. The perspective for the 1883 drawing, up close and head-on, is an imagined one, as if from a vantage point on the field itself that was unavailable to spectators, including the artist. This perspective became conventional, most notably in illustrating the desperate effort to score the winning touchdown in football short stories (see chap. 4),

but it had to begin somewhere. This innovative perspective was among the earliest of many strategies that artists adopted to portray football as no mere game of skill but a challenge and a test.

Most football illustrations in the 1880s and 1890s emphasized the action on the field rather than the crowd watching it. Simple line drawings to illustrate articles explaining the new game had, by the early 1890s, given way to more detailed covers and full-page drawings (plates 24–28). With their boyish players, all of these are strikingly different from the 1889 *Leslie's* cover by John Durkin (plate 10) or even the 1883 drawing in *Harper's*. Casting players as boys rather than rugged "college men" implicitly made football an innocent, carefree sport with no taint of the controversies over eligibility and brutality that swirled around the game. One of the two *Leslie's* covers from 1893 (plate 26) hinted at football's violence in portraying what it called "one of the most exciting scenes ever witnessed on a football field": a wounded young warrior returning to the sidelines in time to see his team's winning touchdown as the fans cheer. But this is the uplifting moment of his return, not the blow that forced him to leave. While football's brutality was becoming a major topic in daily newspapers and humor magazines,

the general-interest illustrated weeklies largely avoided controversy.

The *Harper's Weekly* artist most attentive to the players' experience was Frederic Remington, one of the magazine's few football illustrators, along with Winslow Homer and perhaps A. B. Frost, who are still well remembered."[23] All three became known for their paintings of outdoor subjects, predominantly the "sports" of hunting, fishing, and, in Remington's case, anything done on a horse—but not athletic games (although Frost also drew numerous golf illustrations for *Collier's*). Remington alone created something like a body of work on football. In addition to his 1887 cover (plate 12) and 1890 centerfold (plate 16), Remington produced a double-page suite of seven pen-and-ink washes illustrating a Yale practice in 1888 (plate 29) and, in 1893, both a full-page montage of players in various poses (plate 30) and a full-page painting titled *A Run Behind Interference* (plate 31). To these he added a full-page illustration for a football short story by Walter Camp for *Collier's* in 1898 (plate 32) and a pair of smaller ones for a football story in *McClure's* in 1900 (fig. 6).

Remington's drawings for *Harper's Weekly* in 1888 (plate 29) and 1893 (plate 30), representing the various actors and

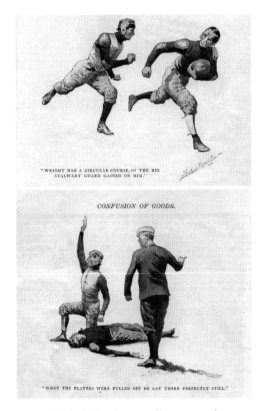

"WRIGHT HAD A CIRCULAR COURSE, SO THE BIG STALWART GUARD GAINED ON HIM."

CONFUSION OF GOODS.

"WHEN THE PLAYERS WERE PULLED OFF HE LAY THERE PERFECTLY STILL."

FIG. 6. Frederic Remington. Illustrations for Frederick Carrol Baldy's short story "Confusion of Goods." *McClure's*, November 1900.

actions in a football game, belonged to a distinct genre in the illustrated weeklies: a collection of snapshots rather than a single panoramic view to capture the variety of picturesque scenes and events. Remington regularly illustrated western outposts and military exercises, as well as New York's annual National Horse Show, in this manner. Football lent itself particularly well to this montage-like treatment, due to the elements of spectacle and the variety of distinct actions (blocking, tackling, kicking, running). Remington's slightly stylized figures anticipated the poster art that soon became an American craze.

Remington was certainly the *Harper's* artist most suited to illustrating football. He played for one season at Yale (in 1879, with Walter Camp as a teammate) and was the hero of one of the game's early legends: supposedly showing up for the Harvard game in a sweater dipped in blood from a local slaughterhouse, to look "more business-like."[24] Remington's first published artwork, as a Yale freshman the year before, was a cartoon in the campus newspaper showing a banged-up player telling his friend, "The doctor says I'll be all right by Thanksgiving and that's all I care for now" (fig. 7). In contrast to this undergraduate's reveling in football's roughness, both *Football—A Collision at the*

Ropes (plate 16) and *A Run Behind Interference* (plate 31) are remarkably tame. The game had become considerably more violent since Remington's one season in 1879. Camp devised his foundational rules in 1880 and 1882 for the sake of the strategies that became possible when a team had clear possession of the ball. But the unintended consequence of separating the two teams to confront each other across a scrimmage line was to transform rugby into a collision sport. "Slugging" became common, to the outrage of critics and the shame of the supposed young gentlemen representing elite academic institutions, but fully legal violence quickly became a greater problem. In rugby, players in front of the ball were offside. In American football, putting the ball in play by healing it to a back left most of the team offside at the outset. When "interference" by players ahead of the ball carrier proved impossible to eliminate, the tactic was simply legalized (we now call it "blocking"). With no limit for several years on the number of men who could line up in the backfield or move forward before the ball was put in play, the obvious strategy for gaining five yards in three tries became so-called mass-momentum plays—attacking the weakest part of the defense with as much bulk and force as possible. Mayhem ensued.

FIG. 7. Frederic Remington. Cartoon in *Yale Courant*, November 2, 1878.

Football had become so violent by 1893—the season of the flying wedge, the ultimate mass-momentum play—that calls for abolishing the sport altogether prompted Camp to launch a supposedly objective investigation of football's dangers by soliciting opinions from former players. Reporting selectively on what he heard back—his real purpose was to defuse the criticism—Camp was no doubt delighted to include a response from Remington:

Let the good work go on—but who the devil is making you all this trouble? They are not going to pass any State laws against it, I hope. Football, in my opinion is best at its worst—to be Irish. I do not believe in all this namby-pamby talk, and hope the game will not be emasculated and robbed of its heroic qualities, which is its charm and its distinctive quality. People who do not like football as now played might like whist—advise them to try that.[25]

Scholars have likened Remington's popular painting *The Charge of the Rough Riders at San Juan Hill* to his earlier *A Run Behind Interference* (plate 31) for their similar depictions of bodies moving through space during combat, with the heroic and violent game of football that Remington knew

firsthand being transposed to the more serious "game" of war.[26] But war produces casualties, as Remington's painting shows, unlike his version of football, which in fact looks like the carefree boys' game portrayed by other illustrators. The nearly identical strides of the four central figures in the football scene create a stylized sense of fluid motion, not dangerous sporting combat. Even his illustration for *Collier's* of a doctor attending an injured player on the field (plate 32) lacks emotion and drama. Players stand around as if at a cocktail party. Perhaps Remington intentionally played down football violence in his art to counter the criticism that threatened the game's future. For whatever reason, the artist who should have known football best surprisingly left out the "Irish" altogether.

ENGRAVINGS AND HALFTONES

A Run Behind Interference was not an engraving but a halftone reproduction, as was the double-page centerfold by W. T. Smedley in 1891 (plate 18) and the full-page illustration by R. F. Zogbaum in 1892 (plate 33). W. A. Rogers's *Out of the Game* (plate 17), published a month before Smedley's centerfold, was the magazine's last wood engraving of football and arguably its most powerful—new school

engraving at its best. Rogers's depiction of a fallen player, calm as death, with one frantic teammate kneeling at his side while the game continues upfield—brutality meeting brutal indifference—was likely never enacted in just this way on an actual football field. The drawing was not sketched from life but conceived to make a statement about football's excessive violence.

For all its success, the new school of wood engraving "marked the last phase of a dying craft," as ever-newer processes made it possible to transfer images, photographs as well as drawings or paintings, more cheaply and less laboriously onto metal plates, and required no engraver to complete the process.[27] Halftones replaced engravings in the early 1890s, and photographs increasingly replaced all artwork by the turn of the century. The primary purpose of illustrations in the weekly magazines, after all, was journalistic, not artistic. Neil Harris has argued for a revolutionary "visual reorientation," brought on by the halftone photograph that showed viewers the reality of their world rather than just an approximation of it.[28] Whatever the gain for understanding, popular illustration was the loser and football art particularly so, because it would be decades before advances in camera technology (high-speed film, telephoto lenses) allowed photographs to capture the game's drama as well as a talented illustrator could. A photograph in this early period could record the picturesque backdrop of the Thanksgiving Day game at Manhattan Field in 1893 (fig. 8) but not the intensity of the game itself.

After the publication of Remington's *Run Behind Interference* in 1893, *Harper's Weekly* published just five more full-page football illustrations over the next seventeen years:

in 1900 a cartoon by Albert Levering, better known for his work for the humor magazine *Puck* (plate 34);

in 1901 a pair of head-and-shoulder portraits of the rival captains for Harvard and Yale by John Cecil Clay (plate 35);

in 1902 a captioned scene painted by Howard Giles that seems more appropriate for illustrating a short story (Giles's specialty) than as a stand-alone representation of the game (plate 36);

in 1903 a painting by Troy and Margaret Kinney of a Princeton player scoring a touchdown against Yale (plate 37)—in effect, a reimagining of the *Harper's* 1883 engraving;

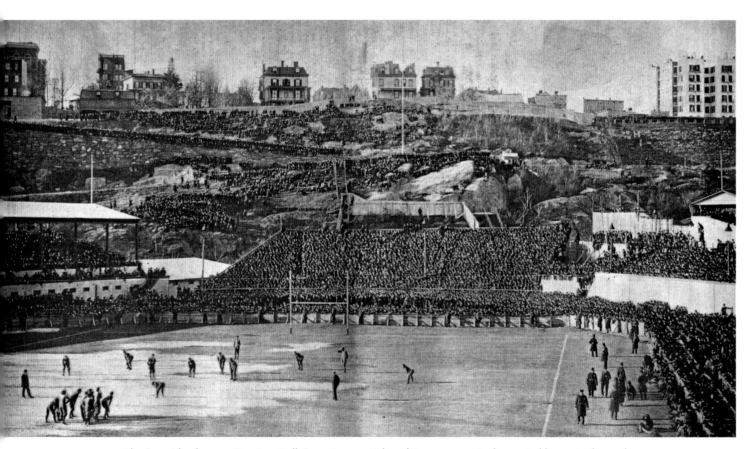

FIG. 8. *The Great Thanksgiving Day Foot-Ball Game Between Yale and Princeton, at Manhattan Field, New York. Frank Leslie's Illustrated Weekly*, December 7, 1893. Princeton is lined up for a flying wedge on the opening kickoff.

and in January 1910 an image by Anton Fischer of grieving parents looking down on their fallen son, surrounded by his solemn teammates (plate 38), following a season in which twenty-six players died from game-related injuries.

Between 1909 and 1912 the *Weekly* also published four covers in the colored poster style adopted by *Collier's*, the *Saturday Evening Post,* and the other popular weeklies of the new generation (see chap. 3).

All of these works were halftones. The various engraving and halftone processes did not succeed each other in orderly fashion but overlapped and coexisted.[29] Halftones first appeared in illustrated magazines in the 1880s, but not until the turn of the century was the quality good enough for them to become the new standard for illustration, color as well as black and white. The halftone process put engravers out of work, though not immediately: they were needed for improving the quality of the reproductions until improvements in the process made them unnecessary.[30] Halftones also freed artists from their dependence on engravers, and W. A. Rogers conceded in his memoir that "the average half tone was far superior to the average work on the block." But he also contended that

"no half-tone engraving has ever equaled the best wood engraving."[31] At its best, new school engraving combined the boldness and clarity of the old school with the tonal and textural detail possible through the photographic transfer of images.

Among the football illustrations in *Harper's Weekly,* "at its best" means Rogers's own *Out of the Game* (plate 17). Some kinds of original art worked better than others as wood engravings. Most obviously, black-and-white halftones from colored originals lost the sharp contrasts and clarity of wood engravings without gaining the subtleties of color. Remington's *Football—A Collision at the Ropes* (plate 16) illustrates the point. Remington's original oil painting of the same subject (plate 39) has three distinct color planes: blue-gray sky, greenish brown field, and a black wedge of spectators jammed between them and setting off the five white figures on the field. The painting depends on the formal arrangement of these colored planes. For the engraved illustration, the contrast between sky and field is mostly lost; distinctions among the spectators are blurred; and clarity in general has disappeared (except for the striped sleeves and stockings that an engraver gave some of the players in order to distinguish the two teams).[32]

The difference between Rogers's engraved drawing and a later halftone painting of essentially the same subject, Anton Fischer's *The Paths of Glory* from 1910 (plate 38), is equally striking. The high black-and-white contrast and lack of textural nuance and tonal gradation of the wood engraving make details stand out while the uncrowdedness of the scene makes them matter. The players in Fischer's halftone look more life-like; those in Rogers's wood engraving create an emblematic tableau in which each figure has a distinct role. The kneeling teammate's bandaged head makes him another casualty; the trainer running onto the field with a water bucket suggests futility in attempting to bring relief; the substitute on the sideline having his sweater pulled off so that he can enter the game makes the fallen teammate seem replaceable; and the players in the background, watched by the referee and cheered by the fans on the sidelines, continue as if nothing has happened or such injuries are commonplace. The focal point is not the fallen player but his frantic teammate, who alone appears to know the seriousness of the injury and whose expression suggests that he will be haunted by it. He, too, appears to be "out of the game."

What is lost in verisimilitude in Rogers's wood engraving is more than made up in dramatic power. Halftones rendered paintings more accurately, but wood engravings at their best achieved an expressionistic effect that amplified simpler drawings. Wood engravings tended toward generalization, abstraction, and symbolism—that is, interpretation of the subject rather than accurate rendering of it—and the best wood engravings exploited this inherent quality rather than conceding the limitations of the process. Artists' desire to control the final appearance of their work is understandable, but the collaboration of artist and engraver—and the process itself—produced highly distinctive illustrations, sometimes of exceptional quality. When their subject was football action, in their necessary simplification and exaggeration wood engravings naturally tended toward an aesthetic of excess.

Harper's Weekly was part of the broader shift to using halftones in the 1890s. The football covers of *Frank Leslie's Illustrated Newspaper* in 1889 (plate 10) and 1890 (plate 24) were engravings; the two in 1893 (plates 26 and 27) were halftones. The covers of *Once a Week* in 1892 and 1893 (plates 19 and 20) were halftones, as were all of the football illustrations that appeared in that magazine after it changed its name to *Collier's*. One great exception to this shift in the early 1890s was the *National Police Gazette*, the scandalous

weekly paper known for showcasing chorus girls and prize-fighters, not for celebrating the sportive battles of lads from Harvard, Yale, and Princeton. Processes of reproduction aside, football illustrations in the *Police Gazette* had a look all their own. The first quarter-page football illustration appeared in 1884 (fig. 9), the first double-page centerfold in 1887 (plate 40), followed by others in 1889, 1890, 1895 (plate 41), 1896, and 1901. Like the mainstream periodicals, the *Police Gazette* illustrated college football either as played or as watched. When played, football was always a brutal slugfest; when watched, the spectators were not the cream of American society but "sporting men" and their tarted-up female companions. The men wore derbies, not top hats; the women in gay bonnets reveled in the game's violence (fig. 10) and swooned over their football heroes in more suggestive ways than proper publications would allow. These illustrations gave the paper's working-class male readers some ownership of the new rough-and-tumble elite sport while at the same time mocking the supposed gentility of its upper-class patrons.

By the mid-1880s, when images of football began to appear in the *Police Gazette*, illustration was primary, text secondary. As the historian Elliott Gorn has put it, "The

Gazette existed to display spectacles, to appeal to individuals' lusts, fears, hatreds, fantasies and desires with viscerally moving images that transformed the world's utter incomprehensibility into readily consumable visual information."[33] The "information" in its football illustrations was that the noble collegiate sport, which thrilled the genteel classes and was valued as an education in manliness, was, in fact, more brutal than prizefighting, which was illegal nearly everywhere. (The *Police Gazette*'s publisher, Richard K. Fox, crusaded to legalize boxing, not ban football.) Ironic captions for the football illustrations mocked this elitist hypocrisy:

"Cheerful sport between the aesthetic young men of Princeton and Yale."

"College boys and Tenderloin lassies have a field day."

Images of college football players in the *Police Gazette* in the 1880s and early 1890s were indistinguishable from countless ones of prizefighters: tough-looking, powerful men strikingly different from the boys at play in most football illustrations of the day (apart from the 1889 cover for *Leslie's*

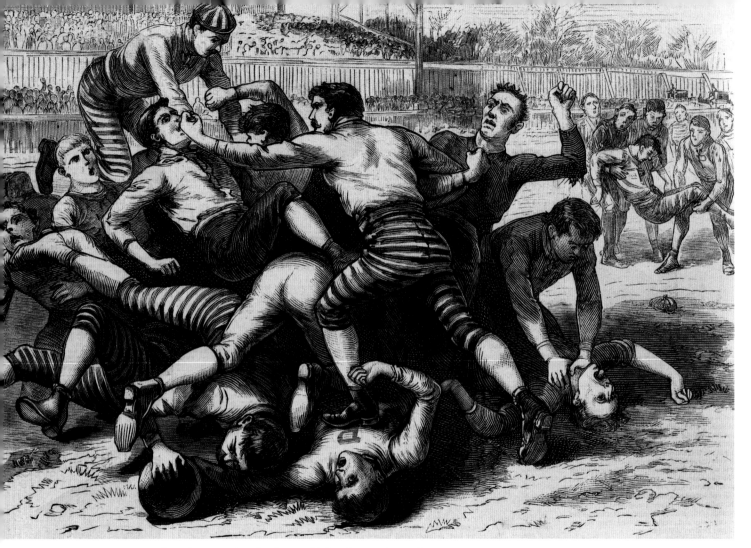

FIG. 9. *Not Under Judge Barrett's Rules. National Police Gazette,* December 20, 1884.

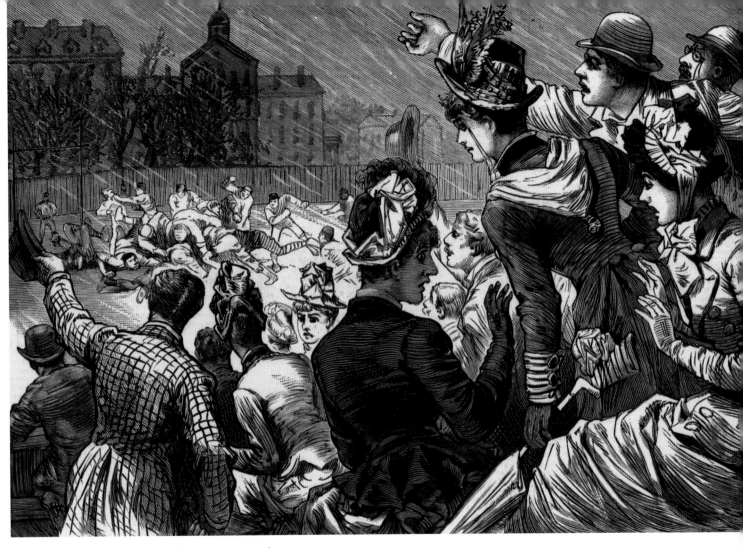

FIG. 10. *Fierce Football. National Police Gazette*, December 11, 1886.

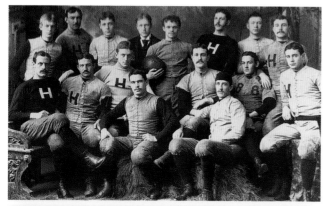

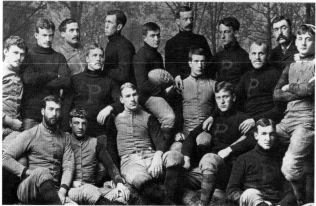

FIG. 11. Team photographs: (*top*) Harvard, 1888; (*bottom*) Princeton, 1889.

[plate 10]). Actual players in team photos from these years (fig. 11) show sturdy young men, neither thuggish nor boyish (though closer to those in the *Police Gazette*). In the faces of the players the illustrated magazines and their artists passed judgment on the collegiate game.

All of the *Police Gazette*'s football illustrations were wood engravings; later halftones came entirely from photographs. Its double-page centerfolds were typically montages of figures or scenes from a championship game. The great exception was the (unsigned) centerfold of the Harvard-Yale game in 1887 (plate 40), arguably the most impressive of all the illustrations in any of these magazines, as it powerfully demonstrates wood engraving's capacity to capture football's intense physicality. Like Rogers's *Out of the Game*, the image is not realistic. Players are not individualized. The uniformly burly men, with strangely emotionless expressions, look like clones of a single prototype: grim men in hard struggle, indifferent to pain, undistracted by anything but the task at hand. Collectively more than individually these figures conjure enormous power. The scene is composed so that everything moves with increasing intensity toward the ball carrier being tackled in the lower right corner of the frame; all of the power and force of both

teams are concentrated on that collision. The drawing is a triumph of imagination, not observation, and a triumph of wood engraving art.

Harper's Weekly published no football art of any kind between 1894 and 1900, only photographs. *Leslie's* published none between 1894 and 1904. When halftone reproduction of football artwork returned to these magazines, it served a new purpose: photographs showed readers what football looked like and artwork (such as Anton Fischer's 1910 centerfold [plate 38]) interpreted what it meant. The improvements in halftone reproduction that ended the era of wood engraving also ushered in the great era of American magazine illustration that lasted until the arrival of television in the 1950s. Paintings could be reproduced to the finest detail, in full color. In 1903 *Collier's* contracted with Frederic Remington for twelve pictures a year for four years, for the astonishing sum of $1,000 per month. A year later the same magazine upped the ante by paying Charles Dana Gibson $1,000 per drawing.[34] (Gibson's line drawings reproduced equally well as engravings or halftones.) Superstar illustrators became famous as well as rich.

By this time both *Harper's Weekly* and *Leslie's Weekly* were in decline, as first *Collier's* and then the *Saturday Evening Post* dominated the new market. But American football art was born in *Harper's Weekly*. With seventeen full- or double-page illustrations from 1878 through 1893, *Harper's* paid both earlier and more sustained attention to the new college sport than the other illustrated magazines did.[35] It developed the conventions for representing football's dual nature as a game to play and a game to watch. But after the early 1890s, the Golden Age of Illustration, and also of football art, mostly played out elsewhere.

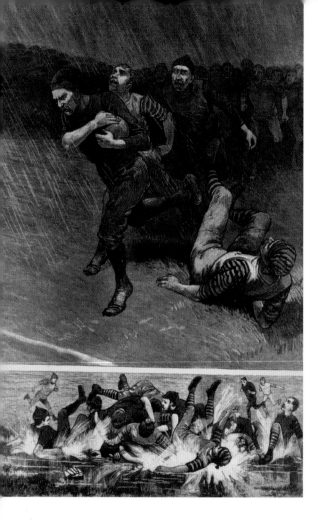

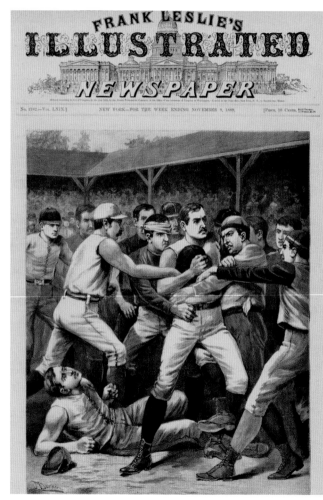

PLATE 9. C. Upham. *The Game of Football for the Championship Between the Yale and Princeton Elevens, at Princeton, November 25th. Frank Leslie's Illustrated Newspaper,* December 4, 1886.

PLATE 10. J. Durkin. *A Game of Foot-Ball—A Struggle for the Ball. Frank Leslie's Illustrated Newspaper,* November 9, 1889.

PLATE 11. C. Upham. *The Thanksgiving-Day Game of Football Between the Yale and Princeton College Teams on the Berkeley Oval, New York City. Frank Leslie's Illustrated Newspaper,* December 7, 1889.

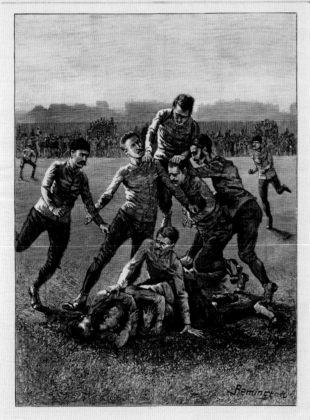

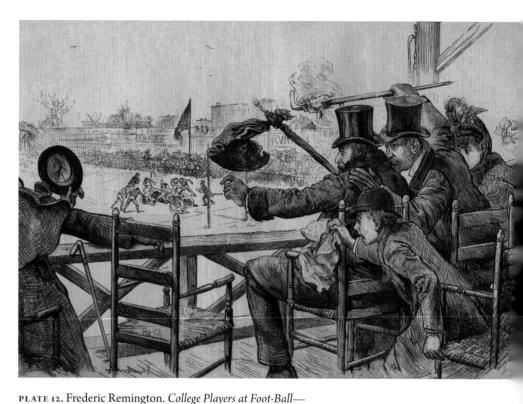

PLATE 12. Frederic Remington. *College Players at Foot-Ball—A Tackle and Ball-Down. Harper's Weekly,* November 26, 1887.

PLATE 13. Frederick Barnard. *The Ardor and the Joy of a Game at Foot-Ball. Harper's Weekly,* November 10, 1888.

PLATE 14. Thure de Thulstrup. *The Princeton-Yale Foot-Ball Match at the Berkeley Oval. Harper's Weekly,* December 7, 1889.

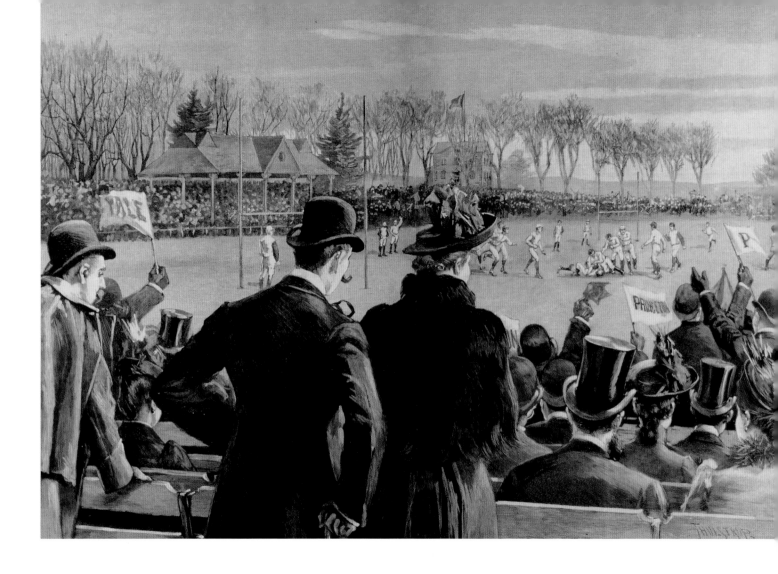

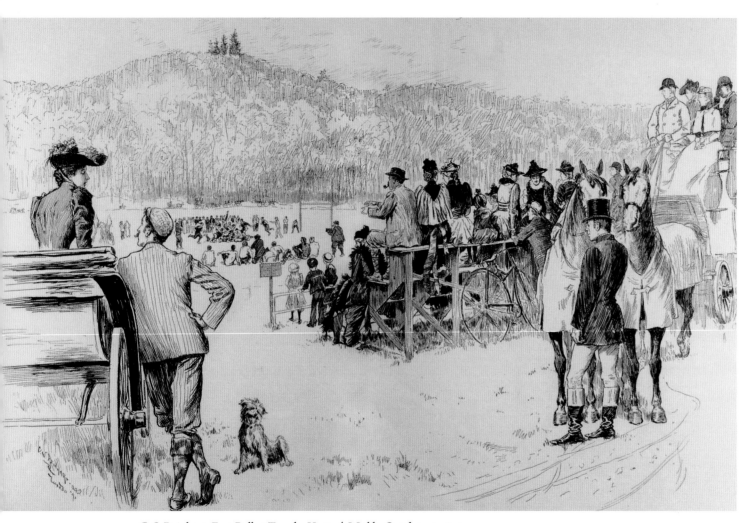

PLATE 15. C. S. Reinhart. *Foot-Ball at Tuxedo. Harper's Weekly*, October 25, 1890.

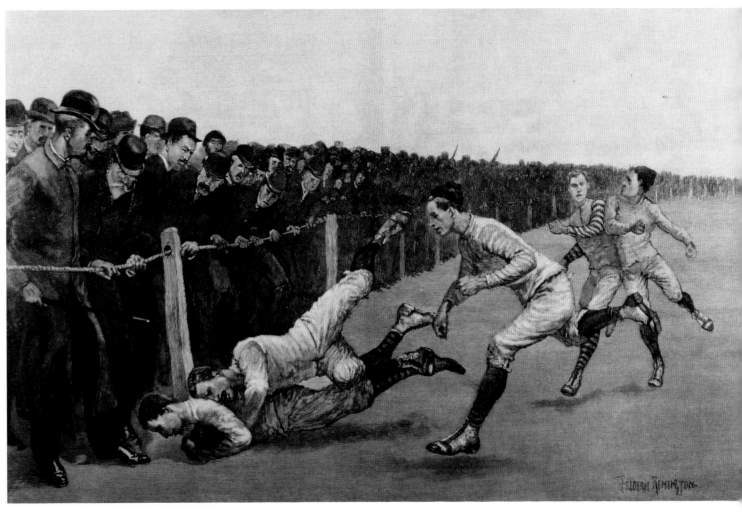

PLATE 16. Frederic Remington. *Foot-Ball—A Collision at the Ropes. Harper's Weekly,* November 29, 1890.

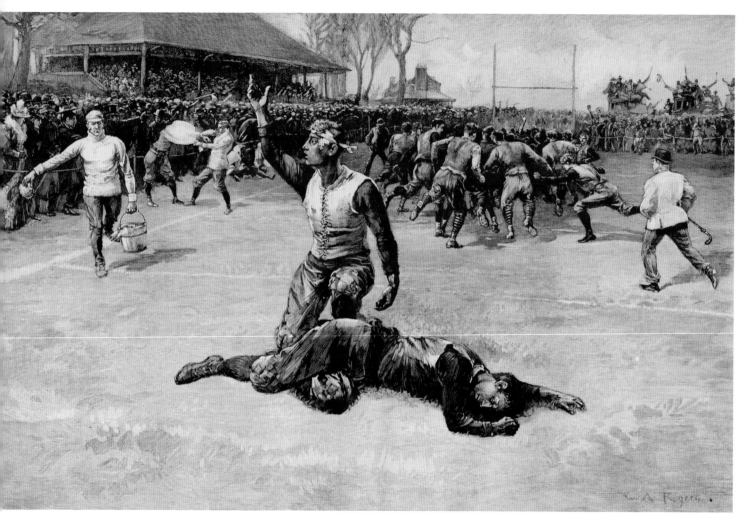

PLATE 17. W. A. Rogers. *Out of the Game. Harper's Weekly,* October 31, 1891.

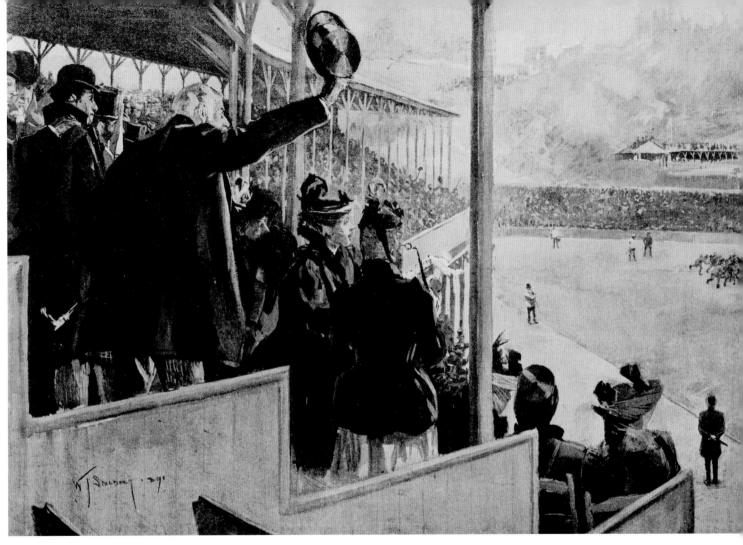

PLATE 18. W. T. Smedley. *Thanksgiving Day in New York—As It Is. Harper's Weekly*, November 28, 1891.

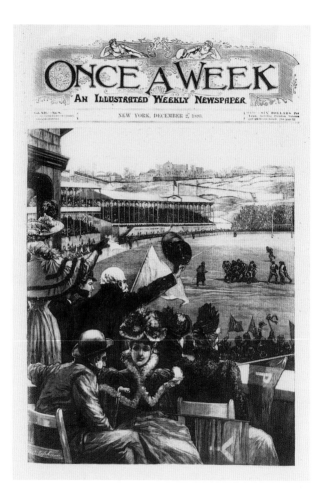

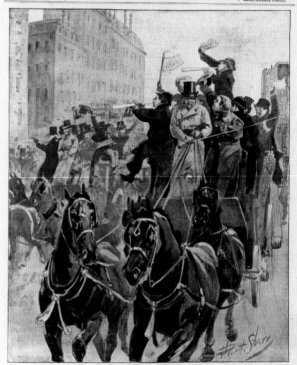

PLATE 19. C. Upham. *The Great Football Match Between Yale and Princeton on Thanksgiving Day. Once a Week,* December 2, 1893.

PLATE 20. *The Yale-Princeton Football Game, Drags of the Rival Universities Going Up Fifth Avenue, En Route to the Field, on Thanksgiving Day. Once a Week,* November 26, 1892.

PLATE 21. W. T. Smedley. *A Touchdown. Collier's,* November 22, 1902.

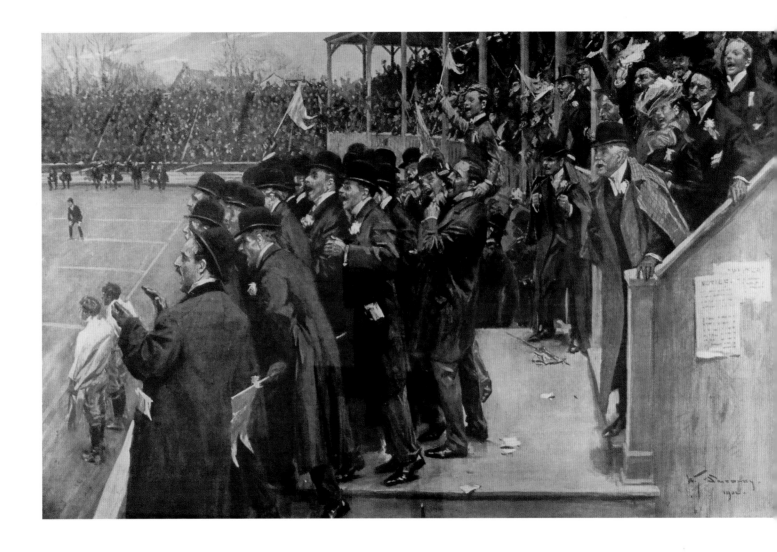

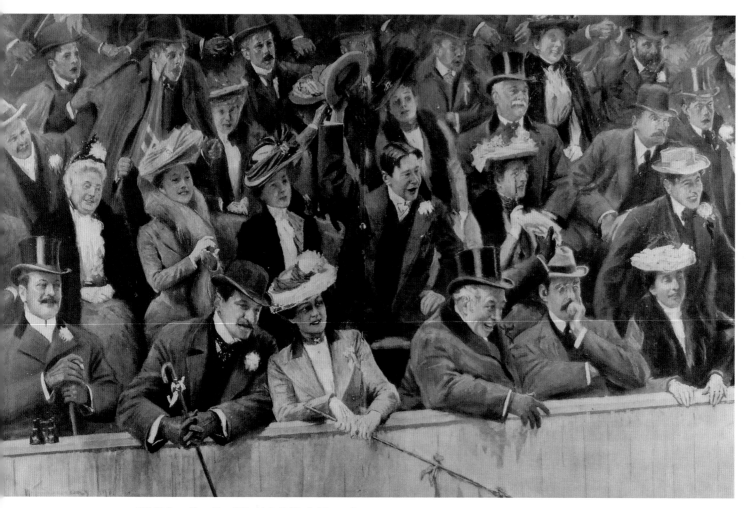

PLATE 22. W. T. Smedley. *Good Tackle!*. *Collier's,* November 23, 1901.

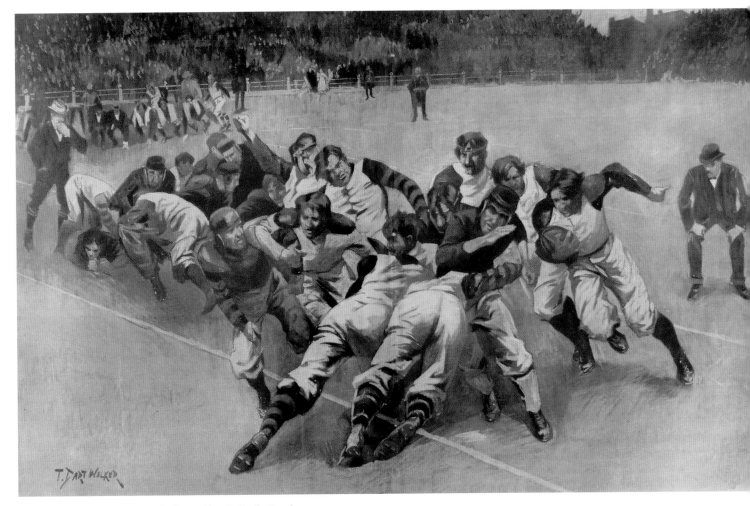

PLATE 23. T. D. Walker. *Outside the Tackle!*. *Collier's*, October 20, 1900.

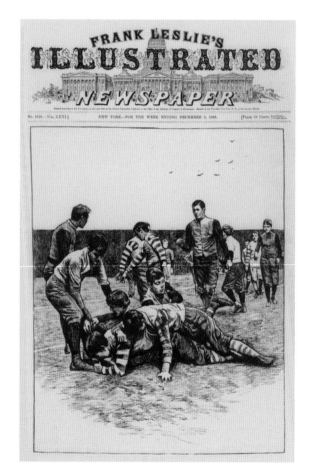

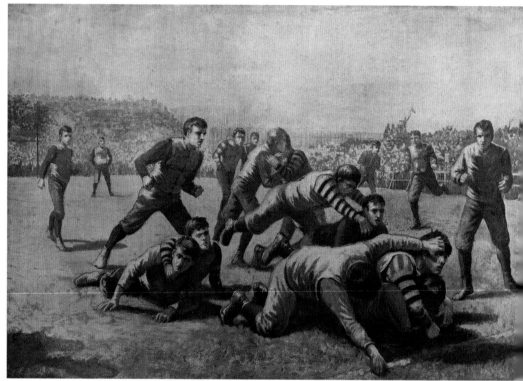

PLATE 24. *The Yale-Princeton Foot-Ball Game—Yale Breaking Through the Princeton Rush Line. Frank Leslie's Illustrated Newspaper,* December 6, 1890.

PLATE 25. *Almost a Touch Down—An Incident of the Great Yale-Princeton Match at Manhattan Field on Thanksgiving Day. Once a Week,* November 26, 1892.

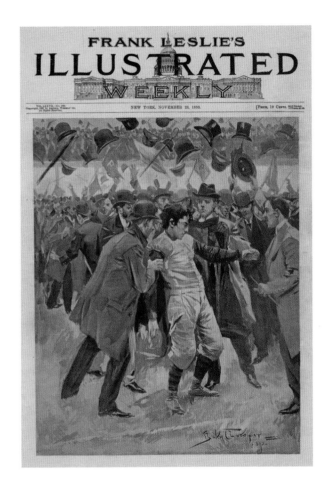

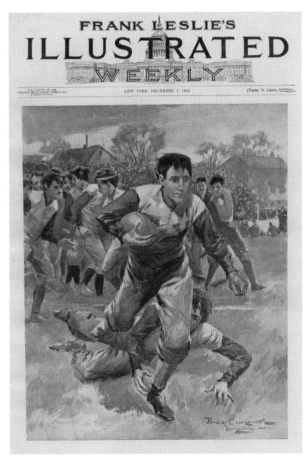

PLATE 26. B. West Clinedinst, from a sketch by Fred. B. Schell. *Intercollegiate Foot-Ball—The Great Game of November 11th, Played Between the University of Pennsylvania and Yale Teams. Frank Leslie's Illustrated Weekly,* November 26, 1893.

PLATE 27. B. West Clinedinst. *The Intercollegiate Foot-Ball Championship. Frank Leslie's Illustrated Weekly,* December 7, 1893. Clinedinst was another major illustrator of the day.

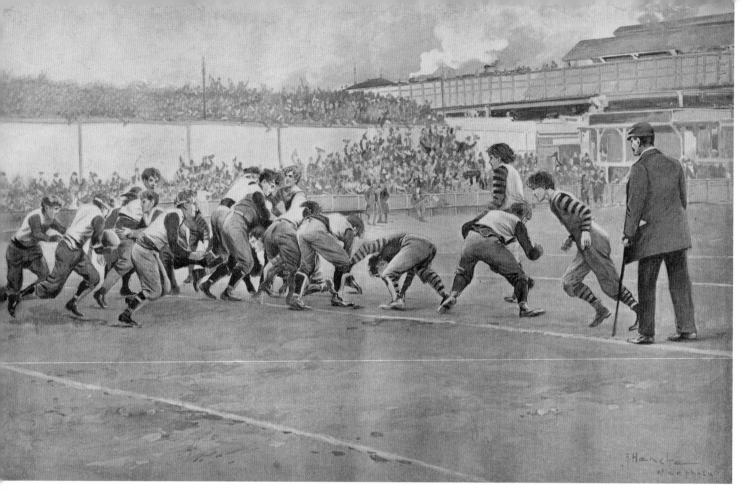

PLATE 28. A. Hancke. *The Intercollegiate Foot-Ball Championship. Frank Leslie's Illustrated Weekly*, December 7, 1893. In addition to the cover and this illustration, the December 7, 1893, issue also included a full-page photograph (see fig. 8) and double-page centerfold of smaller photographs—an astonishing five out of sixteen pages illustrating one football game.

PLATE 29. Frederic Remington. *A Practice Game at Yale by the Champion Foot-Ball Eleven. Harper's Weekly*, November 24, 1888.

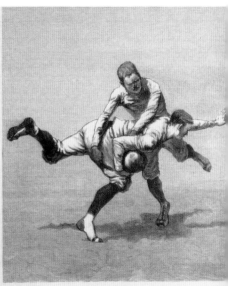
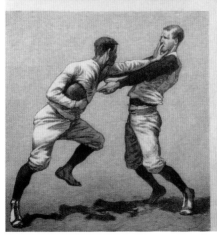
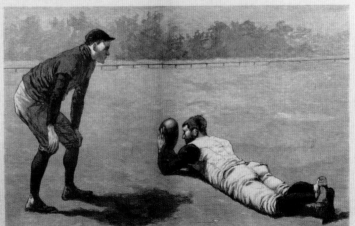

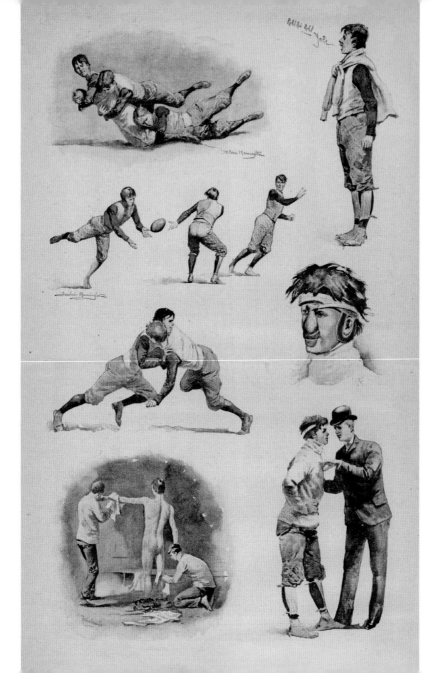

PLATE 30. Frederic Remington. *A Day With the Yale Team. Harper's Weekly*, November 18, 1893.

PLATE 31. Frederic Remington. *A Run Behind Interference. Harper's Weekly*, December 2, 1893.

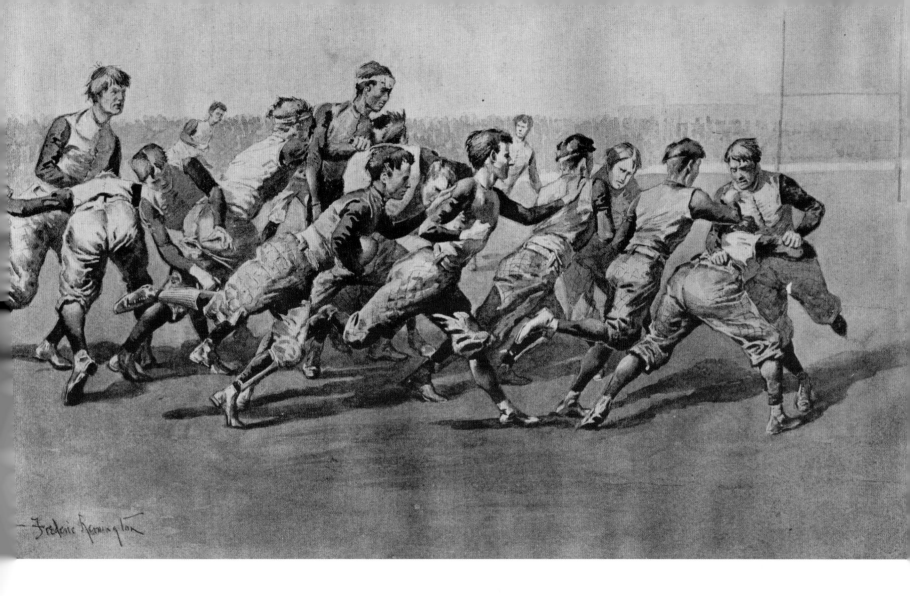

Frederic Remington

41

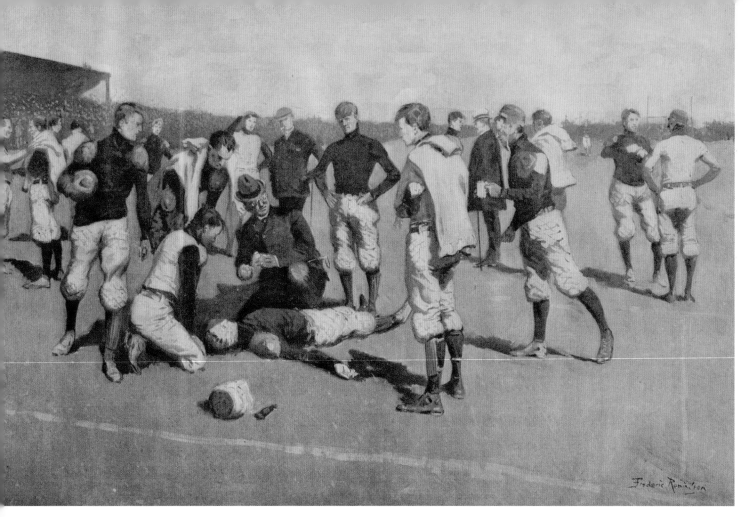

PLATE 32. Frederic Remington, illustration for the story "Jack Bracelin of Yale" by Walter Camp, published in *Collier's*, November 19, 1898.

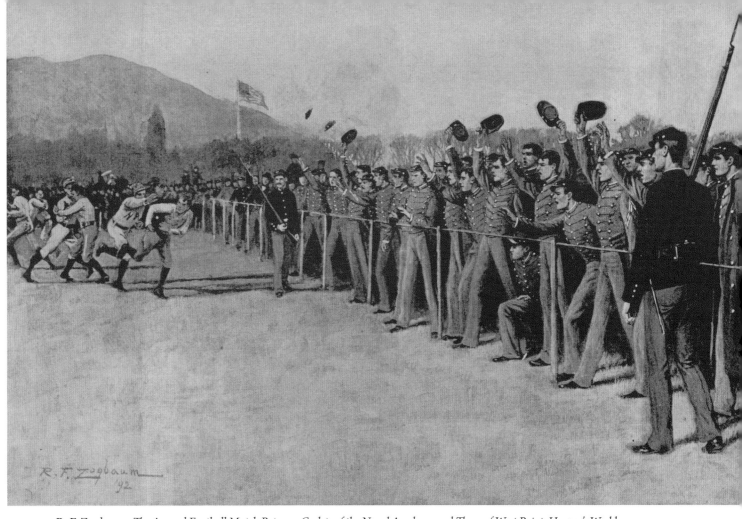

PLATE 33. R. F. Zogbaum. *The Annual Football Match Between Cadets of the Naval Academy and Those of West Point. Harper's Weekly,* December 10, 1892.

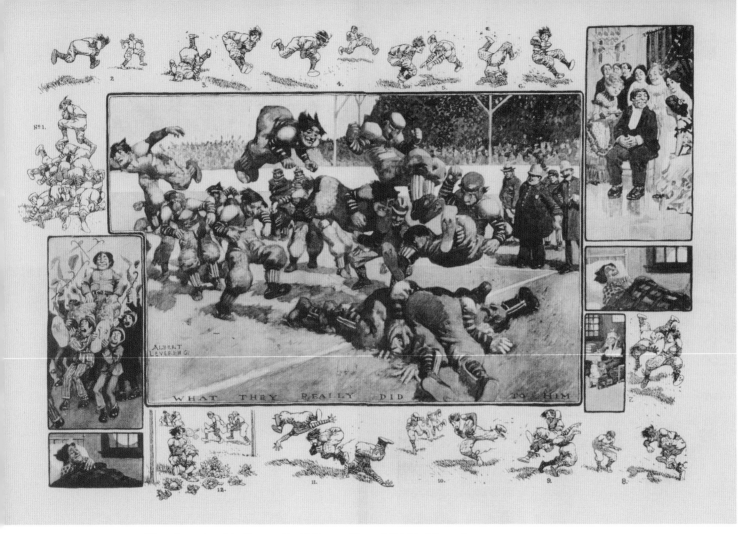

WHAT THEY REALLY DID TO HIM

PLATE 34. Albert Levering. *The Quarter-Back's Dream. Harper's Weekly*, November 17, 1900.

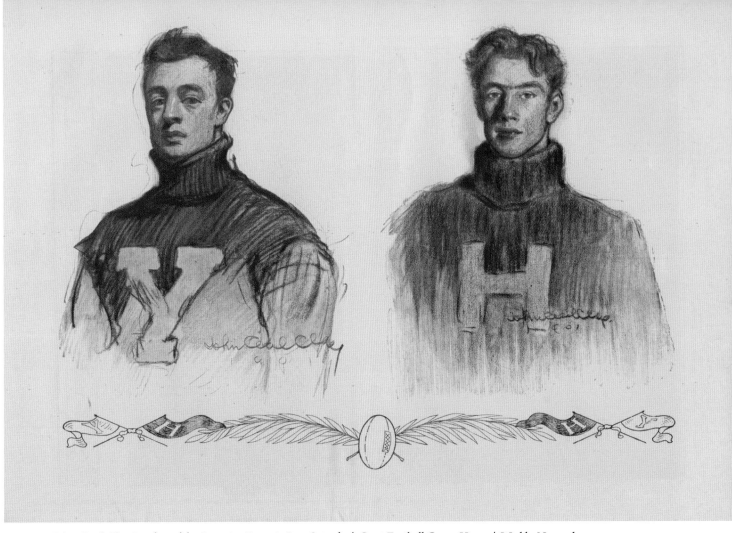

PLATE 35. John Cecil Clay. *Leaders of the Opposing Forces in Last Saturday's Great Football Game. Harper's Weekly,* November 30, 1901.

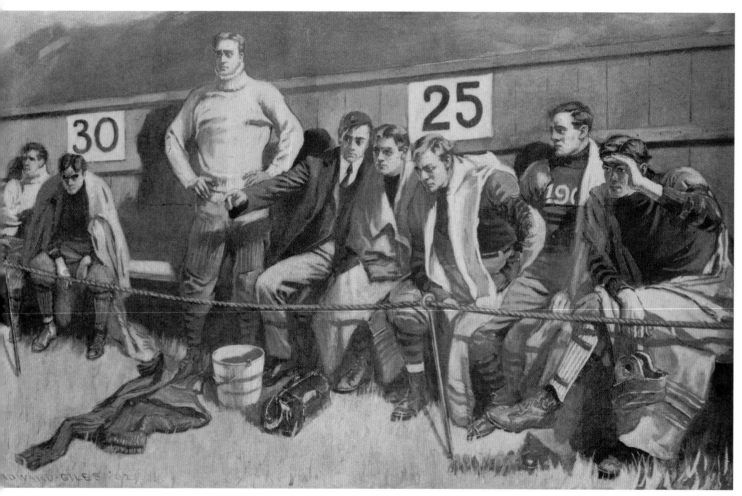

PLATE 36. Howard Giles. *The Men Who Long for the Fray, But Must Always Wait. Harper's Weekly,* November 8, 1902.

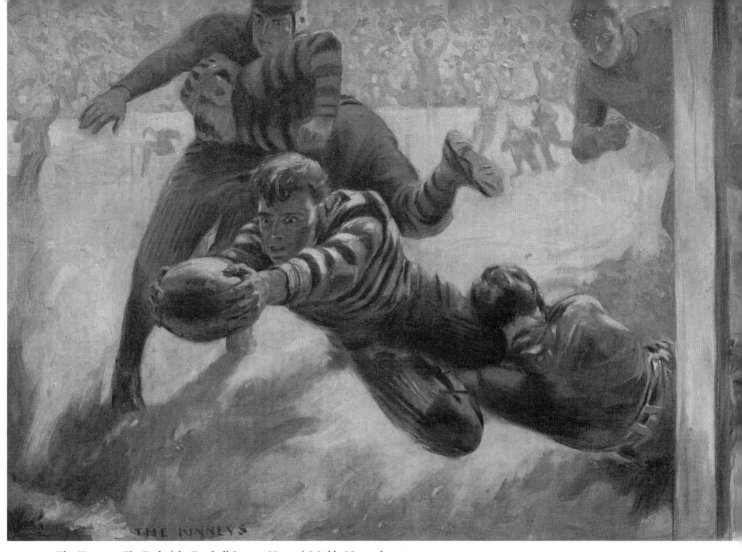

PLATE 37. The Kinneys. *The End of the Football Season. Harper's Weekly,* November 28, 1903.

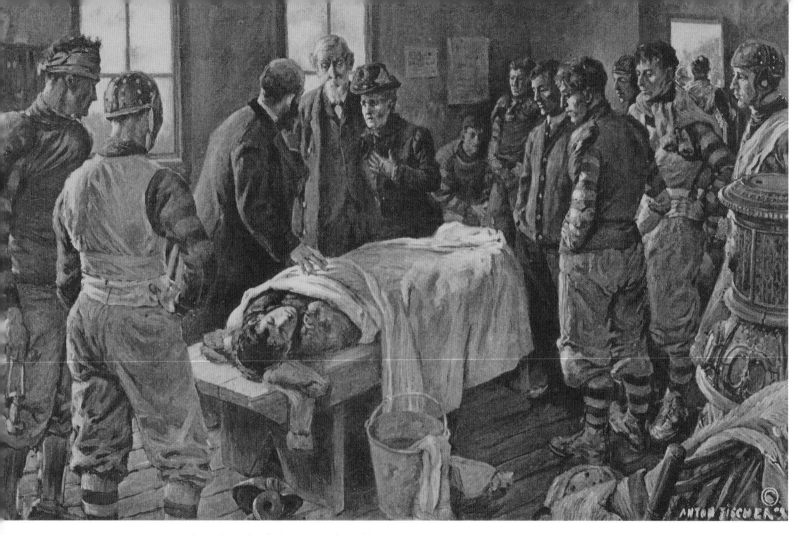

PLATE 38. Anton Fischer. *The Paths of Glory*. *Harper's Weekly*, January 1, 1910.

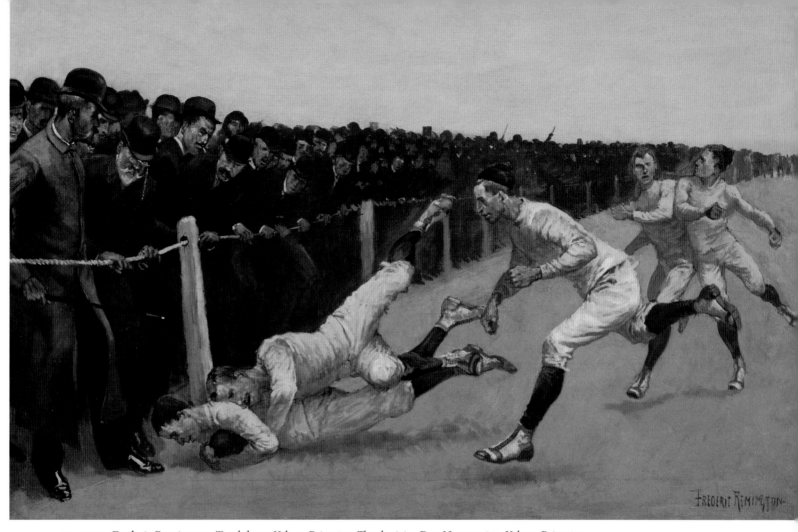

PLATE 39. Frederic Remington. *Touchdown, Yale vs. Princeton, Thanksgiving Day, Nov. 27, 1890, Yale 32, Princeton 0.* Yale University Art Gallery.

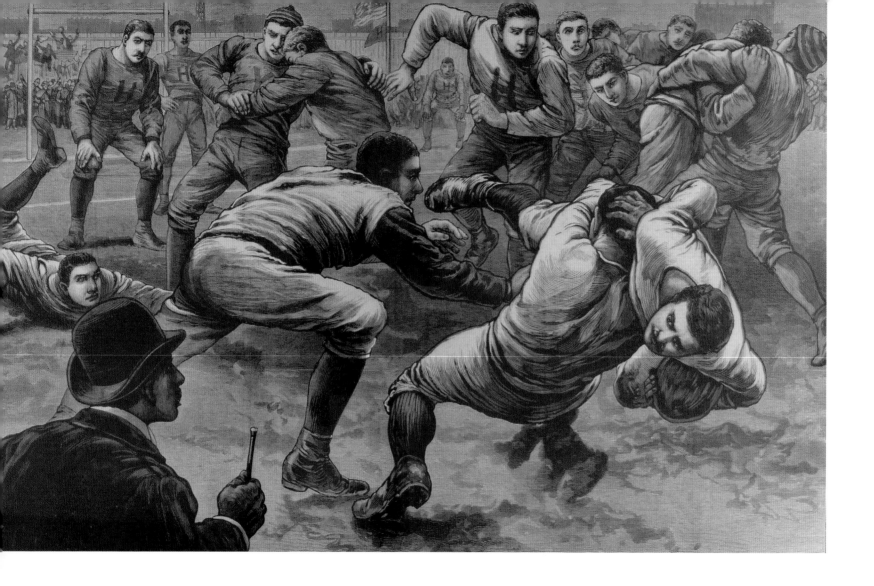

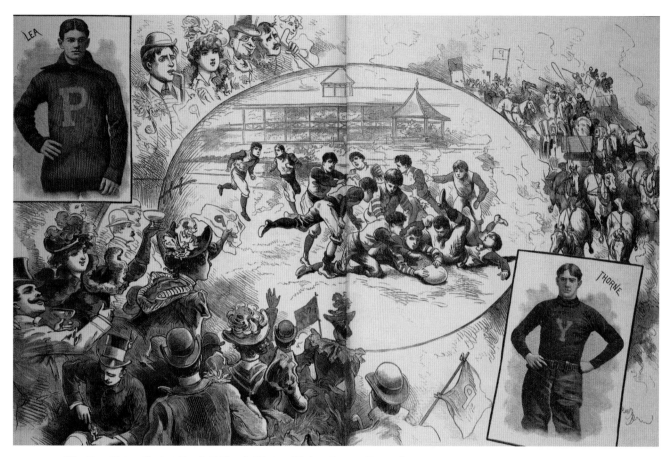

PLATE 40. *The Great Intercollegiate Football Match. National Police-Gazette,* December 10, 1887.

PLATE 41. *Yale Blue Victorious Again. National Police Gazette,* December 7, 1895, now in the paper's distinctive pink. The *Police Gazette* recycled this illustration, with different captains and caption, for a December 7, 1901, centerfold supposedly illustrating the Columbia-Carlisle Thanksgiving Day game.

2

THE GIBSON GIRL, THE YELLOW KID, AND THE ART OF THE FOOTBALL CARTOON

COLLEGE FOOTBALL WAS a curiosity in 1880. By the 1890s it was a phenomenon—with some odd features. It was a game played by boys and students at the country's most elite universities, yet it was exceptionally violent, sometimes fatally. It was a physical contest sponsored by institutions of higher learning committed to the life of the mind and to the practical business of preparing young men (and a few women) for professional careers. It was supposedly an extracurricular activity for students who would show up in the fall to take classes and work toward degrees, yet some of the best players migrated from college to college—in search of the top philosophy professors?—or arrived not from a prep school but from a factory or the docks, maybe even a traveling circus.[1] They played their games not for the amusement of their fellow students, wandering over to the field after classes, but before thousands of strangers who paid for the privilege to watch. The sport aimed to provide an education in healthy living and moral discipline, yet players damaged their bodies and readily resorted to slugging and worse, while their fellow students bet heavily on the big games and got riotously drunk afterward. Newspapers covered major contests much more extravagantly than professional baseball, as though they were championship prizefights. On Thanksgiving Day, New York ministers at fashionable churches had to schedule their services around the football game or risk facing empty pews.

A curious college sport indeed. And the curiosities were not lost on the editors of the trinity of leading humor

magazines—*Puck, Judge,* and *Life*—whose satiric panels added another dimension to emerging American football art. Football's contradictions were ready-made for cartoonists. Cartooning, after all, is an art of either simplification or excess, inclined to exaggeration and distortion. Cartoons also tend to be topical, which makes them a useful guide to understanding what seemed most noteworthy to the new game's first observers.

THE BEGINNINGS OF THE FOOTBALL CARTOON

Of the three great American humor magazines of the late nineteenth century, *Puck* appeared first. Joseph Keppler, an Austrian immigrant, left *Frank Leslie's Illustrated Newspaper* to start his own weekly magazine, a German edition in 1876 followed a year later by one in English. Then in 1881 a group of disgruntled *Puck* artists broke away to start *The Judge* (becoming just *Judge* in 1885) and *Life* arrived two years after that. *Puck* and *Judge* elevated the possibilities for commercial chromolithography in popular magazines with inventive and boldly colored covers, centerfolds, and back pages. *Life* stayed with black-and-white line drawings and later halftones (finally switching to colored covers in 1907). All three magazines targeted sophisticated readers,

but *Puck* and *Judge* were rowdier and emphasized politics while *Life* was more genteel and focused on social satire.[2]

Not surprisingly then, *Life* was the first of the three to take note of the new college game, in November 1884, with a double-page montage of caricatures by E. W. Kemble (plate 42). Kemble was a rising cartoonist on the verge of national prominence for his pen-and-ink illustrations for Mark Twain's *Adventures of Huckleberry Finn* (serialized in *The Century* beginning in December 1884, followed by book publication in February). Over a long career illustrating books and drawing cartoons for most of the popular magazines, Kemble became best known for his portrayal of black life for literary works such as *Uncle Tom's Cabin* and the *Uncle Remus* stories, and in collections of his own—*Kemble's Coons, Kemble's Pickaninnies,* and *The Blackberries and Their Adventures*—whose titles alone suggest why they are now reviled. They were considered amusing and sympathetic in these appallingly racist times.[3]

Kemble also produced dozens of sports cartoons for *Life, Leslie's Weekly, Harper's Weekly,* and *Collier's,* many of them having the elongated figures seen in his 1884 caricatures for *Life.* The humor here was mostly mild, poking gentle fun at the "science and progress" of the new college game with its

overstuffed players, odd terminology ("quarter back," "half back"), and general strangeness. Kemble also caricatured the sport's violence, ranging from shins being kicked to a beheading, and that last comically gruesome detail, nearly lost amidst the clutter, signaled the direction that football cartoons soon took.

Except for a tiny caricature in *Life*, no more football cartoons appeared in any of the three magazines until 1889, when *Judge* published two color lithographs: Grant Hamilton's double-page centerfold, *Political Football* (plate 43), and Victor Gillam's back-page *Slugger's Comment on College Football* (plate 44). As others soon followed, 1889 can serve as the date by which football became familiar enough to be used for political satire and important enough in itself to warrant full-bore satiric treatment. The common theme of the two cartoons was football's roughness, akin to the rough-and-tumble party politics of the day (a wild melee of bearded men attempting to kick a ball labeled "civil service" while President Harrison laments, "What can I do when both parties insist on kicking?") and fundamental to the game itself. Echoing a debate going on in the press about the relative morality of football vs. prizefighting, John L. Sullivan, the reigning heavyweight champion (of a "sport"

that was still illegal) chastises a young collegian, "If that kind of work is eddication, young feller, I orter be a perfesher at Yale, m'self."[4]

Football in the 1890s joined several other sports (boxing, horse racing, and baseball) that were already available for political cartoons, and the best of the football ones appeared in *Judge*. Domestically, political football was usually a brawl like Hamilton's, or a mismatch between, say, "Corporations" and "Consumers" (fig. 12). Internationally, it would not be viewed as sporting for Uncle Sam to win through mere brute strength. He whipped Cuba in 1898 with kicking skill (plate 45).[5]

As football violence became increasingly controversial in the 1890s, the brutality of a "game" played by college boys became one of three major themes running through the humor magazines, along with football's puzzling relationship to education and its role in defining masculinity (which, of course, is related to the first). *Judge* followed its "Slugger's Comment" cartoon of 1889 with a pair of brilliant back-page lithographs by Grant Hamilton that were more inventive and sharper-edged versions of Kemble's 1884 montage for *Life*. In the first, the bizarre armor of *The Future Foot-Ball Player* (plate 46) mocked the game's

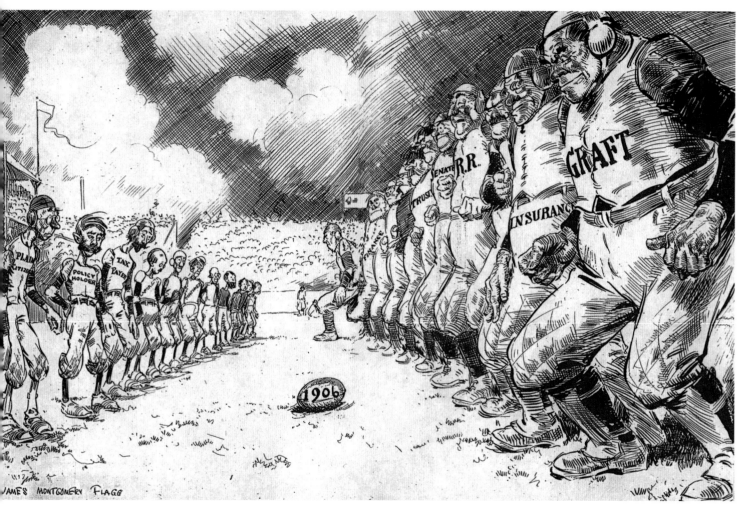

FIG. 12. James Montgomery Flagg. *The Line-Up. Life*, November 23, 1905. Double page.

violence—a supposed gentleman's game that required ambulances in attendance—while other figures satirized the anti-intellectualism of institutions that trained young men in football instead of, say, mathematics or chemistry.

In the second, an even more bizarrely armored "quarterback prepared for the game" is surrounded by images of football craziness: mop-topped players not easily distinguishable from shaggy dogs, a pileup in the line, a banged-up "universally admired" hero of the hour, and rabid fans yelling for good old Harvard, Yale, or Princeton (plate 47). Mop tops—long hair—were in fact football players' first feeble attempt to protect themselves, before manufactured head gear became available. Massive pileups were the usual outcome of the mass-momentum plays that wreaked havoc in the early 1890s. In Hamilton's satiric vision, everything about football was excessive and all but the crazed fans pointed either directly or indirectly to football's brutality. Maybe the crazed fans did too.

Hamilton's third in this series imagined what might happen if Vassar were to join men's colleges in fielding a football team (plate 48). Female players would delay games to fix their hair, panic if rats should run onto the field, refuse to wear nose protectors so as not to spoil their looks, flirt with

the umpire, and take advantage of male chivalry. The progressive and aggressive "New Woman" had already begun invading more consequential male domains than the football field. Was Hamilton mocking women's presumption to be men's equals or satirizing what was already football's powerful link to masculinity?

These three themes—violence, distorted educational priorities, and extreme gender roles—dominated the great football cartoons of the 1890s and early 1900s. Other subjects had less at stake. Football players' appearance—long shaggy hair and leather nose-protectors—was an easy target (plate 49). Caricaturists exaggerated the hair, but an actual player wearing a nose guard, the first piece of manufactured protective equipment, looked as grotesque as the cartoons (fig. 13). The transformation of Thanksgiving into a day of football became another easy source of satire. Horse-drawn carriages bearing players or rollicking students up Fifth Avenue to the Thanksgiving Day game at Manhattan Field in the early 1890s (fig. 14) became an icon of the newly important social event (plates 20 and 93) and, in due course, an object of satire (plate 50). The young men and women on the 1893 cover of *Truth* (a lesser rival to *Puck*, *Judge*, and *Life*) appear ready for a bacchanal rather than a wholesome sport-

FIG. 13. *Leslie's Weekly*, November 2, 1905.

ing contest—the actual concern that sent the Thanksgiving Day championship game back to college campuses.[6] But Thanksgiving football survived in New York without Yale and Princeton (albeit in diminished form), and it spread throughout the country disrupting (or reinventing) holiday traditions. Cartoonists duly noted (fig. 15).[7]

One subset of football cartoons from this era is more disturbing than clever. Crudely racist cartoons portraying the citizens of "Blackville" or "Darktown" (and "Coonville," "Coontown," "Possumville," "Shantytown," "Cullerville") engaged in the normal activities of American life, including sports, as though they were utterly unnatural, were astonishingly popular from the late nineteenth century into the 1930s. Numbering perhaps in the hundreds of thousands, these cartoons were part of a pop culture of minstrel shows, coon songs, darky stories, and grotesque figurines that provided amusement for whites by denying the basic humanity of blacks.[8] Some of the era's foremost popular artists produced racist cartoons, as did all three of the major humor magazines. George Luks drew several for *Truth* and the New York *World* in the 1890s before he became a celebrated painter. Even the relatively genteel *Harper's Weekly* published a series of Blackville cartoons in the late 1870s.[9]

FIG. 14. *The Coaching Parade to the Game.* Photograph of November 30, 1893, Thanksgiving Day game before it was moved back to college campuses.

FIG. 15. Samuel D. Erhart. *Thanksgiving Scene in Ye Old Plymouth Colony. Puck*, November 20, 1912.

The rise of football in the 1880s simply offered another subject for racist humor. Currier & Ives, whose chromolithographs hung in public schools, barbershops, fire stations, and doctors' offices throughout the country, published more than a hundred *Darktown* prints from the mid-1870s through the early 1890s, most of them drawn by Thomas Worth. They were so popular that the lithographic stones for reproducing them were the only ones preserved when Currier & Ives was liquidated in 1907.[10] Apart from the participants, football in Darktown (plate 51) is indistinguishable from other cartoons of the game's violence, yet making the players black creates an entirely different meaning. While Currier & Ives has become a treasury of nineteenth-century Americana, *Darktown* has rightly disappeared from recent collections of its prints as a shameful part of our cultural history to be forgotten, not cherished.[11]

The humor magazines were more comically inventive but also more pointedly racist. *Judge* published a handful of cartoons by one of its leading artists, Eugene Zimmerman ("Zim"), that showed football games pitting "Blackville" against "Shantytown" or "Coonville" against "Darktown."[12] In the first, from 1894, Blackville defeats Shantytown when

its manager is inspired to paint the ball to look like a watermelon (plate 52). (Exactly how, one might ask, would this lead to a scoring frenzy?) When cartoonists satirized the violence and craziness of the football being played by Harvard, Yale, and Princeton, they assumed the civilized humanity of the players—gentlemen's sons not behaving like gentlemen. When they satirized the players in Blackville or Coontown, they assumed that blacks *were* savages, not just acting like them, and that to play football at all was contrary to their nature (despite the fact that black colleges were taking up football in the 1890s along with colleges generally).[13]

In 1904 *Life* published a more topical racist cartoon: a vision of a future all-black football team at Harvard under Theodore Roosevelt as the school's president (fig. 16). The cartoon was drawn by a young James Montgomery Flagg, who was not yet famous for his magazine covers of beautiful women and his iconic World War I recruiting poster (Uncle Sam's *I Want You!*). Early in his career as a cartoonist for *Life*, Flagg dabbled in football as a subject, including the double-page political cartoon in 1905 (fig. 12) and a cutely satiric cover in 1909 (plate 53).[14] Flagg's racist cartoon from 1904 is clearly topical, but what was the topic? Roosevelt

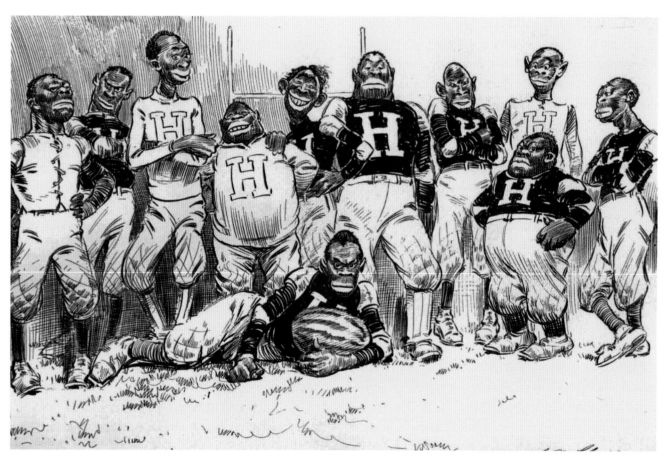

FIG. 16. James Montgomery Flagg. *Harvard's Football Eleven of 1909, Under President Roosevelt, of Harvard. Life*, December 15, 1904.

had offended racist sensibilities when he invited Booker T. Washington to the White House for dinner early in his presidency, but by the time Flagg's cartoon appeared three years had passed. Why this cartoon now? And why Harvard football? Flagg's invisible subjects must have been William H. Lewis and William C. Matthews. Lewis was the first and most remarkable of the early black players on the tiny handful of integrated teams in the north. After three stellar seasons playing at Amherst College, he moved on to Harvard, where he was twice an All-American (in 1892 and 1893) while attending law school. When new eligibility rules ended his playing career, Lewis helped coach at Harvard from 1895 through 1906 and volunteered at Cornell, and he wrote a book on football strategy, *A Primer of College Football*, for Harper & Brothers. He also was elected to the Cambridge, Massachusetts, city council in 1899 and to the Massachusetts state legislature in 1902.[15] It was presumably because he was a Harvard man and a football man, not a Republican city councilman, that President Roosevelt invited Lewis to visit his summer home in Oyster Bay in 1900. When Lewis lost reelection to the state legislature in 1903, and Roosevelt appointed him assistant U.S. attorney for Massachusetts, critics charged that he did so to keep

Lewis in Boston for the sake of his part-time coaching at the president's alma mater. In 1904, two months before Flagg's cartoon appeared, Walter Camp named Lewis to his all-time All-America team as the best center-rush of his generation.[16]

One of Lewis's players at Harvard was William Matthews, a baseball and football star at Tuskegee Institute in the 1890s who had been sent north by the school's president, Booker T. Washington, to finish his education. First at a prep school and then at Harvard, Matthews starred on the baseball team and was an undersized quarterback and end on the football team. Playing against Yale in 1904, in what would be a sadly typical experience for black players well into the 1930s, Matthews was subjected to "savage assaults" that Harvard partisans claimed were intended to put Matthews out of the game (though Matthews publicly defended the Yale players).[17] It was presumably this controversy, in addition to Roosevelt's relationship with Lewis, that prompted Flagg's vicious cartoon a month later.

Like Lewis, Matthews earned a law degree at Harvard and went on to serve in the same position, as assistant U.S. attorney for Massachusetts, early in his own distinguished political and public-service career. William Lewis

and William Matthews would seem to have exploded the racist assumptions of the day, but that was a threat to some of their fellow citizens, to be met with ridicule.

VIOLENCE AND MANLINESS

The three major humor magazines directed their most sustained and inventive satire at football's role in higher education and in defining a new masculine ideal for the age. Two of *Life*'s leading cartoonists, E. W. Kemble and Charles Dana Gibson, played a sort of tag-team match with football subjects in the 1890s. In November 1894 and January 1895, Kemble and then Gibson took aim at the anti-intellectualism signaled by football's prominence in American universities. Then in October and November 1895, first Kemble again and then Gibson cast the New Woman as a football warrior. In the first pair Kemble was the more inspired satirist; in the second, Gibson produced one of the gems from his long and distinguished career.

Kemble's hilarious cartoon of college faculties slugging it out in the trenches asked readers to ponder where football fit within the college curriculum (plate 54). (Kemble's professors bore a striking resemblance to the con-man "King" he had drawn for *Huckleberry Finn*—presumably

an added pleasure for attentive readers.) Gibson's drawing two months later (plate 55) made the same satiric point, but only in the title: what could the game of football possibly have to do with liberal education? The drawing itself resembled Gibson's straightforward rendering of football action for *Harper's Young People* in 1890 (plate 56). In this instance Kemble's cartoon showed more comic invention. (Flagg's 1909 cover for *Life* [plate 53] also poked fun at college football's anti-intellectualism, with the sentimental cherub softening the satire.)

The following fall, Kemble burlesqued the era's athletic and professionally ambitious New Women as a horde of Amazons trampling mop-topped pygmy males in a football game, with a vaguely threatening caption: "The Coming Girl: Woman Is Every Day Enlarging Her Sphere" (plate 57). This was full-blown burlesque and, like Grant Hamilton's less-striking cartoon for *Judge* that fall (plate 48), it cut both ways. Did it mock males for their lack of manliness or ridicule females for their excess of it? Was the New Woman invading spheres where she did not belong, or were men worrying too much about the invasion? A month later Gibson raised the same questions but with more visual subtlety (plate 58). The social relations of men and women were

preeminently Gibson territory, and *The Coming Game* was among his most inspired forays into it.

Gibson began his forty-six-year association with *Life* in 1886, and by 1889 he was already a "new luminary in illustration" being courted by the big three literary monthlies—*Scribner's, The Century,* and *Harper's.*[18] (*The* 1890 football drawing for *Harper's Young People* was among his many new commissions.) Art directors loved Gibson's draftsmanship; the pubic loved, above all, the "Gibson Girl," a New Woman who was beautiful and haughty but also strong and athletic.[19] The New Woman in American life challenged entrenched views of male power and female fragility; the Gibson Girl in American magazines played teasingly with male anxiety while celebrating female beauty and strength.

The Coming Game was one of five cartoons that were featured by an English critic when introducing Gibson to his countrymen in 1896 as a superb draftsman who was also an incisive social commentator, a "Thomas Hardy . . . in art" who was acutely sensitive to "Life's Little Ironies."[20] Blandly subtitled *Yale versus Vassar,* Gibson's drawing offered a typically handsome football hero, the paragon of manly self-possession, but this one is glancing anxiously at the aggressive (and beautiful) female opponent about to tackle him. Among her teammates, all equally beautiful, one is pausing to fix her hair in an act of conventional female vanity, while another gazes haughtily into the distance, indifferent to the contest at hand. But the two out front pursue the ball carrier with determination. Does the New Woman represented here embody progress or threat and is she truly different from the frivolous creature of earlier stereotypes? Should the self-respecting male pursue her, flee her, or defend himself against her? Regarding football itself, though only implicitly, does the game demand and foster qualities that are exclusively masculine? Kemble's cartoon mocked the grotesque figures on both sides of the gender divide. Gibson's drawing played with the same momentous social revolution but with greater nuance and complexity. Football provided a perfect setting.

Gibson's final major football cartoon, a 1912 painted cover for *Life* (plate 59), reprised a conceit from his great series, "The Weaker Sex," from a decade earlier (fig. 17), but now wedded to the theme shown in *The Coming Game.* The tiny male, helpless before female beauty, has become a football player, the paragon of young manhood. The second time around the result was less startling but still on target.

FIG. 17. C. D. Gibson. *The Weaker Sex II. Collier's*, July 4, 1903.

Gibson and Kemble depended on the viewer's identification of football with masculinity. Only that assumption made the New Woman's widening her sphere to include football provocative and humorous. And these New Women on the gridiron were part of the humor magazines' ongoing satire on the deeply gendered nature of football. However grotesque the football player might look in his shaggy hair and leather nose guard, he was the hero of the hour and the modern maiden's manly ideal (plate 49). The 1900 centerfold for *Harper's Weekly* drawn by Albert Levering (plate 34), a long-time cartoonist for *Puck*, compared a quarterback's dream of football heroics and postgame female adoration to "what they really did to him" on the field. As the quintessentially masculine football player became the new cultural hero, satire followed the law of gravity: what goes up must come down.[21]

What made football manly and heroic also made it brutal. Excessive violence became a problem in football virtually from the moment it was transformed from English rugby into an American collision sport. The collisions were initially unintended but quickly embraced as a test of manly character. From that moment to this day, rule-makers have tried to keep football rough, but not *too* rough. Cartoonists have regularly noted their failures.

More or less continuous public controversies over the game's violence culminated in 1905, when the season's death toll hit eighteen and was punctuated by a late-season fatality that happened not on some far-off sandlot but in New York City, in the presence of distinguished spectators and metropolitan sportswriters. Calls to abolish football nearly succeeded this time. Instead, college and university leaders came together to form an organization that would become the National Collegiate Athletic Association, and to radically change the rules—most significantly legalizing the forward pass. (The game became marginally safer for a few years, but the full reckoning with football's dangers was only postponed.) Cartoons in the three great humor magazines over the historic seasons of 1905 and 1906 wonderfully captured the dilemma posed by football violence as this drama played out.

The 1905 season was barely underway when President Roosevelt summoned the football leaders of Harvard, Yale, and Princeton to the White House in order to win their pledge to make the game less brutal lest the public

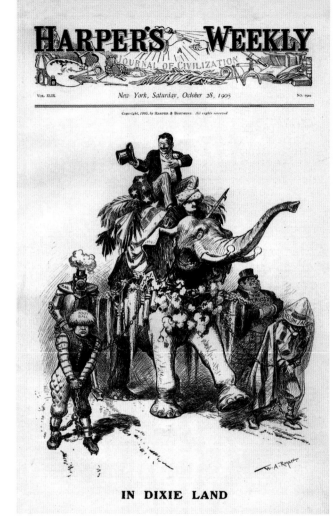

HARPER'S WEEKLY

JOURNAL OF CIVILIZATION

VOL. XLIX New York, Saturday, October 28, 1905. NO. 2549

Copyright, 1905, by HARPER & BROTHERS. All rights reserved

IN DIXIE LAND

FIG. 18. W. A. Rogers. *In Dixie Land. Harper's Weekly,*
October 28, 1905.

demand that it be abolished altogether. *Judge* responded with a double-page centerfold casting Roosevelt as the tamer of the football slugger, the most recent of the many international and domestic foes he had subdued (plate 60). (*Harper's Weekly* published a less-inspired cartoon cover by W. A. Rogers with the same theme [fig. 18].) Roosevelt's intervention, however, had little effect, and the death of Union College's Harold Moore in a game against New York University in late November prompted a handful of universities to drop football immediately and threatened its survival everywhere. As college leaders quickly moved to reduce the roughness, *Puck* responded with a satiric vision of the next season's football games being played by fops with dinner party manners and the hardihood of Victorian invalids (plate 61). As specific rule changes were debated over the winter, *Judge* weighed in with a similar cartoon in which two daintily attired captains—one in powder blue for Yale, the other in pink (diluted crimson) for Harvard and bearing a striking resemblance to the Harvard alum currently occupying the White House—meet at mid-field to go over the new rules: "No Pinching, No Slapping, Hug Easy, Don't Yell" (plate 62). Midway through the 1906 season under the new rules *Life* took up the theme last (and

least inventively) with a football player on the cover proposing "The Only Solution": "If you want to make us play like gentlemen make it a ladies' game" (fig. 19).

This sequence of cartoons did what cartoons do best: distill complex issues into single provocative images. Football's foundational class prejudice remained implicit: the violence of gentlemen for the honor of alma mater was very different from the violence of lower-class ruffians. But the deeper (and still persistent) response to the game was also here: Americans wanted to keep their football violent, as an antidote to an emasculating modern world; they just didn't want it so violent that it maimed rather than developed manliness. These cartoons challenged the possibility of finding that fine line, a problem whose intractability football's later history would bear out.

THE YELLOW KID AND THE ASHCAN SCHOOL

When metropolitan daily newspapers first became illustrated, beginning with Joseph Pulitzer's New York *World* in the mid-1880s, they created massive employment for pen-and-ink artists and cartoonists. George Luks and William Glackens were among the twentieth-century painters of the urban scene who served apprenticeships in draftsman-

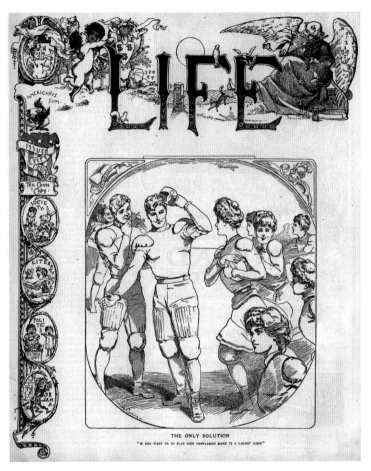

FIG. 19. Otho Cushing. *The Only Solution. Life*, November 8, 1906.

ship and close observation at daily newspapers in the 1880s and 1890s—in their cases, both in Philadelphia. The weekly humor magazines poached some of the best of these newspaper cartoonists only to face retaliation when those newspapers, beginning again with Pulitzer's *World*, in 1893, created comic and magazine supplements for their new mammoth Sunday editions. The equivalent of an issue of *Puck* or *Judge* could now be bought more cheaply as a single section of the Sunday newspaper. First Pulitzer and then William Randolph Hearst lured major artists away from the humor magazines with salaries that magazine publishers could not match.

The big football contests were profusely illustrated in the large-circulation daily newspapers that emerged in the 1880s and 1890s. These were mostly quick sketches of players, teams, and scenes at games (that later were produced more cheaply with photographs) but also cartoons satirizing the players' grotesque appearance and the game's extreme violence. Full-page cartoons in the Sunday supplements during the 1890s likewise played with the same themes that predominated in the humor magazines. Arguably the best of them all, a larger-than-life football gladiator in the *New York Herald* in 1896 (fig. 20), remains provocative today, as metaphorical gladiators have begun to seem like the real

thing. (Published in full color but apparently surviving only in microfilm, original copies of this cartoon are a sad loss to the archives of early football art.)

The Sunday comic supplements also gave birth to R. F. Outcault's "Yellow Kid" (after earlier appearances in a minor role in the humor magazine *Truth*), the country's first popular newspaper comic character and the source of the term "yellow journalism" that describes the newspaper sensationalism of the era.[22] The Kid debuted in 1895 in Pulitzer's *World* as part of the gang in "Hogan's Alley," Outcault's cartoon version of the slums whose life was being documented by Jacob Riis and other social reformers. Outcault's busy tableaus—"bodies sticking up everywhere and crowding the space in the cartoon," as one later historian put it—captured the overcrowding and chaos of the modern city teeming with immigrants, a startling transformation for the mostly rural nation of just a generation earlier.[23] The Yellow Kid moved from the periphery of Hogan's Alley to center stage in January 1896 as a flap-eared, completely bald (common for slum children as a cheap way to get rid of lice) ten- or eleven-year-old, dressed in a yellow nightshirt (also common in the slums, a hand-me-down from older siblings). On one level the Yellow Kid belonged to the same cartoon

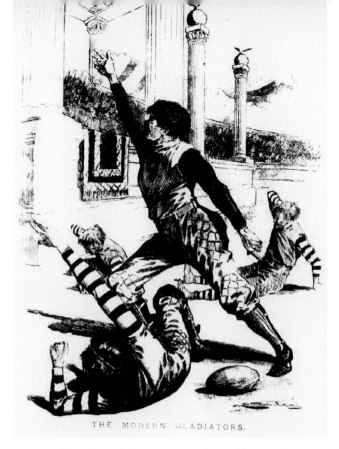

genre that included Darktown and Blackville, where outsiders mimicked the genteel classes, including their derbies and sailing regattas, golf and tennis tournaments, and baseball and football games. With the Yellow Kid, however, Outcault did not ridicule these outsiders but took them on their own terms. Hogan's Alley, as the art historian Rebecca Zurier puts it, was "a gleefully anarchic world where slum children lived on their own, untouched by the rules of polite society or the crusades of the Progressive Era."[24]

Before he conceived Hogan's Alley, with the Yellow Kid as its leading resident, Outcault had created "Casey's Alley," where *The Great Football Match* was like the wild melee seen in numerous cartoons in both daily newspapers and weekly humor magazines (fig. 21). Cartoonists who cast football as a brawl indulged in by the sons of gentlemen at Harvard and Yale satirized the brawlers' betrayal of their professed values. In Casey's Alley, slum kids did what slum kids do, which, during a football game, happened to be exactly what gentlemen's sons did while pretending otherwise.

The Yellow Kid was an instant sensation on his arrival in the *World* a few weeks after this cartoon appeared and soon spawned branded candy and cigars, toys and games, music hall skits and vaudeville plays (five of them copy-

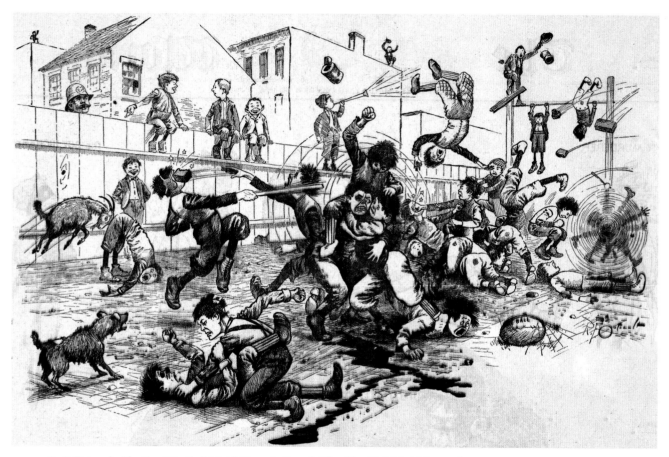

FIG. 21. R. F. Outcault. *The Great Football Match Down in Casey's Alley*. *New York World*, December 22, 1895. San Francisco Academy of Comic Art Collection, The Ohio State University, Billy Ireland Cartoon Library & Museum.

righted in 1896 alone).[25] In October 1896 William Randolph Hearst lured Outcault away from the *World* to his Sunday *Journal*'s new *American Humorist* comic supplement. Outcault brought the name "Yellow Kid" with him to Hearst, but "Hogan's Alley" belonged to Pulitzer, who assigned a recently hired staff artist, the future painter George Luks, to keep producing it. The Yellow Kid suddenly had two homes: Hogan's Alley in the *World* (drawn by Luks with only slight stylistic changes and a leading character without a name); and "McFadden's Row" in the *Journal*, drawn by Outcault and with text provided by Edward H. Townsend, author of the popular *Chimmie Fadden* stories.[26]

Sunday editions published that fall saw a great football match in both neighborhoods (plates 63 and 64). Although football in the 1890s had spread to sandlots as well as colleges and secondary schools throughout the country, Hogan's Alley and McFadden's Row clearly existed outside the recognized football world. Luks's version of the gang training for the championship—his first rendering of Hogan's Alley after taking over from Outcault—satirized the game played by elite college boys with pointed jibes, such as the rules on a large banner: "No Bitin' Scratching' or Trowing Brix Allowed in Praktiss Gaimes Keep Your Weapons fur de Real Gaim on Tanksgivin'." A figure in the lower-left corner of the cartoon, wearing boxing gloves, a nose guard, and a baseball chest protector that bears the inscription, "Dey Kant Hurt Me," echoes Grant Hamilton's satires on football violence in *Judge*.

Outcault's drawing of the Kid at the moment of scoring the winning touchdown was more about the kids in McFadden's Row, doing what they could with what they had, than the mainstream sport they parodied. The Kid is no mop-topped football player; as one would-be tackler tries to grab him by the hair, the text at the bottom of his nightshirt reads, "He can't git me by the hair its cut too shy." Chorus girls wave banners and lead cheers. Rooters on the fence chant, "Yell yell yell kid kid kid yell oh! yell oh! yellow kid hot stuff."[27] In a small but striking detail, the startled black child trampled under the cloud of dust to the Kid's left is a stereotype straight out of Darktown. Whether progressive or reactionary, his appearance makes McFadden's Row a multiracial as well as multiethnic neighborhood. (On other occasions Outcault more simply contributed to the era's racist humor [fig. 22].[28])

Luks stopped drawing the Yellow Kid in 1897, Outcault in 1898. Outcault briefly produced other cartoons for both

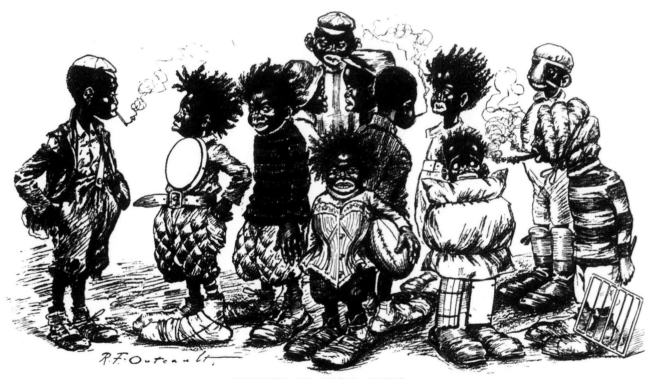

ANOTHER IN THEIR FAVOR.

THE CAPTAIN—" De reason we so shuah ter win is bekase, dis bein' feet-ball, we got de advantage ob habin' de feet."

HIS FRIEND—" Yais, suh ; yo' got de advantage ob lookin' like de wild men from Borneo, so dem white kids gwine ter git skeered so bad dey cain't play—dat's what."

FIG. 22. R. F. Outcault. *Another in Their Favor. Judge*, November 18, 1899. Quarter-page.

the *World* and the *Journal* before moving on to the more genteel *New York Herald. There*, in 1902, he created Buster Brown, a wealthy schoolboy who spoke perfect English (and didn't play rough games like football) and who always paid a penalty for his mischief.[29] Luks turned to political cartooning for *The Verdict* (another rival to *Puck* and *Judge*) and soon took up more ambitious painting. Nevertheless, the Yellow Kid lived on in popular culture for decades and inspired tamer reinventions such as the *Our Gang* (*Little Rascals*) short film comedies that ran from the 1920s into the 1940s, including one football episode.

Outcault's primary legacy is the modern comic strip, but he also brought something new to football art: the densely populated and seemingly chaotic but carefully arranged scene that overwhelms the viewer's initial response and demands close scrutiny.[30] Behind Hogan's Alley and McFadden's Row lay the social satires of the great eighteenth- and nineteenth-century British caricaturists William Hogarth and Thomas Rowlandson. And, behind them, the medieval villages painted by Pieter Breughel the Elder (one of which, *Children's Games*, had related subject matter). The Yellow Kid's influence on major artists of the modern city, including members of the so-called Ashcan School, appears

in what art historian Rebecca Zurier calls the "cartoonist's vision" of Luks, William Glackens, and George Bellows.[31] Luks began as a cartoonist for *Puck* and *Truth* in the early 1890s and remained one intermittently throughout his career.[32] After he inherited the Yellow Kid from Outcault, he got a job for his friend Glackens on the staff of the *World*'s comic supplement. Although Bellows never worked as a cartoonist, Zurier finds the Kid's influence pervasive in his urban scenes that defied both genteel moralizing and conventional art standards, most controversially in his great boxing paintings with their grotesquely distorted figures.

The paucity of football in the work of the Ashcan artists is disappointing and frankly puzzling. Robert Henri, their teacher at the New York School of Art, encouraged roughhouse behavior in class—sparring sessions and the like—and urged his students to "be a man first, be an artist later." Henri's students took up basketball, handball, and boxing, and organized a baseball team, led by Bellows, the serious athlete in the group.[33]

Given their athletic interests as well as their attraction to urban amusements as subjects for their art, the Ashcan artists' relative ignoring of spectator sports such as baseball and football as subject matter is surprising. Luks painted

other sports (*The Wrestlers, The Boxing Match*) but abandoned football after his stint as Outcault's replacement (a late painting, *Football Night at Jack's—Nothing but Touchdowns*, depicts a saloon brawl, not the sport).[34] Edward Shinn painted the crowds at theaters and circuses but not at football games. John Sloan painted bathers at the beach, diners in restaurants, drinkers in bars, and viewers in movie theaters but not fans cheering for the home team.[35] Bellows produced major paintings of boxing at one end of the social-class spectrum and polo and tennis at the other (he was himself an avid tennis player).[36] Of football, which existed socially between the two extremes, Bellows drew just a handful of magazine illustrations (remarkable ones, a subject in chap. 4) but no major paintings. (Most surprisingly, he all but ignored baseball, despite his personal passion for the game.)[37]

Only William Glackens included football among the city's amusements he painted—not the organized sport played on a proper field but a ragtag affair in a place very much like Hogan's Alley. Glackens was particularly adept at rendering crowds at work or play, first as a sketch artist for Philadelphia newspapers, then as a cartoonist, then as an illustrator for popular magazines, and eventually as a celebrated painter. The subjects of his early paintings included roller skating and sledding in Central Park. His illustrations for a 1905 boxing story in *Cosmopolitan* magazine resemble (or perhaps influenced) the boxing paintings that his friend George Bellows would soon be executing.[38] Glackens's sole football painting (plate 65), a watercolor now held in a private collection, was included in his series of covers and full-page illustrations of New York scenes for *Collier's* mostly between 1910 and 1913. *For the Championship of the Back-Lot League* exemplifies Glackens's cartoonist's vision and possibly the more direct influence of the Yellow Kid.

What initially seems chaotic is in fact highly organized. The rough-and-tumble going on in the painting's foreground is the familiar football brawl, and Glackens's figures are "cartoonish" in their simplicity. But they are also individualized in their facial expressions, achieved with little more than dots and a few tiny lines of black ink. Lower-class humanity in this scene is remarkably varied. The ironically titled "championship" seems to be simply a violent struggle over a ball in the foreground, drawing the attention of the boys in the mid-background, who root for their own side or run toward the action, but remaining unnoticed by those farther away. (These three distinct planes are marked by

figures in identical white-and-orange striped shirts.) While the ball seems to have been forgotten by the scuffling boys more intent on hitting each other (one of the smallest, at the bottom of the scene, is tackling one of the stoutest), the little girl reaching to pick it up risks being engulfed by the melee if her mother or older sister cannot pull her away in time. The other mothers and daughters in the lower right corner of the frame make their escape, with varying degrees of interest, anxiety, and disapproval. All of this plays out against a backdrop of tenement buildings that are "home" to all of the figures. The Back Lot is their city park.

For the Championship of the Back-Lot League exemplifies the acute observation and management of crowded scenes for which Glackens was known, whether set in Central Park, Washington Square, or the Lower East Side.[39] Glackens's football scene said much more about the lives of New York's immigrant poor than about the sport of football; it simply appropriated football to capture a fundamental aspect of tenement life. In doing so, however, it also created a new pictorial structure for football art, or built on Outcault's. The same roughness and barely organized chaos of Glackens's backlot "championship" that characterized the lives of New York's urban poor also belonged to football itself—its

excesses—and to football art both here and into the future. Whether the source was Glackens or Outcault (or neither specifically), football's organized chaos became another convention available to artists (plate 68).[40]

Over the following decades finely detailed cartoons became a fixture in the sports sections of daily newspapers, providing steady work for talented artists such as Tad Dorgan, Bob Edgren, Hype Igoe, Burris Jenkins, Pete Llanuza, and Willard Mullin.[41] While their best work transcended the limitations of daily deadlines, the most lasting football cartoon art appeared on magazine covers. The three great humor magazines of the late-nineteenth century weathered the competition from the Sunday supplements, but *Puck* did not survive the Great War, folding in 1918. When college football boomed in the 1920s, the so-called Golden Age of Sports, both *Life* and *Judge* responded with regular and often brilliant football covers created by a new group of exceptional comic artists that included Ellison Hoover, Vernon Grant, Russell Patterson, and John Held Jr. Neither magazine survived the Depression, but in 1925 the *New Yorker* had arrived to reinvent the humor magazine—and the cartoon football cover. Football's fundamental excessiveness remained ripe for satiric treatment.

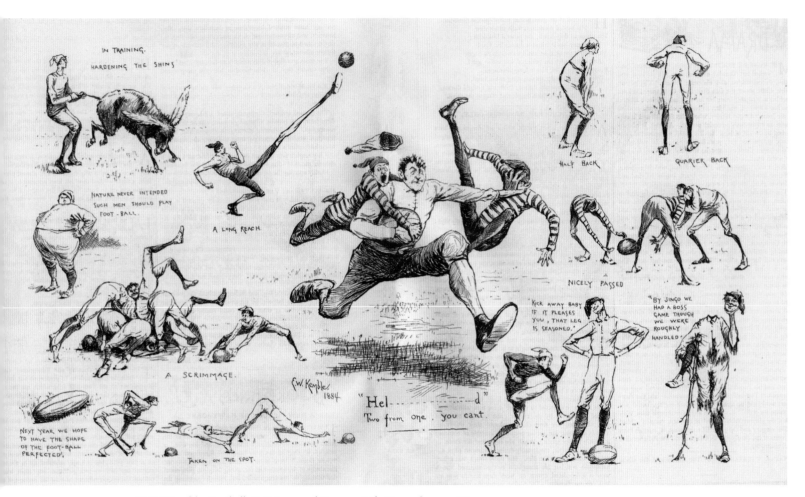

PLATE 42. E. W. Kemble. *Football: Its Science and Progress. Life*, November 20, 1884.

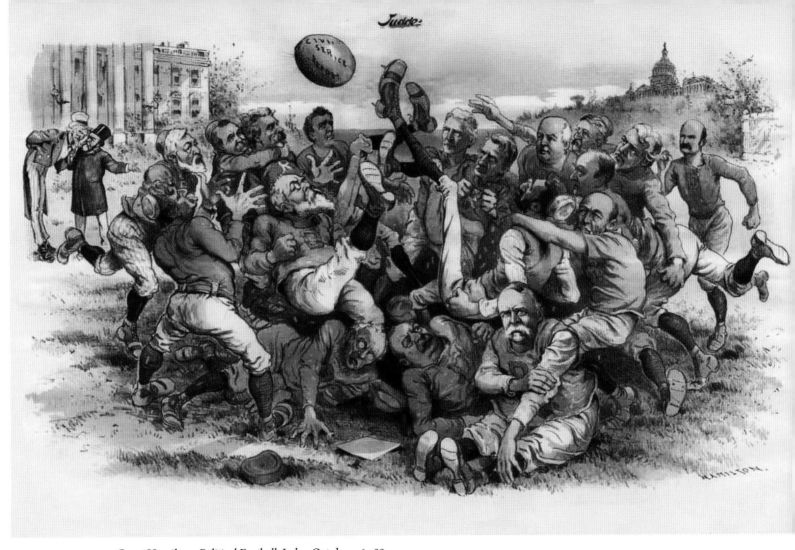

PLATE 43. Grant Hamilton. *Political Football. Judge*, October 26, 1889.

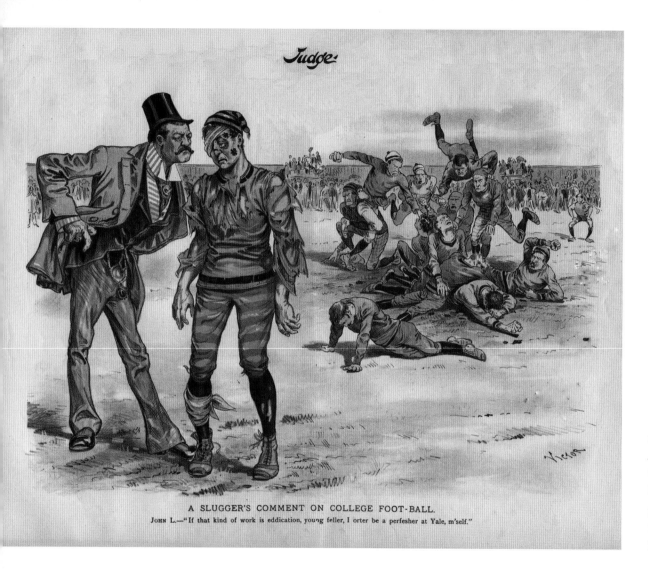

A SLUGGER'S COMMENT ON COLLEGE FOOT-BALL.

JOHN L.—"If that kind of work is eddication, young feller, I orter be a perfesher at Yale, m'self."

PLATE 44. Victor [Gillam]. *A Slugger's Comment on College Foot-Ball. Judge,* November 30, 1889.

PLATE 45. Victor Gillam. *The End of the Game. Judge,* November 12, 1898.

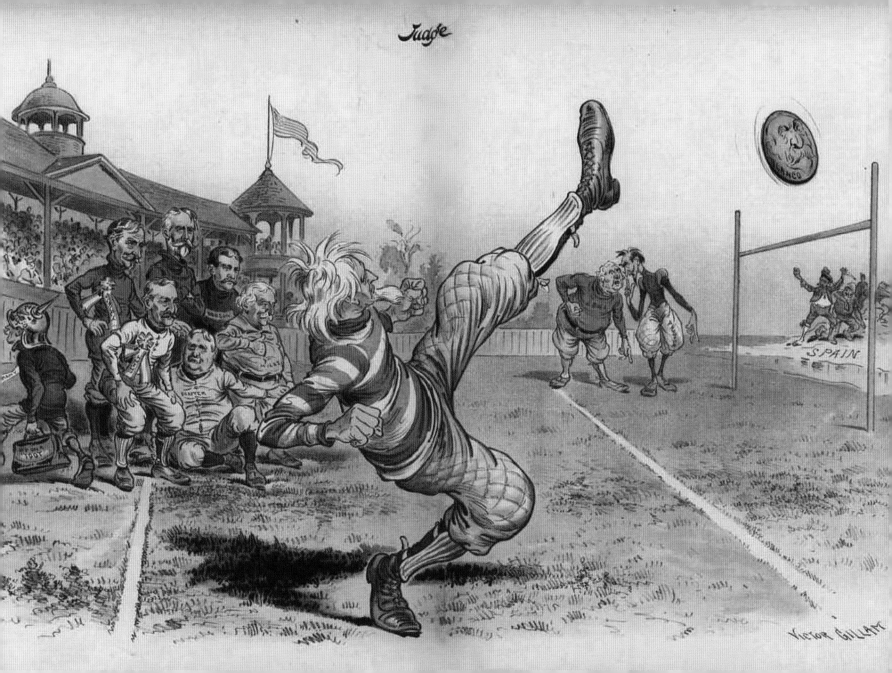

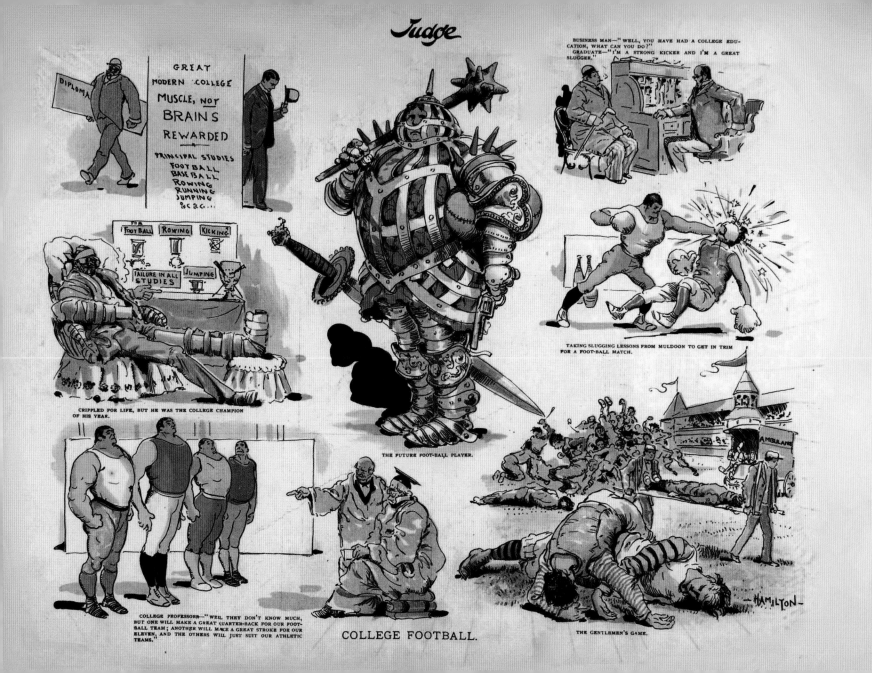

COLLEGE FOOTBALL.

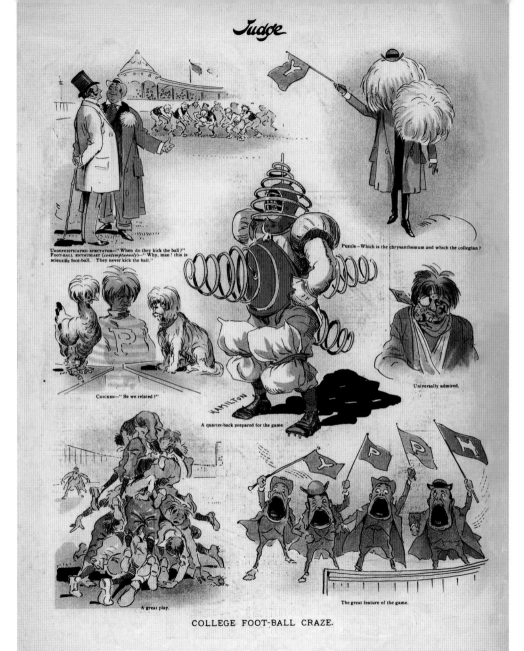

PLATE 46. Grant Hamilton. *College Football. Judge,* November 21, 1891.

PLATE 47. Grant Hamilton. *College Foot-Ball Craze. Judge,* November 25, 1893.

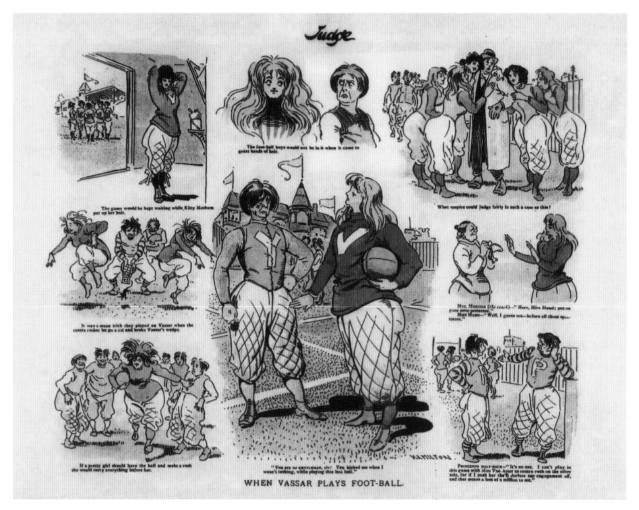

PLATE 48. Grant Hamilton. *When Vassar Plays Football*. *Judge*, November 23, 1895.

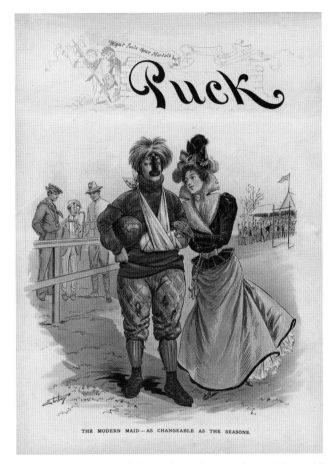

THE MODERN MAID—AS CHANGEABLE AS THE SEASONS.

PLATE 49. Samuel D. Ehrhart. *The Modern Maid—As Changeable as the Seasons. Puck*, November 23, 1898. Library of Congress, LC-DIG-ppmsca-28649.

PLATE 50. Charles Johnson. *Rah Rah Rah! Rah Rah Rah! Rah Rah Rah! Yale. Truth*, November 17, 1893.

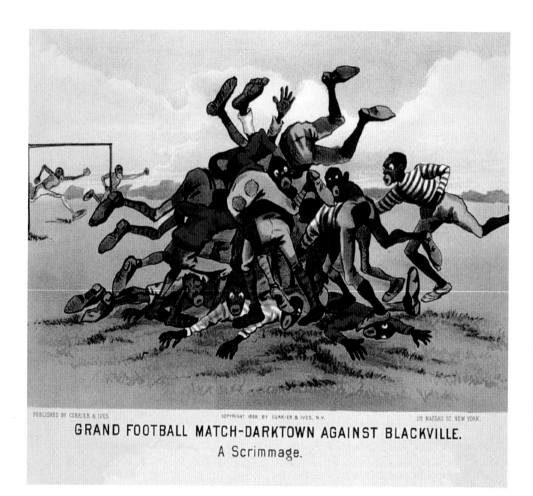

GRAND FOOTBALL MATCH—DARKTOWN AGAINST BLACKVILLE.
A Scrimmage.

PLATE 51. *Grand Football Match—Darktown Against Blackville. Scrimmage.* 1888. This is one of two "Darktown" football prints in the Library of Congress. Library of Congress, LC-USZC2-2480.

PLATE 52. Eugene Zimmerman ["Zim"]. *How the Great Foot-Ball Game Was Won. Judge,* December 1, 1894. Others appeared on October 29, 1898, and October 21, 1899.

HOW THE GREAT FOOT-BALL GAME WAS WON.

It was Blackville vs. Shantytown, and the Blackvilles had no chance until their manager was inspired to paint the ball like a watermelon.

RESULT—Blackvilles, 80; Shantytowns, 6.

PLATE 53. James
Montgomery Flagg.
Cover for *Life*,
November 4, 1909.

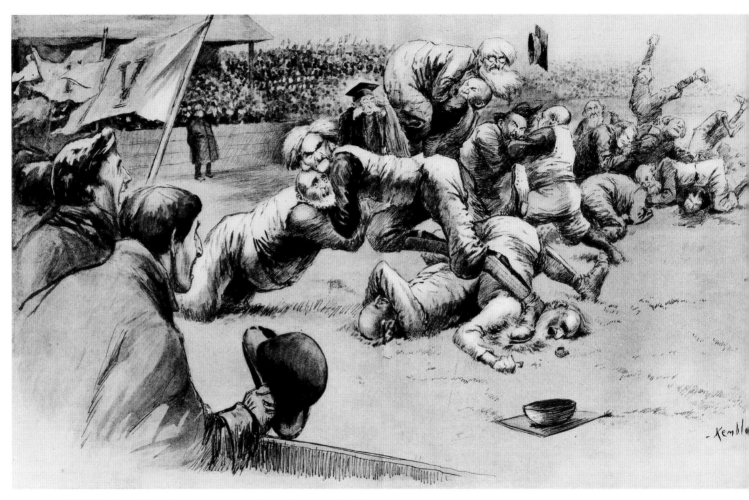

PLATE 54. W. H. Kemble. *A New Feature for Intercollegiate Struggles. Life*, November 29, 1894.

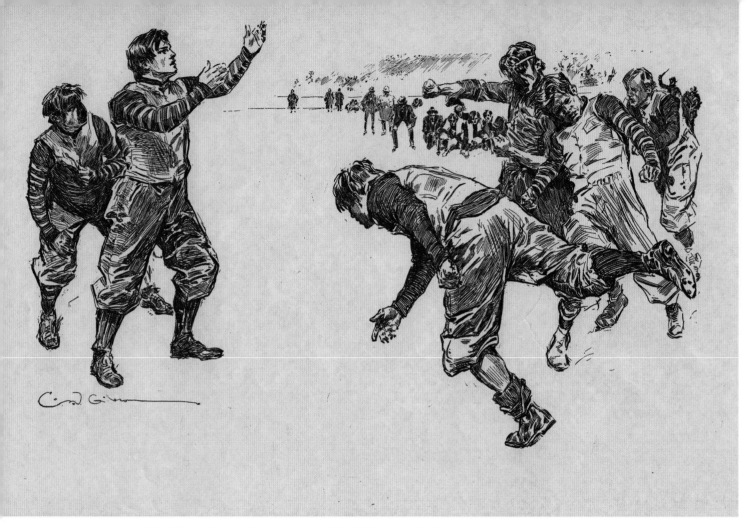

PLATE 55. C. D. Gibson. *The Leading Features of a Liberal Education. Life,* January 1, 1895.

PLATE 56. C. D. Gibson, *Intercollegiate Football—"Down!" Harper's Young People,* November 25, 1890.

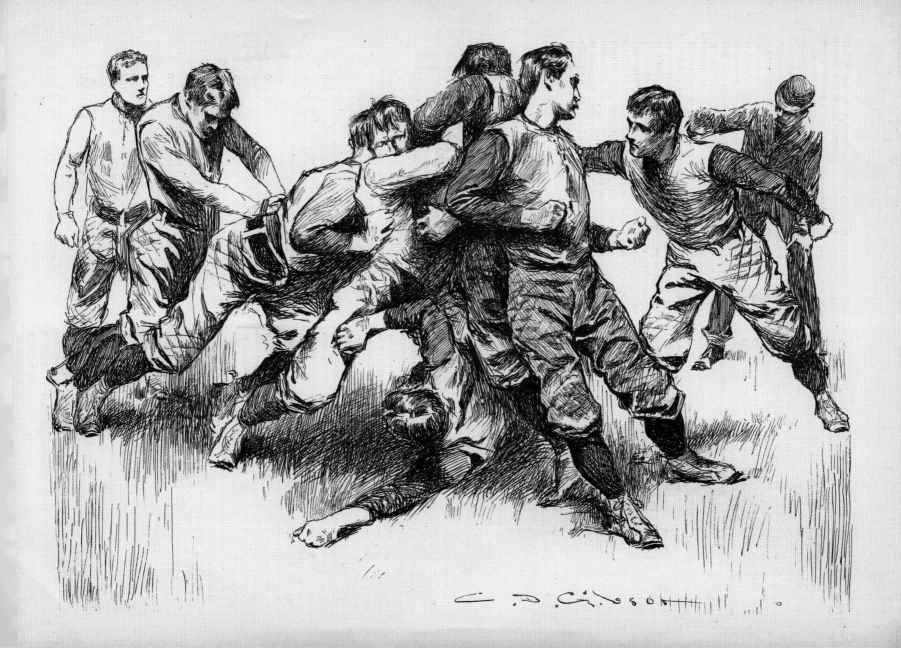

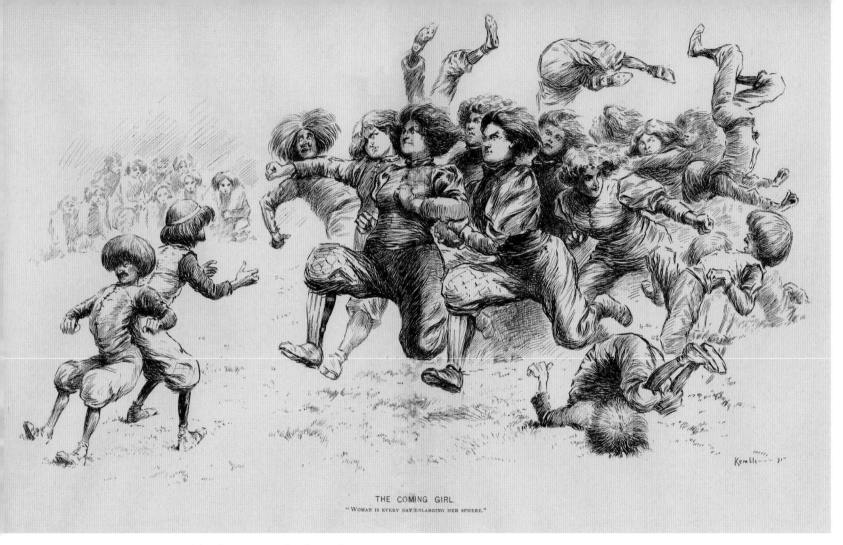

THE COMING GIRL

"WOMAN IS EVERY DAY ENLARGING HER SPHERE."

PLATE 57. E. W. Kemble. *The Coming Girl. Life,* October 31, 1894.

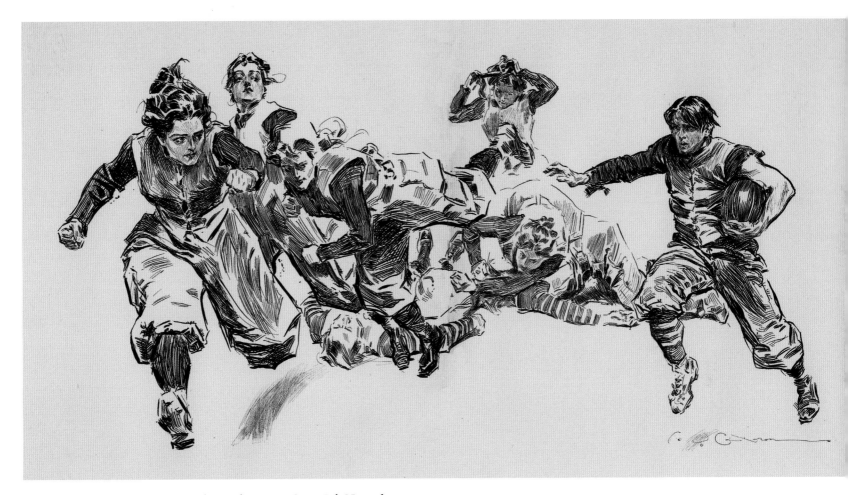

PLATE 58. C. D. Gibson. *The Coming Game. Life*, November 21, 1895.

93

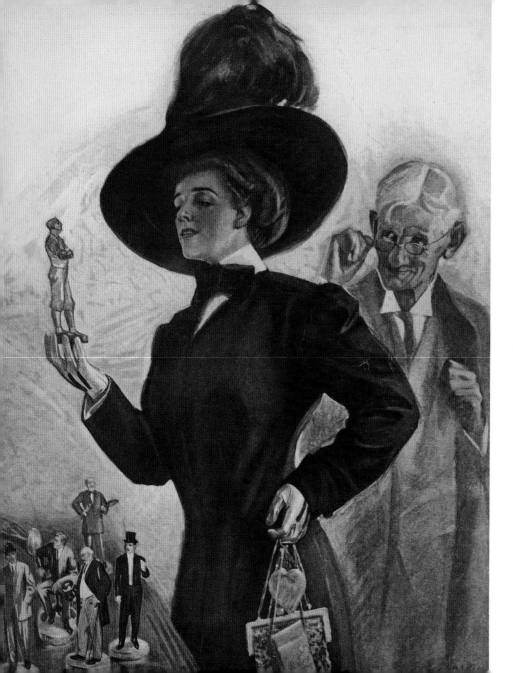

PLATE 59. C. D. Gibson. *Man. Life*, January 18, 1912.

PLATE 60. Emil Flohri. *Taming the Football Slugger. Judge*, November 4, 1905.

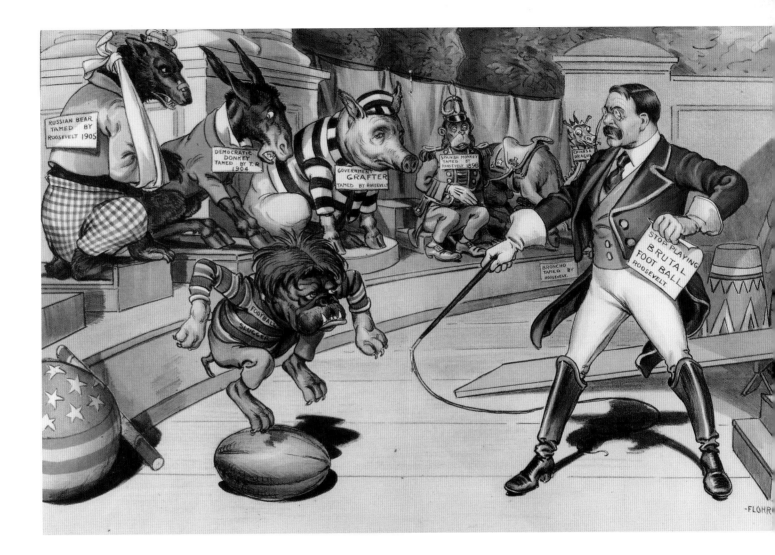

95

PLATE 61. John S. Pughe. *Football in 1906*. *Puck*, January 1, 1906. Library of Congress, LC-DIG-ppmsca-26022.

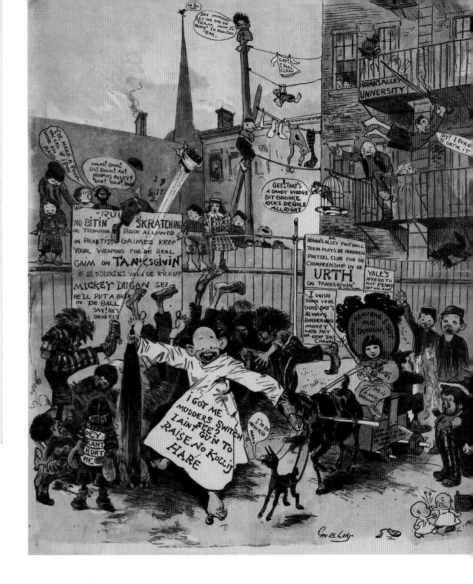

PLATE 62. Emil Flohri. *Football in 1906 Under the New Rules. Puck,* March 10, 1906.

PLATE 63. George B. Luks. *Training for the Football Championship Game in Hogan's Alley. World,* October 11, 1896. San Francisco Academy of Comic Art Collection, The Ohio State University Billy Ireland Cartoon Library and Museum.

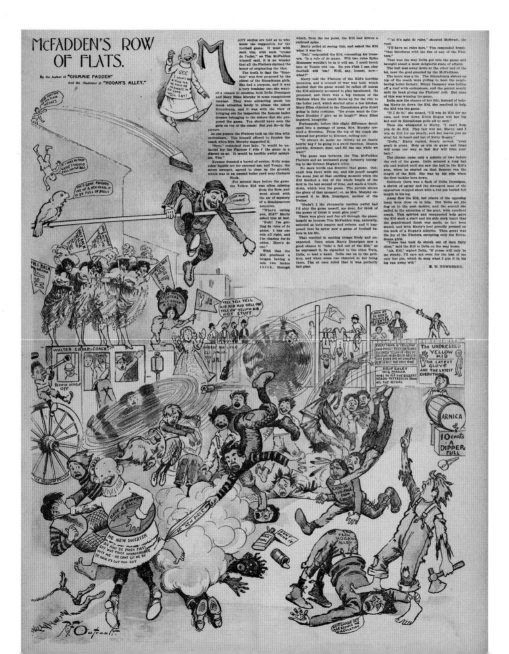

PLATE 64. R. F. Outcault. *Inauguration of the Football Season in McFadden's Row.* New York *Journal*, November 15, 1896. San Francisco Academy of Comic Art Collection, The Ohio State University Billy Ireland Cartoon Library and Museum.

PLATE 65. William Glackens. *For the Championship of the Back-Lot League. Collier's*, November 11, 1911.

PLATE 66. W. W. Clarke. Cover for *American Boy*, October 1920.

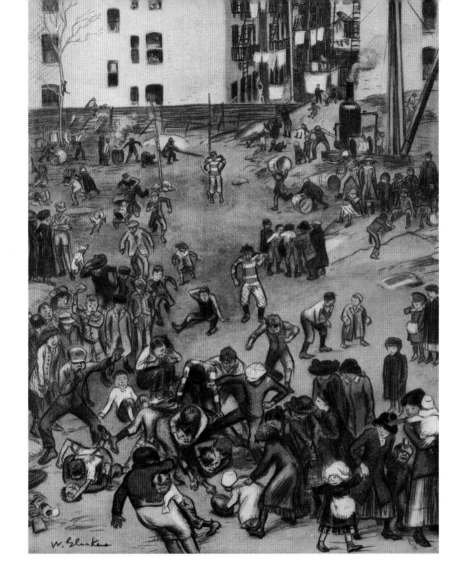

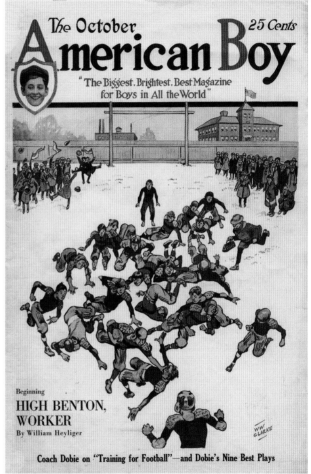

3

EDWARD PENFIELD, J. C. LEYENDECKER, AND FOOTBALL POSTER ART

IN THE 1890S the United States experienced an art-poster craze, triggered by a series of lithographic posters produced by Edward Penfield from March 1893 through August 1899 for advertising each new issue of *Harper's Monthly Magazine.* The art poster had emerged in Europe in the 1880s and, like most cultural productions, came belatedly to the United States. Posters promoting circuses, musical and theatrical performances, and various commercial products were nothing new, but illustrators such as Penfield, Will Bradley, and Louis Rhead began exploring the artistic possibilities in such commercial work. Penfield's 11 in. x 17 in. monthly placards for *Harper's* were artfully simple, with a single or pair of slightly misshapen figures colored in flattened tones with no realistic detailing and set against uncluttered backgrounds, sometimes with a small object to hint at the appropriate month. Penfield strove for frivolity rather than seriousness. He also believed that the image and its message should be instantly grasped, not studied. For all their simplicity, his "startling unbalanced compositions," as a contemporary critic described them, seemed modern and sophisticated.[1]

The immediate popularity of Penfield's posters for *Harper's* prompted *Scribner's, Century, Lippincott's,* and other rival monthlies to commission their own advertising posters, some with Penfield's simplicity, others in the more ornate Art Nouveau style of some of the European poster artists. Promotional placards boosted circulations while becoming collectors' items (booksellers sometimes sold the posters

instead of displaying them). When the illustrated weeklies added color to their covers around the turn of the century, the covers themselves became the marketing posters to capture attention at the newsstand, and the great era of magazine cover art began. The craze in the United States for collecting and exhibiting art posters lasted only a few years but it established the poster as a medium of artistic expression as well as commerce. The poster style also became the dominant form of magazine cover illustration, including football cover art, well into the 1930s.[2]

Penfield's posters for *Harper's* included just one with a football theme: a November 1894 placard with a varsity letterman walking with a young woman to the field for the Harvard-Yale game (plate 67). Within two years football images began appearing on fall advertising posters for several monthly magazines. Penfield's influence is evident in the designs of two young artists, J. J. Gould and Will Carqueville, who would go on to major careers as illustrators. (Gould became best known in the 1920s for his illustrations of "darky" stories, including *Amos 'n' Andy*.) Among his roughly two dozen posters for *Lippincott's*, Gould's one football poster had a runner and a tackler in the background, watched by a young man with a copy of *Lippincott's* in his lap (plate 68). Carqueville's poster for the *International Magazine*, a new monthly published in Chicago, put the runner in the foreground, midstride, with a ball tucked under his left arm and right arm extended as if to ward off tacklers (plate 69)—a football icon that endures to this day, most famously as the figure on the Heisman Trophy. The *International* offered this limited-edition poster to subscribers as "the very thing to adorn a student's room."[3] That same fall, advertising posters for the rival Hearst and Pulitzer newspapers in New York included one of the Yellow Kid in a similar pose, announcing his defection to Hearst's *Journal*.[4] A poster for *Ainslee's* in 1899 featured a female fan rather than her football hero (plate 70). *Outing*, the sport-and-recreation monthly, printed less artful football posters in 1895 and 1896.

For the monthly magazines, football was a sign of the season for advertising November issues. A new genre of posters emerged just after the turn of the century that advertised football itself (and other sports) and their sponsoring universities. Printers produced them to advertise themselves as well as the universities; students used them to decorate their dormitory rooms.[5] The idea apparently originated with John E. Sheridan, a recent Georgetown graduate whose

posters launched his long career as a popular illustrator.[6] One of Sheridan's two 1901 football posters—showing a Harvard player striding across campus (plate 71)—proved to be an anomaly. The other—a Princeton player posing with a ball tucked under his arm as he faced the viewer (plate 72)—became the model copied by other artists.[7] The success of these posters earned Sheridan commissions to produce a football-themed advertising poster for *Sunset* magazine on the West Coast in 1903—depicting substitutes waiting anxiously on the sidelines (plate 73)—and illustrations for a football story in that same issue (fig. 23). Sheridan's career as an illustrator took off from there.[8]

Edward Penfield, who started the poster craze, came belatedly to sports posters, but when he did he brought his distinctive style. His images of a Princeton guard and a Harvard tackle in 1907 (plates 74 and 75) were from his series of posters of college athletes printed by the Beck Engraving Company of New York in 1907 and 1908. Their hulking figures, small heads, and disproportional bodies exude masculine power, in striking contrast to the blander, more conventional figures drawn by other poster artists (fig. 24). Penfield's other athletes—a runner for the University of Pennsylvania, a hammer thrower for Yale, a baseball

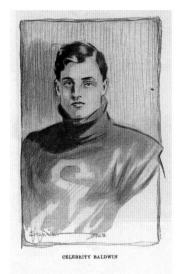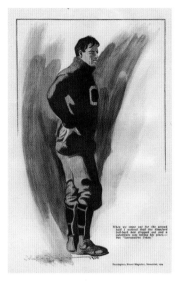

CELEBRITY BALDWIN

FIG. 23. John E. Sheridan. *Left*: Poster-style illustration for Edward Felton Wheaton's "Celebrity Baldwin." *Sunset*, November 1903. *Right*: Poster-style portrait illustrating James Hopper's "Locomotive Jones," *Sunset*, November 1904.

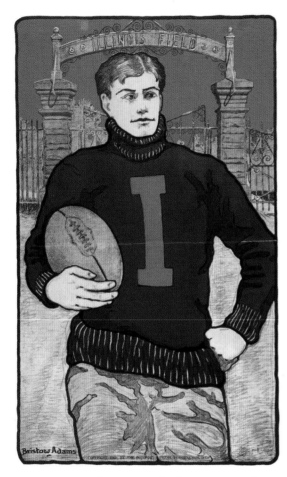

FIG. 24. Bristow Adams. Poster for the University of Illinois (1903) typical of the many by Adams and other artists. Library of Congress, LC-USZC4-3092.

player for Cornell—were overly muscular like his football players, but less menacing (fig. 25). All of Penfield's sports posters had the same distinctive style, but his football posters hinted at dangers not present in the other sports.

An undated and untitled small banner-style drawing in the Library of Congress shows Penfield's characteristic blocky figures in football action (plate 76). Other holdings in the Library of Congress include a 1905 banner poster of fans at a game (*Harvard Scores*) by John Jepson (plate 77) and a ball carrier outrunning his tacklers (*Clear*) by Hibberd Van Buren Kline from 1910 (plate 78). Kline, a recent graduate of Syracuse University, was clearly influenced by Penfield's bulky Princeton guard and Harvard tackle. Kline produced at least four more chromolithographic football posters in 1909 and 1910, all of them published by Close, Graham & Scully of New York.[9] An advertising poster for *Scribner's* from 1907 featured a football hero possibly modeled on John Sheridan's (plate 79).

With so few football posters surviving (or having disappeared into private collections), it is hard to gauge their popularity in the early years of the new century. But the broader impact of the poster style is clear. The celebrated poster artist Will Bradley (the "American Beardsley")

painted what was essentially a poster for the 1898 Harvard-Yale game program, but in Beardsley's characteristic Art Nouveau style rather than with Penfield's flat simplicity (plate 80).[10] (Bradley's program could have been a model for Mark Rutherford's poster a year later for *Ainslee's* [plate 70].) Football-themed postcards, usually portraying pretty women waving school pennants or admiring their football heroes (fig. 26), were in effect mini-posters, and these same images also appeared on pennants, sweaters, mugs, and even pillowcases.[11] But the art poster's greatest and longest-lasting importance resulted from its transformation of the magazine cover.

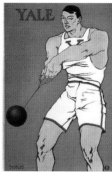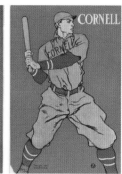

FIG. 25. Edward Penfield. Nonfootball posters printed by Charles W. Beck in 1908. Library of Congress, LC-USZC2-516, LC-USZC4-3097, LC-DIG-ppmsca-18479.

COLLIER'S, THE SATURDAY EVENING POST, AND THE BEGINNING OF A GOLDEN AGE OF FOOTBALL COVER ART

Over the duration of a long career following his resignation as art editor at *Harper's* in 1901, Edward Penfield took on assignments ranging from magazine and book illustrations to golf calendars, almanacs, and commercial advertisements (including famous ones for Pierce Arrow Automobiles, Northampton Bicycles, and Hart, Schaffner, and Marx tailors). But he was best known for his magazine covers,

well over a hundred for *Collier's* alone, all in his distinctive poster style. More than a dozen of them illustrated sports: baseball, rowing, golf, tennis, lacrosse, and polo, as well as football, the latter the subject of his first one in 1901 (plate 81).[12] Peter Collier, an Irish immigrant, had founded the magazine in 1888 as a story paper called *Once a Week*, but then repositioned it as an illustrated news magazine in 1892. In 1895 he changed its name to *Collier's*. It was a typical illustrated weekly with black-and-white covers portraying distinguished personages or scenes from the news (includ-

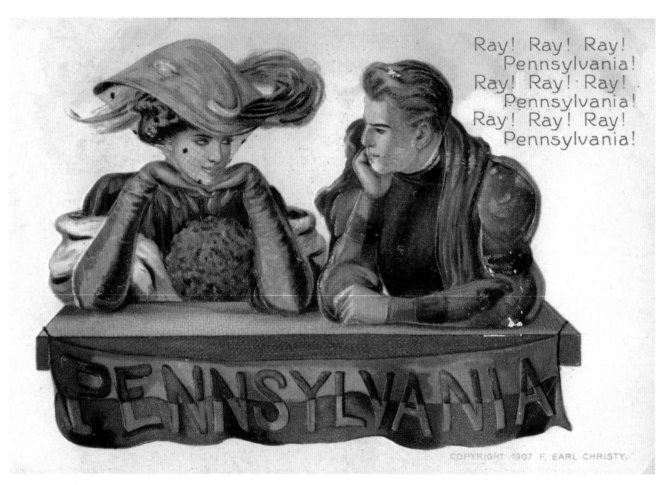

FIG. 26. F. Earl Christy. Embossed postcard. 1907.

ing championship football games [plates 19 and 20]) until 1901, when it began using colored covers in the new poster style and became a leader in magazine graphic art to match its equally high-quality journalism.[13]

The style of Penfield's 1901 football cover reflected a shift from his *Harper's* posters, toward what a contemporary critic called "finer outlines and more carefully studied delineation of face."[14] (Penfield alternated between the two styles over the rest of his career.) The single figure against a blank background remained relatively simple, but the few textural details in the player's Harvard sweater and pants, combined with the grim expression on his face, marked a departure from the flat tones and blank expressions of the posters for *Harper's*. Penfield's cover is usefully seen in a sequence of iconic ball carriers that began with Will Carqueville's 1896 poster for *International Magazine* (plate 69) and continued with an 1899 cover of *Ainslee's* by G. Y. Kauffman (plate 82) and one by C. D. Williams in 1900 (plate 83). The faces of the ball carriers become increasingly grimmer, the sense of football's danger increasingly heightened. *Ainslee's* was a literary monthly published by the firm of Street & Smith better known for the dime novel serials it published in the late nineteenth century and as the future publisher of pulp

magazines and sports publications in the twentieth. With Frank Merriwell and his chums, who appeared in *Tip Top Weekly* from 1896 to 1913, Street & Smith essentially created the genre of boys' sports fiction; its *Sport Story Magazine* (published from 1923 to 1939) was the first sports pulp. *Ainslee's* was Street & Smith's initial attempt at a general-interest magazine for adult readers, and it published the work of the top writers and illustrators of the day. *Ainslee's* advertised with posters but also put what was effectively a poster on its own cover. (Other literary monthlies used advertising posters but had the same decorative cover on every issue.) Illustrated weeklies such as *Collier's* and the *Saturday Evening Post* also began using colored poster-style covers around this time.

In Carqueville's poster, the clenched fist on the runner's outstretched arm and the partial arm reaching for him from outside the frame hint at violence in the game not directly portrayed by the image. In the two *Ainslee's* covers the hint is stronger, registered in the ball carriers' facial expressions (whether fearful or wary is uncertain). In Penfield's cover the facial expression is more fiercely determined and is reinforced by the runner's clenched right fist aimed at the viewer and by his claw-like left hand clutching the ball. The threat

remains outside the frame but has become more threatening. This is a football warrior, not just an athlete, and the sequence of images neatly illustrates a developing aesthetic of excess for capturing football's fundamental nature.

Collier's next football cover, by Blendon Campbell in 1903 (plate 84), proved to be the magazine's single departure from the simpler Penfield style in these early years. With its paint-filled frame and layered planes—female figure in the foreground, football player in midframe, football action faintly in the background—Campbell's composition was a poster to be studied, not instantly grasped, as Penfield preferred. With its third football cover, the first of three by J. C. (Joseph) Leyendecker (plate 85), *Collier's* returned to the uncluttered style that continued into the 1930s. Leyendecker's hundreds of covers, in styles as distinctive as his signature at the bottom, included 48 for *Collier's* and 322 for the *Saturday Evening Post* and made him the country's premier cover artist for three decades. His dozen football covers (several of them also published separately as posters) and numerous football-themed advertisements made him the premier football artist as well.[15]

Like Penfield, Leyendecker painted other sports, too, but none so abundantly or distinctively as football, and with his first cover for *Collier's* he created something new for football poster art.[16] Instead of Penfield's single iconic football hero, Leyendecker distilled the violent action of the game into three figures: a ball carrier, a tackler clinging to him, and a prone figure face-down on the field, creating not an entire scene but rather "the apex of action" that captured a dramatic moment.[17] Otho Cushing had used multiple figures for an 1897 cover for *Truth*, the former humor magazine redesigned as a general-interest weekly (plate 86), but Leyendecker's tableau was more imaginative and powerful. Both artists used blank backgrounds, like Penfield typically did, but Leyendecker's created a dreamlike quality. While the runner looks calm, the still figure on the ground appears more like a battlefield casualty than a sporting athlete. The image has three-dimensional depth, with the ball carrier and tackler thrust toward the viewer and the smaller configuration in the background more like a mirror image than another part of the same play. Leyendecker's interest in this painting seems predominantly formal, but, like Penfield, Kauffman, and Williams, he also pushed beyond verisimilitude to capture something deeper in football. "The apex of action" in the foreground concentrates the drama, sacrificing realism for symbolic power.

Having published a football cover in three of the four years from 1901 through 1904—as well as double-page centerfolds by major illustrators (plates 21–23)—*Collier's* did not have another football cover until 1913. Whether this gap was due to conscious editorial decision would be interesting to know. Always politically progressive, *Collier's* was a muckraking journal during the Roosevelt and Taft administrations and its exposés included a series of articles in fall 1905 on the professionalism in midwestern college football programs (today's Big Ten).[18] A full-page illustration by Penfield in 1906, *A Day of Football* (plate 87), echoed the satiric cartoons in *Puck* and *Judge* that touched on the public's competing fears that football was too violent but might be made not violent enough (see plates 61–62). In Penfield's drawing, a pileup has a caption, "The same old game in spite of the New Rules." Just below, opposing players bow politely to each other above a second caption, "Why not introduce a little bridge whist into the game." Stylistically the simplifications and figural distortions of Penfield's poster style create a cartoon-like effect, pointing to the blurred boundary between these two forms of graphic art.

Collier's published William Glackens's *For the Championship of the Back-Lot League* (plate 65) in 1911, and it was also no endorsement of football as a noble game. But *Collier's* also kept publishing Walter Camp's articles celebrating football, including his annual selection of an All-America team. By 1913 successive rule changes *seemed* to have solved the problem of excessive violence (and muckraking had run its course). Regardless of whether any of this mattered, the next football cover in *Collier's* did not appear until 1913 (plate 88). It was Penfield's second and last, a more conventional football hero than the one on his 1901 cover (and 1907 posters, plates 74 and 75).

Two more Leyendeckers followed, in 1914 and 1916, one of the least and then one of the most interesting football covers Leyendecker painted over his long career. The first (plate 89) was a surprisingly static configuration: a closeup of a quarterback and interior linemen before the play has begun, with the hard edges and bold textures characteristic of Leyendecker's style but conveying no particular drama or formal novelty. The 1916 cover (plate 90) then introduced an entirely new kind of football hero, both for Leyendecker and for football art generally: Penfield's football brutes radically reimagined.

By this time Leyendecker was the country's best-known football artist, having published seven more magazine

covers in addition to the three for *Collier's*. Four of the covers were for the *Saturday Evening Post*, the struggling nineteenth-century story paper purchased by Cyrus Curtis in 1897 and redesigned as an illustrated weekly magazine. Under the editorial leadership of George Horace Lorimer the *Post* pulled even with *Collier's* in circulation by 1902 and kept roaring past it: 747,000 by 1908 (compared to 568,000 for *Collier's*) and 2 million by 1920 (to 1 million of *Collier's*), by which time the *Post* had become "a dominant force in middle-class culture."[19] Both magazines initially targeted male readers, until the *Post* announced in its June 28, 1908, issue that it was "Not for Men Only."[20] *Collier's* did not make this shift until the 1920s. Lorimer had a personal aversion to sports but had to please his readers. Likely for a mix of reasons, *Collier's* paid more attention to sports, though the *Post* by no means ignored them.

Lorimer introduced black-and-white pictorial covers in 1899—the cover before then was simply the first page of an illustrated story or article—then quickly added color and adopted the poster style. The *Post's* first two-color cover appeared on September 30; the second, four weeks later, was painted by Leyendecker's brother, Frank, and featured an iconic scholar and athlete expressing an ideal already

too often at odds with reality (plate 91). This issue was the "College Man's Number" for the fall, and by 1899 college in the fall meant football. The covers of three more College Man Numbers, plus two additional covers over the next seven years, offered a variety of football icons in the poster style: a kickoff, a coach laden with cheering fans, two female fans wearing emblems of their favorite teams—one of them by J. J. Gould, the poster artist for *Lippincott's* (plate 69)—and just one football hero, in repose (plates 92–96). The absence of football covers in 1905 and 1906 (then again from 1909 through 1911) may reflect Lorimer's response to the crises over football violence in 1905 and 1909. But the relative downplaying of the football hero in favor of football's larger social world characterized *Post* covers into the 1950s.

J. C. LEYENDECKER AND THE AESTHETICS OF EXCESS

Football covers in the poster style appeared on magazines of all kinds in the early years of the new century, including a new sports weekly, the *Illustrated Sporting News*, which over its short run from 1903 to 1907 published nine poster-style football covers, four of them by an artist named Howard

Giles (plates 97 and 98).[21] With a full-page illustration for *Harper's Weekly* in 1902 (plate 36), a cover for *Leslie's Weekly* in 1904 (plate 111), and a poster cover for a football novel by Walter Camp in 1908 (fig. 27), along with illustrations for numerous football stories and articles published between 1902 and 1911 (see chap. 4), Giles belongs with Penfield and Leyendecker among the major inventors of popular football art.

In 1908 the *Saturday Evening Post* published the first (plate 99) of what would eventually amount to six football covers by Leyendecker. This small portion of his huge output of *Post* covers over forty-four years was a major contribution to football art. Leyendecker had a monopoly on the *Post*'s football covers from 1908 until 1919 (his final two would appear in 1928 and 1933). He originally painted the punter on his 1908 cover as a poster for the University of Pennsylvania in 1906, and then again in 1907 as a poster celebrating Cornell's 10–0 victory over Harvard.[22] The recurrence of kickers in Leyendecker's work is a reminder that football began as a game played with the feet, and being able to kick long and accurately remained the single most valued skill for decades, despite the adoption of the forward pass.[23] The punter with leg fully extended and arms spread as if to

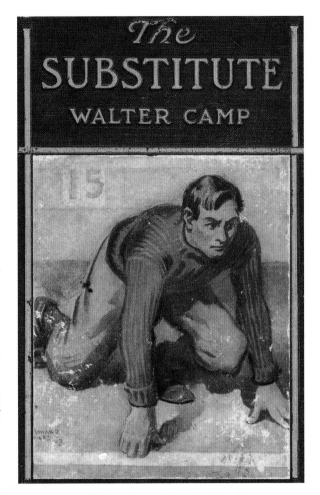

FIG. 27. Howard Giles. Cover for Walter Camp's *The Substitute*. 1908.

fly remained one of the most familiar iconic images of the sport for just as long.

The hard-edged straight lines in the figure of Leyendecker's punter marked a new style for him—images "composed of planes like the facets of a crystal," as one critic has described it—that alternated with his older style over the rest of his career.[24] Leyendecker's 1912 cover for the *Post* (plate 100), for example, reverted to the smoother, rounder lines of his older style, while the straight lines and harder edges of the new style are evident in his covers for the *Post* in 1913 and 1914 (plates 101 and 102), for *Collier's* in 1914 and 1916 (plates 89 and 90), for *Popular Magazine* in 1908 and 1909 (plates 103 and 104), and for *The Century* in 1909 (plate 105). The cover for *The Century* announced the first of a series of football articles written by Walter Camp, with illustrations by N. C. Wyeth and Frank Leyendecker. *Popular* was Street & Smith's all-fiction pulp magazine—before "the pulps" became identified with a subliterary world of sensationalism and formulaic genre fiction.[25] The magazine in these years published the same artists and writers who appeared in the major weeklies and monthlies. J. C. Leyendecker also contributed several other sports covers to *Popular*, and Wyeth painted dozens of covers for the magazine (most with western themes) between 1909 and 1923, Wyeth's years as a major illustrator.[26]

Leyendecker's new hard-edged style could not be imitated without seeming too obviously an imitation, and it marked his most distinctive contribution to football art.[27] The 1914 *Post* cover (plate 102) also introduced a new football icon that would become ubiquitous in the 1920s: the rough-and-tumble kid in football togs, usually more sentimentalized than Leyendecker's.[28] The rest of the covers reveal an artist experimenting with how best to capture football's "excessive" nature. The linemen in the 1913 *Post* cover (plate 101) convey something missing from the more realistic 1914 *Collier's* cover (plate 89). The more stylized bodies and synchronized charge—arms and legs at precisely at the same angle—pushed beyond realistically representing football players toward an abstract image of dynamic power. The runner's left hand in the 1908 *Popular* cover (plate 103), with finger tips appearing chopped-off, looks threateningly claw-like, while the opponent on the ground appears to be shielding his face from the cleated shoe about to trample him. The 1909 *Popular* cover is less violent (plate 104) , yet the graceful S-shape formed by the placekicker and holder, set against the harsh lines and

brushstrokes elsewhere in the frame, conveys the tension in football between violence and beauty. The cover for *The Century* (plate 105) may be the greatest of all Leyendecker's football paintings, a perfect distillation of this fundamental tension into the two figures wrapped in a fierce embrace. Appearing at yet another moment of crisis over football fatalities, the cover prompted a cartoon in a Philadelphia newspaper (fig. 28), which made explicit what Leyendecker's image more subtly hinted at.

Leyendecker applied his new style to all of the subjects of his magazine covers. For representing football it exploited a minor detail of football attire. The quilting on the players' canvas pants that provided minimal protection from blows to the legs also gave artists a useful textural detail to exploit (plates 69, 82, and 83). Penfield achieved a dramatic effect when he simplified this detailing to a few V-shaped slashes for his 1901 *Collier's* cover (plate 81). By exaggerating it and extending it across the entire canvas Leyendecker transformed a simple textural detail into a potent suggestion of football's violent physicality. The sense of force is only latent in his images of kickers, though even here the slashing lines in Leyendecker's 1909 cover for *Popular Magazine* express masculine power (plate 104). It is more overt when he portrays figures tackling and being tackled. This power is most emphatic in Leyendecker's football brute for the 1916 *Collier's* cover (plate 90), whose torn jersey, exposing bare chest and upper arm, became another Leyendecker signature, this one copied often enough to become conventional.[29]

Leyendecker once commented that, compared to other forms of popular illustration, a magazine cover "hits harder because it is a symbol; it is concentrated."[30] He was speaking of poster-style covers rather than the detailed scenes on covers of the illustrated weeklies of the 1890s (or the storytelling covers later associated with the *Saturday Evening Post* and Norman Rockwell).[31] But he also put his finger on an element that produced much of the superior football art from this era. Distortion and exaggeration made Leyendecker's images not just stranger but also more highly suggestive. Particularly the covers in his new style can be added to the sequence from Carqueville's poster to Kauffman's and Williams's covers for *Ainslee's*, to Penfield's 1901 cover for *Collier's*, which exposed the heart of the game, not just its surface. Leyendecker's figures appear chiseled from granite. Their harshly angled facial features suggest determination, anguish, or cruelty; their oversized gnarled hands look like weapons. His images were richer in meaning

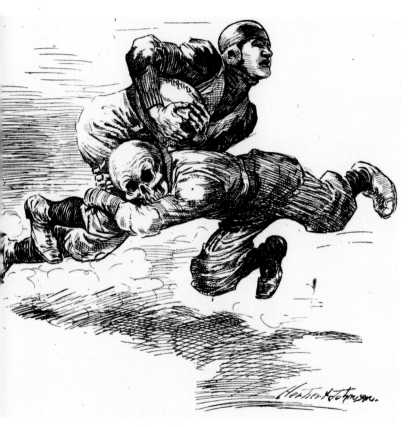

FIG. 28. Herbert Johnson. *Down! Philadelphia North American*, November 16, 1909.

as well as more artful than the blander images that most of his fellow artists were producing and than some of his own more idealized figures. Leyendecker's 1912 dropkicker for the *Post* (plate 100) was a Platonic ideal of the impossibly handsome football hero, unmoved and immovable. His 1916 football brute for *Collier's* (plate 90) was handsome, too, but in an over-the-top rugged way, and the image conjured violence experienced in the past (by the torn jersey) and more to come (with the gnarled hands partially clenched, as if to throttle someone). The effect is slightly unsettling and a provocation to think about the nature of football that is wholly absent from his figure of the doe-eyed, meditative dropkicker.

Collectively, Leyendecker's ten covers in the 1900s and 1910s for *Collier's*, the *Saturday Evening Post*, *Popular Magazine*, and *The Century* created the era's most potent composite image of the football hero. Displayed on newsstands and appearing in multiple formats, they had to have been nearly unavoidable. As noted earlier, some were published separately as posters. The 1909 cover for *The Century*, for example, was published that same year as a 23½ in. x 27½ in. poster titled *Downed*, and it appeared again on the football program for the Harvard-Yale game in 1916.[32]

Leyendecker also used his football icons in several of the stunning magazine ads he produced for manufacturers of fine clothes (plate 106 and fig. 29).[33] When advertising art began including football images around the turn of the century, it appropriated the available conventions for football illustration rather than creating its own and adding a fifth distinct tributary to the mainstream of popular football art. Dozens of Leyendecker's ads for Arrow Collars and Kuppenheimer suits or overcoats in the 1910s and 1920s featured a young man dressed in the company's finest, holding a golf club or tennis racket or standing with an athlete appropriate to the season (hockey in winter, rowing or baseball in spring, swimming or golf or tennis in summer, football in fall). These ads are among the earliest instances of the now-ubiquitous branding that links a product not to intrinsic qualities like comfort or durability but to a lifestyle or a fantasy of self-invention.[34] While Leyendecker's football-themed ads branded Kuppenheimer suits with the prestige of college football, these ads in turn branded college football with the social distinction of the well-dressed gentleman.

Leyendecker's ads created an American male ideal as popular as the Gibson Girl (his models received thousands of fan letters). In effect, the football players (and other college athletes) portrayed in these ads occupied a place where one would expect to see a lovely female, admiring and admired by the handsome man in the stylish topcoat. The posthumous revelation that Leyendecker was gay, unknown in his lifetime to all but those closest to him, has sparked recent interest in the coded eroticism of these ads and of his magazine covers as well. More than any other artist, Leyendecker created the football hero as an object of envy and desire. The figures themselves, striking for their aloofness, are beyond such emotions (the smiling player in the 1919–1920 Kuppenheimer style book is atypical in this regard). Illustrators who came after Leyendecker tended to make their football heroes more boyish and eager to please.[35] Leyendecker's was a demigod, set apart from lesser mortals.

THE TRIUMPH OF THE POSTER STYLE

Edward Penfield and J. C. Leyendecker were the two most important innovators among the numerous artists who painted football covers in the poster style for magazines ranging from general-interest weeklies and monthlies to boys' magazines, to all-fiction pulp magazines, to the magazine sections of Sunday newspapers, even to women's magazines. Both *Collier's* and the *Saturday Evening Post* published

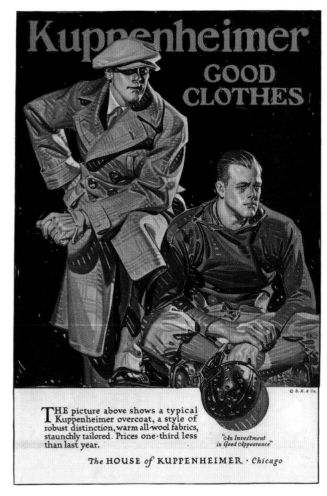

THE picture above shows a typical Kuppenheimer overcoat, a style of robust distinction, warm all-wool fabrics, staunchly tailored. Prices one-third less than last year.

"An Investment in Good Appearance"

The HOUSE *of* KUPPENHEIMER · *Chicago*

FIG. 29. J. C. Leyendecker. Ad for the House of Kuppenheimer. *Literary Digest*, November 21, 1921.

one more football cover in the 1910s, post-Leyendecker, in both cases featuring the sentimentalized kids who became ubiquitous in the 1920s.[36] The older nineteenth-century illustrated weeklies, *Harper's* and *Leslie's*, switched from black-and-white to colored poster-style covers around 1909 as part of a failed effort to compete with the new generation of rivals. *Harper's* published one of these covers each year from 1909 through 1912 (plates 107–110). Following black-and-white covers of football action in 1904 (by Howard Giles) and 1906 (plates 111 and 112), and then a hybrid of the two styles in 1907 (plate 113), *Leslie's* converted to poster covers in the teens, which continued until the magazine folded in 1922 (plates 114–117). A "pretty girl," the most common subject for magazine covers generally, wore a chrysanthemum in her team's color on the occasional woman's magazine (plate 118).[37]

St. Nicholas (1873–1937), the beloved late nineteenth-century children's magazine, adopted pictorial covers around 1907, occasionally with football images (plate 119). A new generation of boys-only magazines, led by *American Boy* (1899–1941) and *Boys' Life* (1911–) but also including shorter-lived publications such as *Star Monthly* (1894–1908) and *The Boy's Magazine* (1910–1924), offered a poster-style

football cover nearly every season (plates 120–123). The best of them were painted by W. W. Clarke for *American Boy*.[38] Equally unsurprising, the sports-and-adventure publications of Street & Smith also ran football covers more or less every fall, often of very high quality. *Popular Magazine* (1903–1931), as noted earlier, published many of the same artists whose work had appeared in the *Post* and *Collier's*. In 1910 Street & Smith launched *Top-Notch* (1910–1937), a magazine targeted to boys as a successor to the firm's hugely successful dime novel, *Tip Top Weekly* (the home of Frank Merriwell), which was nearing the end of its run. Street & Smith thus had staff artists available who for years had produced the highly conventional dime-novel cover each week for *Tip Top*, but instead it commissioned major illustrators, often the same ones who painted covers for *Popular*.

In addition to J. C. Leyendecker, Street & Smith's football artists in the 1900s and 1910s included Leyendecker's brother, Frank (plate 124), himself a prolific cover artist for the *Post*, *Collier's*, and other top magazines; and Hibberd V. B. Kline, another leading but long forgotten figure in the development of popular football art. Kline's football posters in 1909–1910, noted earlier, led to five football covers for *Popular* and *Top-Notch* between 1910 and 1915 (plates 125–128), in addition to non-poster-style paintings for the sporting journal *Outing* (plates 129 and 130).[39] Kline's distinctive style shows traces of both Penfield's distorted figures and Leyendecker's hard-edged detailing (with touches also of George Bellows, discussed in chapter 4), and marks him as another football artist working to capture the emotional and psychological depths of the sport. It is striking that Kline's football covers for the two Street & Smith magazines, with younger or older readerships, appear interchangeable (as do those by other artists).[40] This points to the blurred boundary between childhood and adulthood in which team sports existed in this period—in the case of football, a school sport whose greatest heroes were college boys being turned into men.[41]

The most easily overlooked source of poster-style football covers in the 1910s appeared in the supplements of the Sunday editions of major daily newspapers, another of the elements of the modern newspaper pioneered by Pulitzer and Hearst. By the late 1890s some metropolitan dailies were offering readers occasional art supplements in their Sunday papers, reproductions of paintings suitable for framing. Football was an available subject in the fall. In 1897, the *Philadelphia Inquirer* published A. J. Keller's "The

Rivals": the captains for Princeton and the University of Pennsylvania competing for the attention of a lovely young woman.[42] Near the end of the 1900 football season the *Chicago Tribune* offered readers a more impressive painting by a young local artist, G. C. Widney. Simply titled *Football*, it shows the University of Chicago team in a game at Marshall Field (later Stagg Field) and rivals the best football art of the era (plate 131).[43] Customers could stop by the *Tribune* offices to pick up a frame for 25 cents.

The covers of Sunday magazine supplements tended more often to the poster style. To spread out the cost of publishing high-quality Sunday magazines, four major syndicates were formed in the early 1900s to produce them for metropolitan newspapers outside the growing Hearst empire, which developed its own.[44] The earliest was Associated Sunday Magazines, created in December 1903 as a cooperative venture among the *Chicago Record-Herald, St. Louis Republic, Philadelphia Press*, and *Pittsburgh Post* in partnership with the American Lithographic Company. By 1917 when Associated dissolved, nine more papers had joined the group. The *Illustrated Sunday Magazine* began a few years later in fifteen papers and lasted until 1919. In 1909, United Sunday Newspaper Magazines, published by the Pulitzer company, served a dozen papers and added five more by 1913. Finally, the *National Sunday Magazine*, published in Chicago by Abbott & Briggs, appeared (under various titles) from 1911 through 1916 in as many as sixteen papers, including at various times the *Chicago Tribune, Boston Globe*, and *Los Angeles Times*.[45] By 1914 huge Sunday editions with magazine supplements and comic sections had nearly twice the circulation of the same papers' daily editions and produced about 75 percent of overall profits through ads.[46] Circulations of the syndicated Sunday magazines in the 1910s topped a million, even two, in some cases surpassing the *Saturday Evening Post*.[47] In short, Sunday magazines in a variety of ways were equivalent to major illustrated weeklies.

Like magazines on newsstands, covers of the Sunday magazine supplements helped sell the higher-priced Sunday papers.[48] Styles varied. Hearst's *American Sunday Magazine* (renamed *American Weekly* in 1917) featured ornate illustrations, often for bizarre or sensationalistic stories. The Pulitzer covers were similar in style though less prurient in subject matter. Associated Sunday Magazines,

the *Illustrated Sunday Magazine,* and the *National Sunday Magazine* at various times used poster-style covers by the same artists who painted them for the major periodicals. Pretty-girl covers were overwhelmingly dominant, but the fall months meant an occasional football cover (plates 132–136), including ones by John E. Sheridan and Hibberd V. B. Kline.[49] In 1905 Associated Sunday Magazines also published a Will Grefe centerfold of a football hero and his lovely admirer, which, like Widney's painting for the *Chicago Tribune,* was sold separately as a 14 in. x 20 in. print (plate 137).[50]

Collectively the poster artists of the 1900s and 1910s created a cluster of iconic figures—the handsome hero cradling a football, the running back (sometimes with a tackler at the moment of impact), the punter, the fans (including the pretty girl wearing a chrysanthemum), the cheerleader (male), and kids mimicking their heroes in all of these roles—which together defined football's distinctive place among American sports and in American culture. They also established a visual grammar for other artists to appropriate, reinvent, or subvert in the following decades.

Most of this poster football art was in no way provocative. Editors and publishers avoided controversy on their covers, which were to invite readers in, not put them off. For family-oriented magazines in particular this meant more attention to football's larger social world than to the game itself, and kids were the ultimate family-friendly subject regardless of what they were portrayed doing.[51] *Harper's* and *Leslie's* offered football action but without violence, as did the Sunday magazines (with the exception of Kline's 1913 cover for the *Illustrated Sunday Magazine).* Male-oriented magazines such as *Popular* and *Top-Notch* expressed more of the sport's fundamental roughness, but with no crushed bodies here either. W. W. Clarke's covers for *American Boy* portrayed football as a physical test, but not too dangerous.

Nonetheless, the humor magazines were not the only ones to probe football's elemental violence, and the best football poster art from this era, aside from technical skill alone, captured a sense of football as a test of body and spirit, not just a game. Penfield's misshapen heads and bodies, Leyendecker's slashing lines, and Kline's blending of the two were marks of individual style, but all three of these artists handled football differently from other sub-

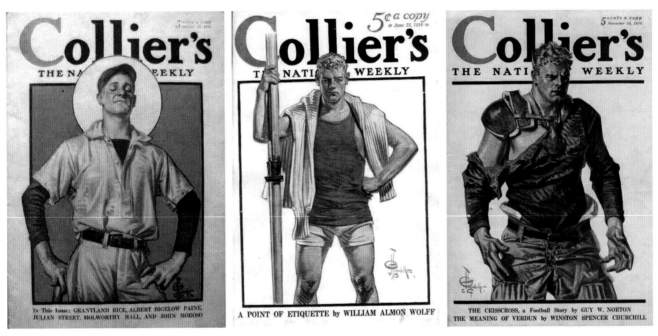

FIG. 30. J. C. Leyendecker. Sports covers for *Collier's,* October 14, June 24, and November 18, 1916.

jects, even other sports. Kline's numerous other covers for *Popular Magazine* were more realistic and conventional than his football covers. Penfield's nonfootball athletes painted *for Collier's* covers had more regular features and placid expressions than his 1901 football cover.[52] Leyendecker provides a most striking case. Three sports covers for *Collier's* in a single year illustrate how football for Leyendecker differed from other sports (fig. 30). The pitcher on the baseball cover for the October 14, 1916, issue (on newsstands during the World Series) was an ordinary-looking figure distinguished only by a strangely smug look on his face—most likely a nod to Ring Lardner's Jack Keefe, the self-regarding and mostly clueless rube pitcher from the *Saturday Evening Post* stories that were published that year as *You Know Me Al*. The rowing cover on June 24 had a massive, powerful, and rugged figure quite unlike this baseball player. As a collegiate sport, rowing had the same social standing and basic ideology as football—sport as test and training in manhood for elite amateurs. But the football cover on November 18, using the same model, was even more massive, more powerful, and more rugged—as well as battle-scarred and vaguely menacing. If we take

Leyendecker at his word, that covers were symbolic, football symbolized for him something quite different from baseball and rowing.

Like all forms of art, popular illustration was governed by conventions that had to begin somewhere and then evolved and expanded through the distinctive styles of strong artists. Football brought out work that was edgier than other sports art. This art was not necessarily superior in technique or formal composition but it was more visually striking and denser in meaning. And it pushed the boundaries of football art for future artists.

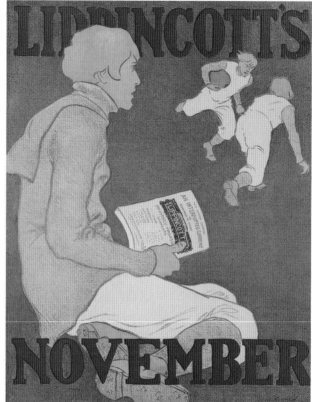

PLATE 67. Edward Penfield. Poster for *Harper's Monthly*, November 1894.

PLATE 68. J. J. Gould. Poster for *Lippincott's*, November 1896. Library of Congress, LC-DIG-ppmsca-42636.

PLATE 69. William L. Carqueville. Poster for *The International Magazine*, November 1896.

PLATE 70. Mark Rutherford. Poster for *Ainslee's*, November 1899. Library of Congress, LC-DIG-ppmsca-43243.

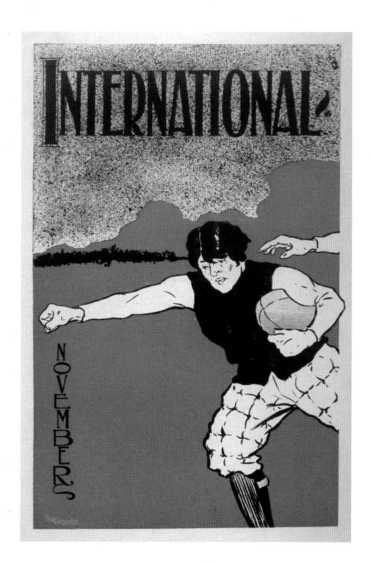

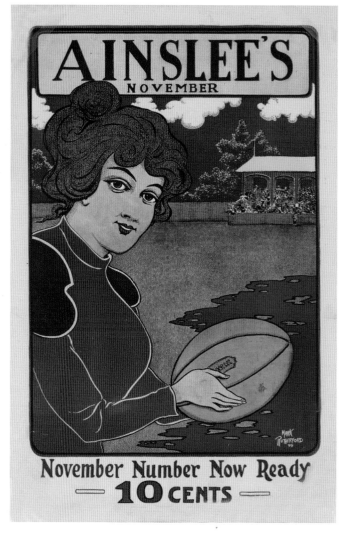

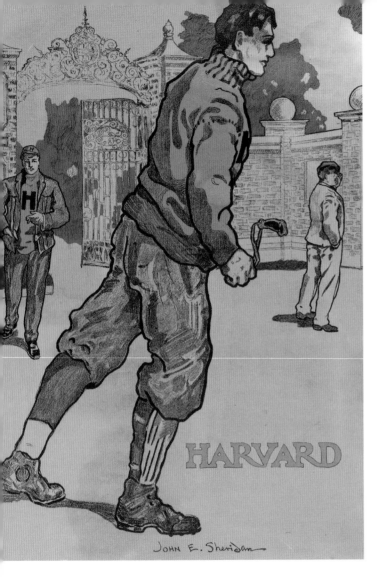

HARVARD

JOHN E. Sheridan

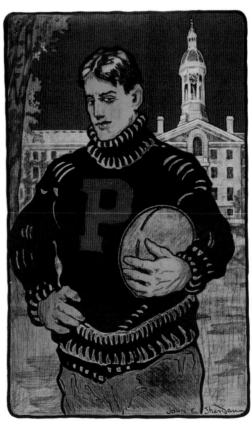

JOHN E. Sheridan

PLATE 71. John E. Sheridan. Poster for Harvard, 1901. HUD_10901_4, Harvard University Archives.

PLATE 72. John E. Sheridan. Poster for Princeton, 1901. Library of Congress, LC-USZC4-3087.

PLATE 73. John E. Sheridan. Poster for *Sunset*, November 1903. The issue contained a football story also illustrated by Sheridan.

PLATE 74. Edward Penfield. Poster for Princeton, 1907. Library of Congress, LC-USZC4-13255.

PLATE 75. Edward Penfield. Poster for Harvard, 1907. New York Public Library.

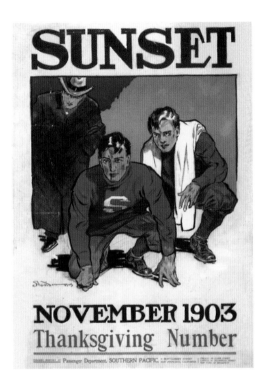

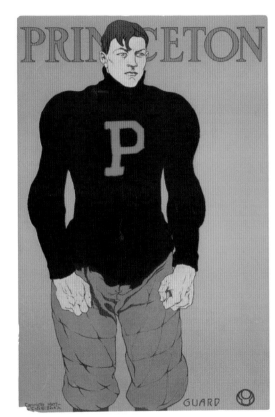

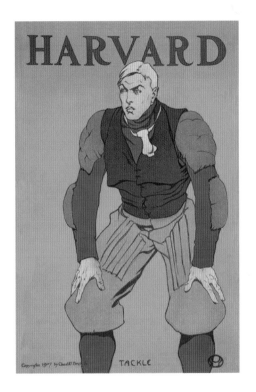

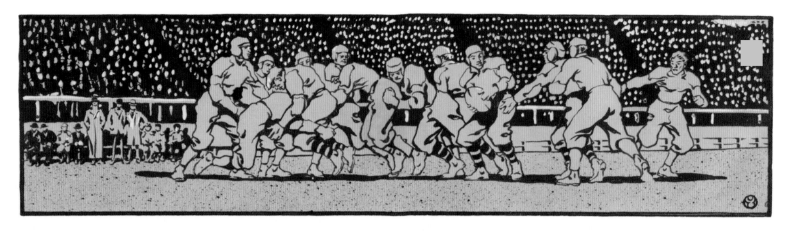

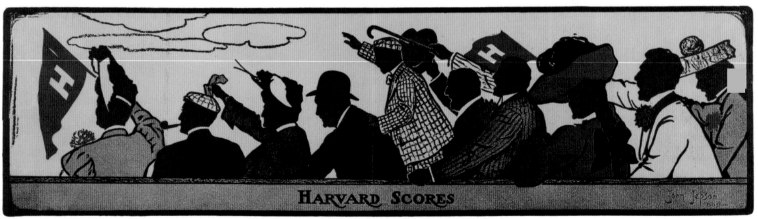

HARVARD SCORES

PLATE 76. Edward Penfield. Untitled and undated poster. Library of Congress, LC-DIG-ds-03786.

PLATE 77. John Jepson. *Harvard Scores.* 1905. Library of Congress, LC-DIG-ds-03791.

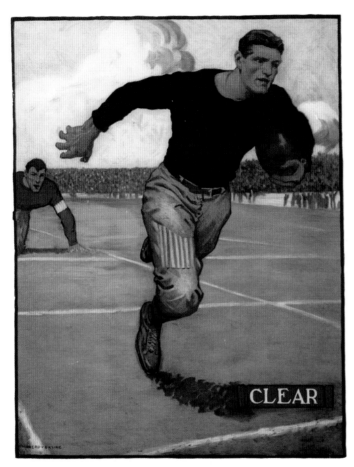

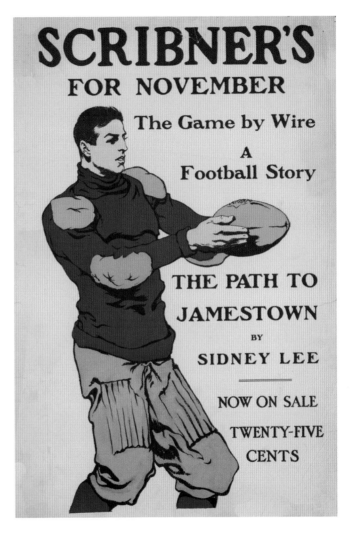

PLATE 78. Hibberd V. B. Kline. *Clear*. 1910, Library of Congress, LC-USZC4-3080.

PLATE 79. Unsigned poster for *Scribner's*, November 1907. Library of Congress, LC-DIG-ppmsca-43272.

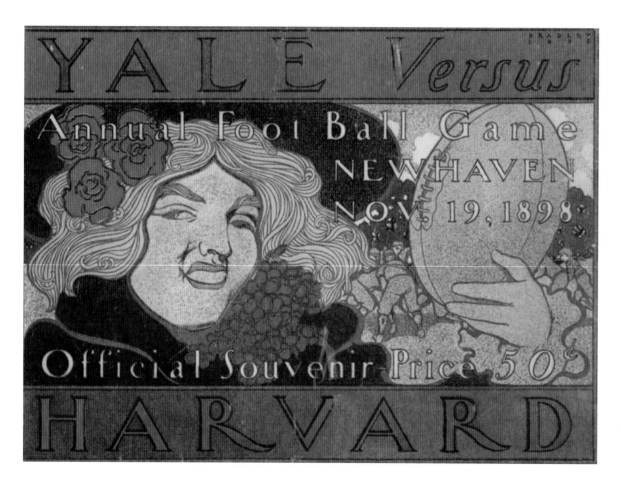

PLATE 80. Will Bradley. Cover of program for Yale-Harvard football game, November 19, 1898. Reproduced from the original held by the Department of Special Collections of the Hesburgh Libraries of the University of Notre Dame.

PLATE 81. Edward Penfield. Cover for *Collier's*, October 12, 1901.

PLATE 82. G. Y. Kauffman. Cover for *Ainslee's*, November 1899.

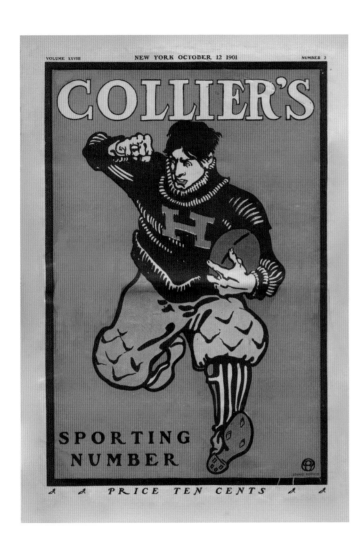

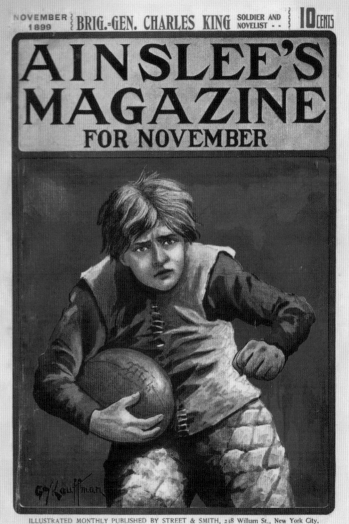

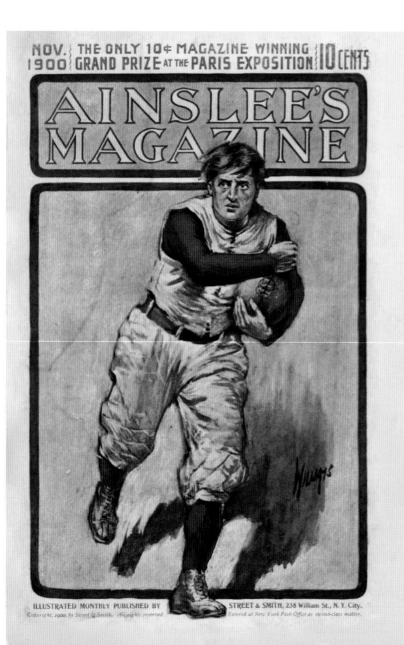

PLATE 83. C. D. Williams. Cover for *Ainslee's*, November 1900.

PLATE 84. B. R. Campbell. Cover for *Collier's*, October 17, 1903.

PLATE 85. J. C. Leyendecker. Cover for *Collier's*, November 19, 1904.

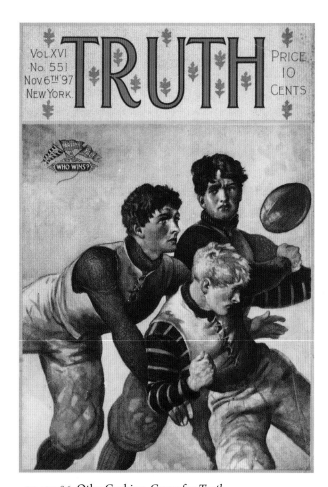

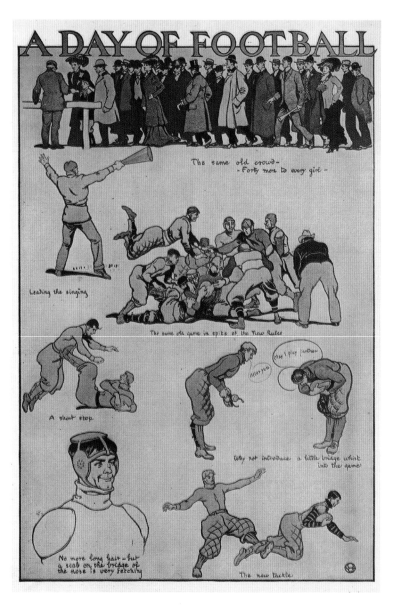

PLATE 86. Otho Cushing. Cover for *Truth*, November 6, 1897.

PLATE 87. Edward Penfield. *A Day of Football. Collier's,* November 24, 1906.

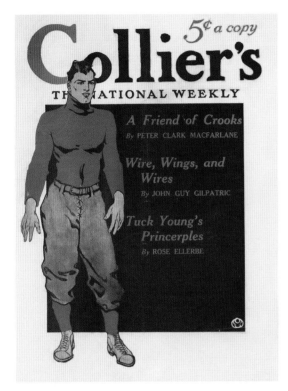

PLATE 88. Edward Penfield. Cover
for *Collier's*, November 15, 1913.

PLATE 89. J. C. Leyendecker. Cover
for *Colliers*, November 28, 1914.

PLATE 90. J. C. Leyendecker. Cover
for *Collier's*, November 18, 1916.

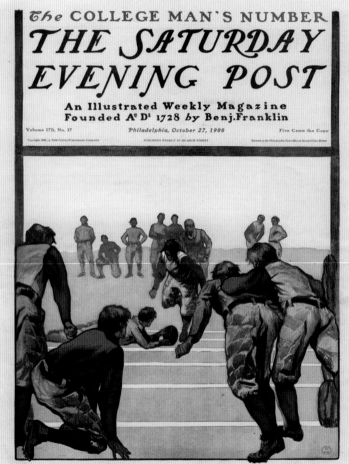

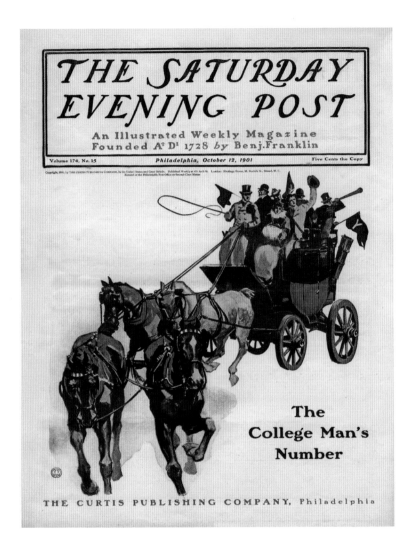

PLATE 91. Frank X. Leyendecker. Cover for *Saturday Evening Post*, October 28, 1899.

PLATE 92. C. Y. Cory. Cover for *Saturday Evening Post*, October 27, 1900.

PLATE 93. C. Y. Cory. Cover for *Saturday Evening Post*, October 12, 1901.

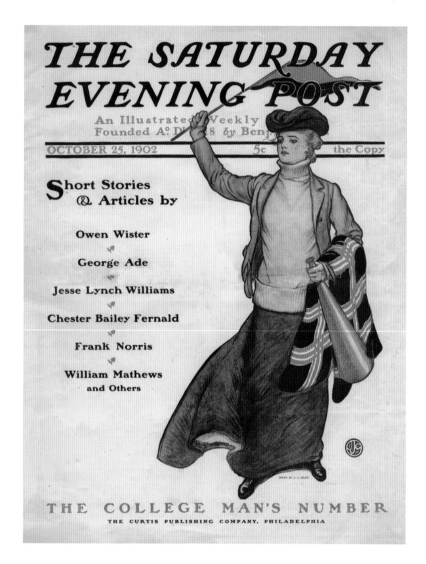

PLATE 94. J. J. Gould. Cover for *Saturday Evening Post*, October 25, 1902.

PLATE 95. Guernsey Moore. Cover for *Saturday Evening Post*, November 19, 1904.

PLATE 96. Harry B. Lachman. Cover for *Saturday Evening Post*, November 9, 1907.

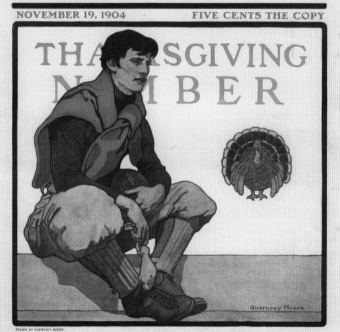

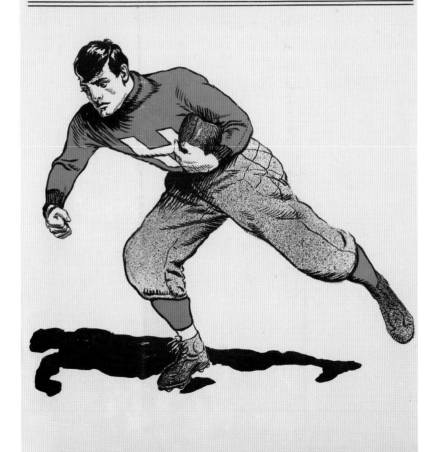

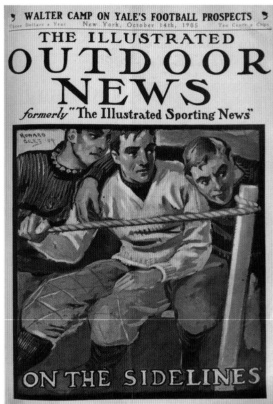

PLATE 97. Howard Giles. Cover for *Illustrated Sporting News*, October 24, 1903. Reproduced from the original held by the Department of Special Collections of the Hesburgh Libraries of Notre Dame.

PLATE 98. Howard Giles. Cover for *Illustrated Outdoor News*, October 14, 1905.

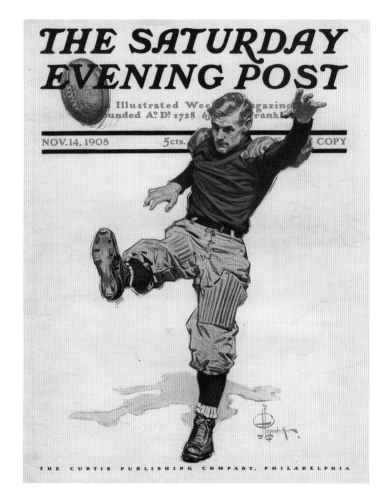

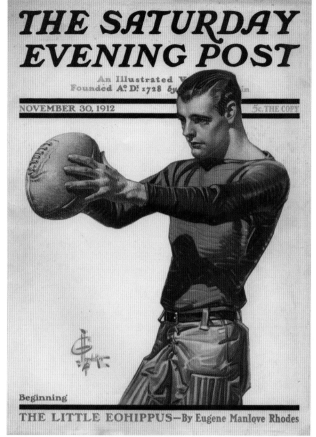

PLATE 99. J. C. Leyendecker. Cover for *Saturday Evening Post*, November 14, 1908.

PLATE 100. J. C. Leyendecker. Cover for *Saturday Evening Post*, November 30, 1912.

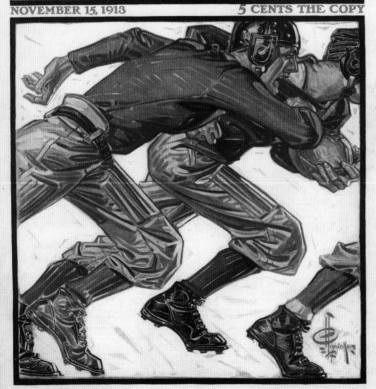

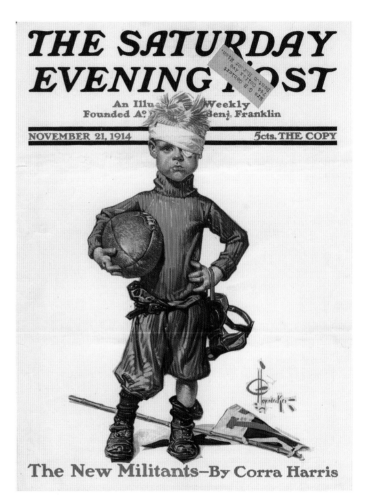

PLATE 101. J. C. Leyendecker. Cover for *Saturday Evening Post*, November 15. 1913.

PLATE 102. J. C. Leyendecker. Cover for *Saturday Evening Post*, November 21, 1914.

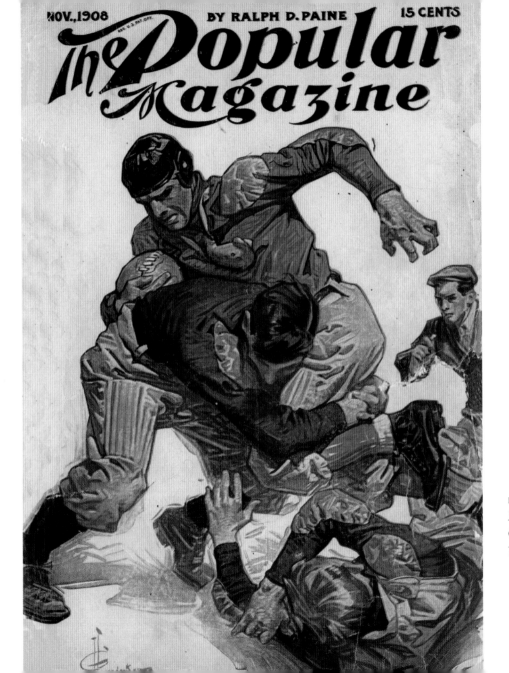

PLATE 103. J. C. Leyendecker. Cover for *Popular Magazine*, November 1908. Special Collections Research Center, Syracuse University Libraries.

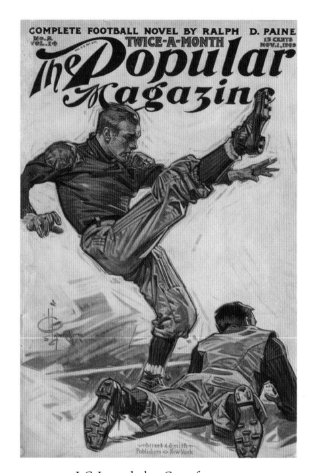

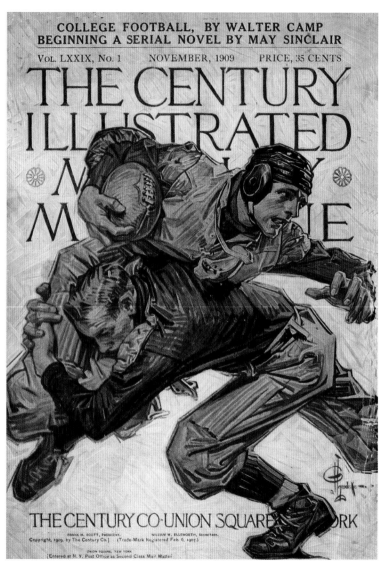

PLATE 104. J. C. Leyendecker. Cover for *Popular Magazine*, November 1, 1909.

PLATE 105. J. C. Leyendecker. Cover for *The Century*, November 1909.

PLATE 106. J. C. Leyendecker, illustrations from the House of Kuppenheimer's 1919–20 style book (a fourteen-page brochure advertising the company's line of suits and coats): two facing pages, with a third page following, to make a three-panel scene of postgame celebration.

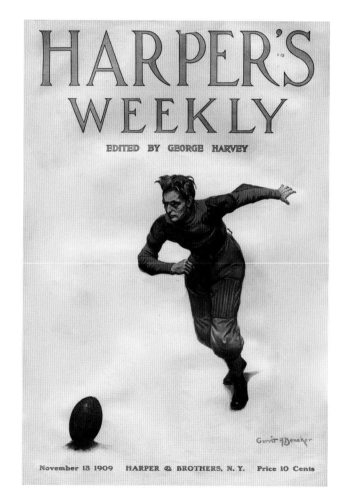

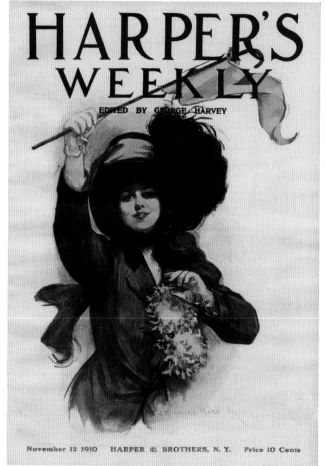

PLATE 107. Geritt A. Beneker. Cover for
Harper's Weekly, November 13, 1909.

PLATE 108. Knowles Hare Jr. Cover for
Harper's Weekly, November 12, 1910.

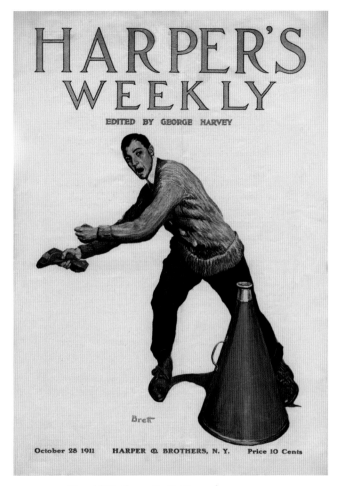

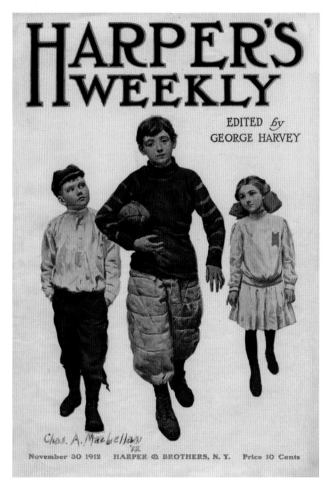

PLATE 109. Harold Mathews Brett. Cover for
Harper's Weekly, October 28, 1911.
PLATE 110. Charles A. MacLellan. Cover for
Harper's Weekly, November 30, 1912.

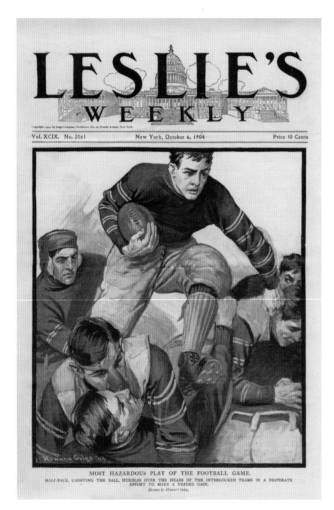

MOST HAZARDOUS PLAY OF THE FOOTBALL GAME.
HALF-BACK, CARRYING THE BALL, HURDLES OVER THE HEADS OF THE INTERLOCKED TEAMS IN A DESPERATE
EFFORT TO MAKE A NEEDED GAIN.
Drawn by Howard Giles.

PLATE 111. Howard Giles. Cover for *Leslie's Weekly*, October 6, 1904.

PLATE 112. Gerrit A. Beneker. Cover for *Leslie's Weekly*, October 25, 1906.

PLATE 113. Arthur E. Jameson. Cover for *Leslie's Illustrated Weekly*, November 14, 1907.

PLATE 114. Charles A. MacLellan. Cover for *Leslie's Illustrated Weekly*, November 2, 1911.

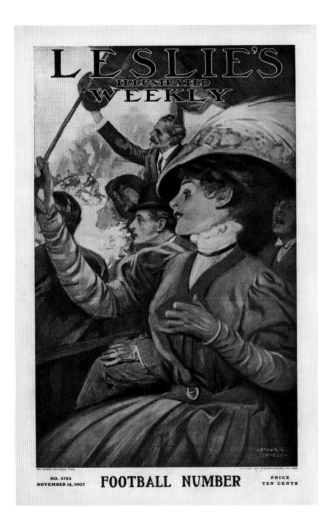

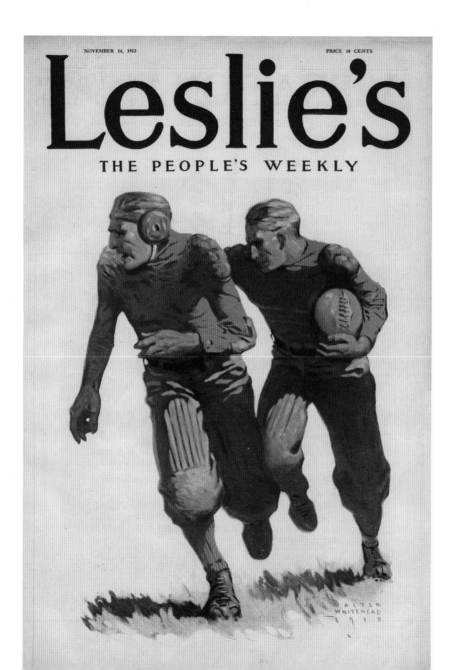

NOVEMBER 14, 1912　　　　　PRICE 10 CENTS

Leslie's

THE PEOPLE'S WEEKLY

PLATE 115. Walter Whitehead. Cover for *Leslie's*, November 14, 1912.

PLATE 116. Sidney H. Riesenberg. Cover for *Leslie's*, November 6, 1920.

PLATE 117. John A. Coughlin. Cover for *Leslie's Weekly*, October 29, 1921.

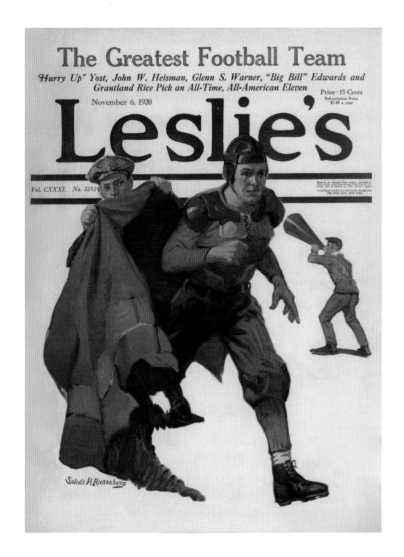

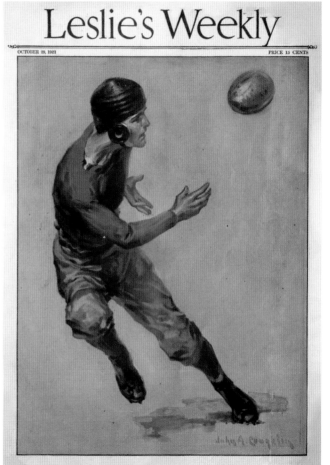

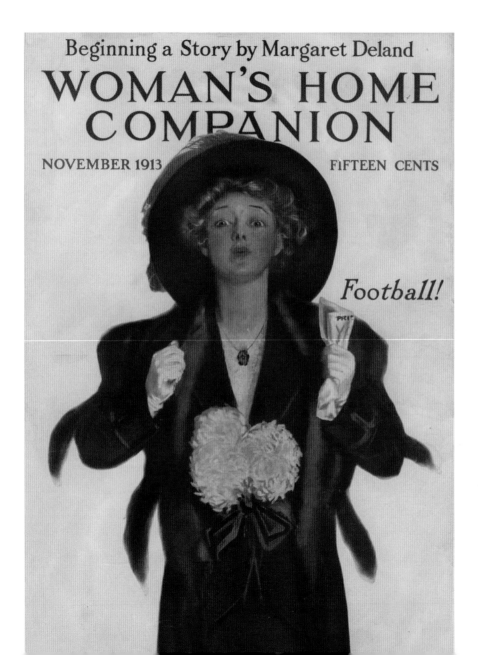

PLATE 118. Penryhn Stanlaws. Cover for *Woman's Home Companion*, November 1913.

PLATE 119. Norman Price. Cover for *St. Nicholas*, October 1915.

PLATE 120. W. W. Clarke. Cover for *American Boy*, October 1910. The first of nine covers by Clarke, including one every year but one (1912) from 1910 through 1917.

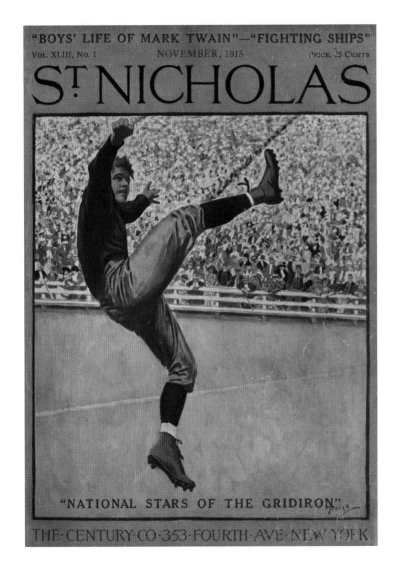

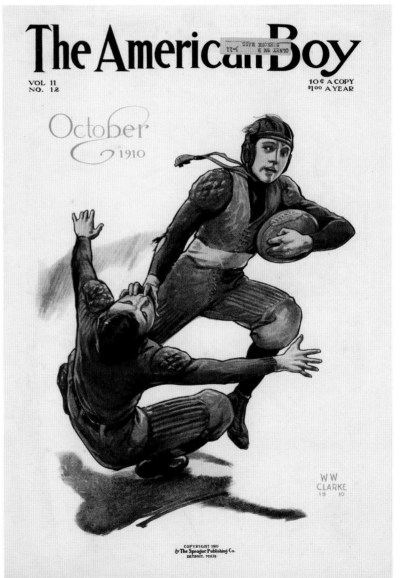

BOYS' LIFE
THE BOY SCOUTS
MAGAZINE

OCTOBER
1912

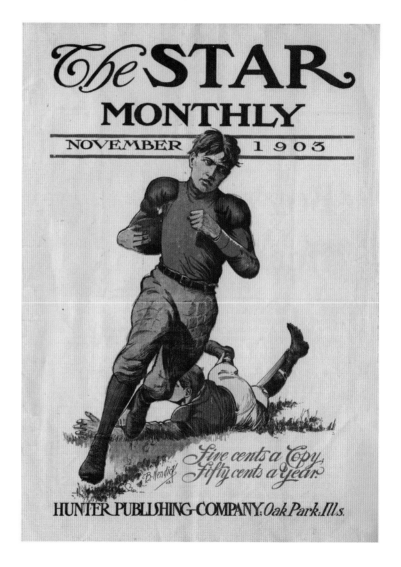

The STAR
MONTHLY
NOVEMBER 1903

Five cents a Copy.
Fifty cents a Year.

HUNTER PUBLISHING COMPANY. Oak Park. Ills.

PLATE 121. *Sweet.* Cover for *Boy's Life*, October 1912.

PLATE 122. B. Nendick. Cover for *Star Monthly*, November 1903.

PLATE 123. John Cassel. Cover for *The Boys' Magazine*, November 1910.

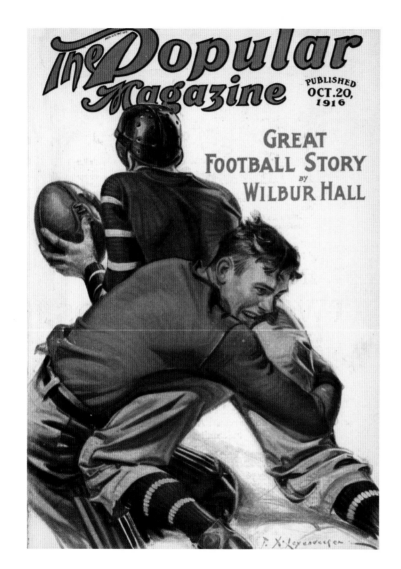

PLATE 124. Frank X. Leyendecker. Cover for *Popular Magazine*, October 20, 1916. Special Collections Research Center, Syracuse University Libraries.

PLATE 125. Hibberd V. B. Kline. Cover for *Popular Magazine*, November 15, 1910. Special Collections Research Center, Syracuse University Libraries.

PLATE 126. Hibberd V. B. Kline. Cover for *Popular Magazine*, November 1, 1911.

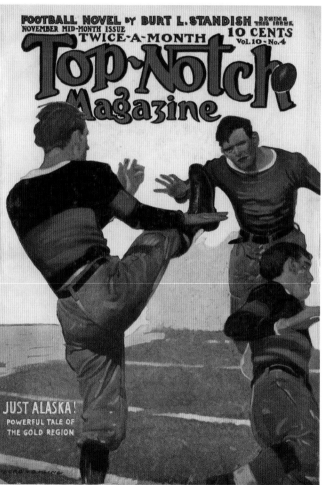

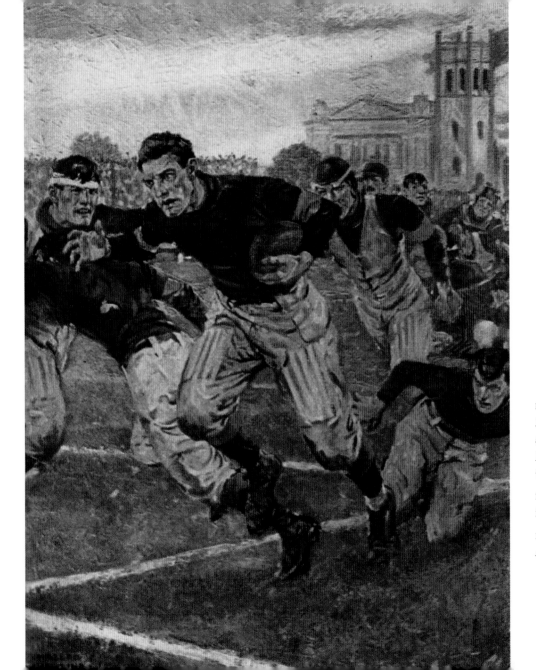

PLATE 127. Hibberd V. B. Kline. Cover for *Popular Magazine*, October 20, 1916. Kline also painted a fourth football cover for *Popular Magazine* (November 15, 1912), this one of a male cheerleader.

PLATE 128. Hibberd V. B. Kline. Cover for *Top-Notch*, November 15, 1912.

PLATE 129. Hibberd V. B. Kline. *Around the End. Outing*, May 1910.

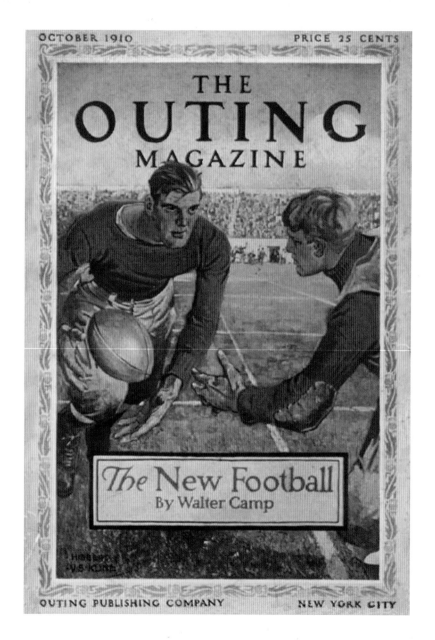

PLATE 130. Hibberd V. B. Kline. Cover for *Outing*, October 1910.

PLATE 131. G. C. Widney. *Football*, a supplement in the *Chicago Tribune*, November 25, 1900.

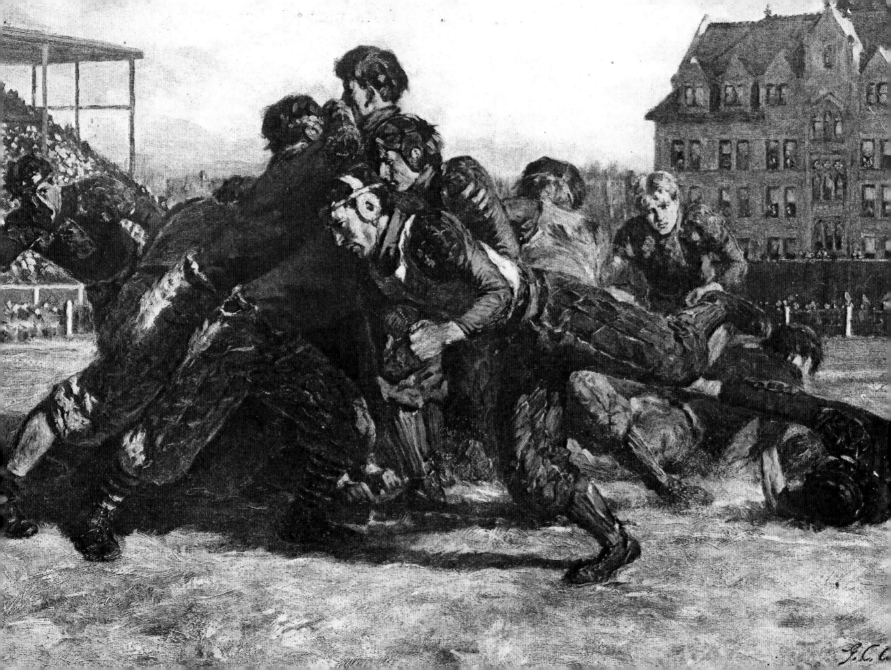

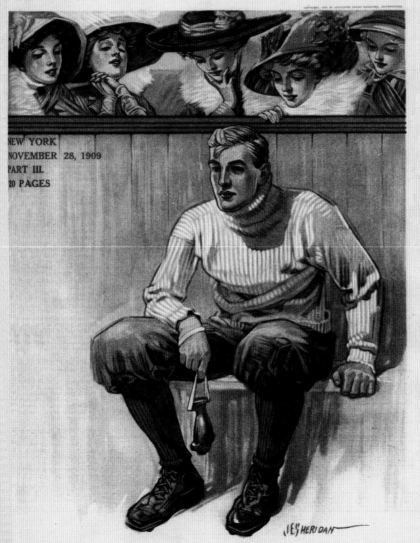

PLATE 132. John E. Sheridan. Cover for *New York Tribune*, November 28, 1909. Associated Sunday Magazines.

PLATE 133. J. V. McFall. Cover for *Rocky Mountain News and Denver Times*, November 15, 1908. Associated Sunday Magazines.

PLATE 134. Cover (signed but undecipherable) for *Rochester Democrat and Chronicle*, November 11, 1910. *Illustrated Sunday Magazine.*

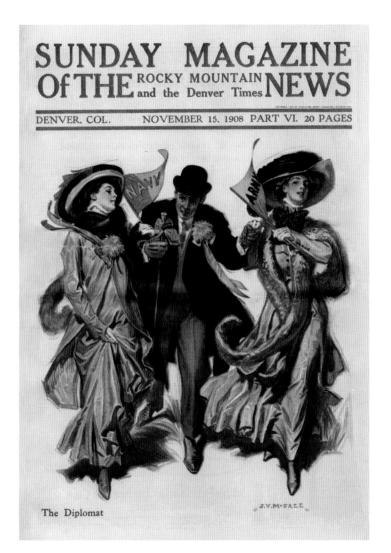

SUNDAY MAGAZINE
Of THE ROCKY MOUNTAIN and the Denver Times NEWS

DENVER, COL. NOVEMBER 15, 1908 PART VI. 20 PAGES

The Diplomat

J. V. McFALL

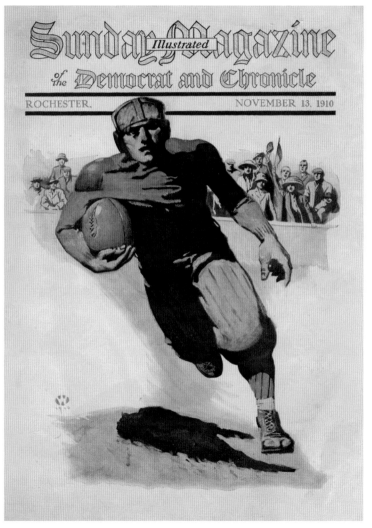

Sunday Illustrated Magazine
of the Democrat and Chronicle

ROCHESTER. NOVEMBER 13, 1910

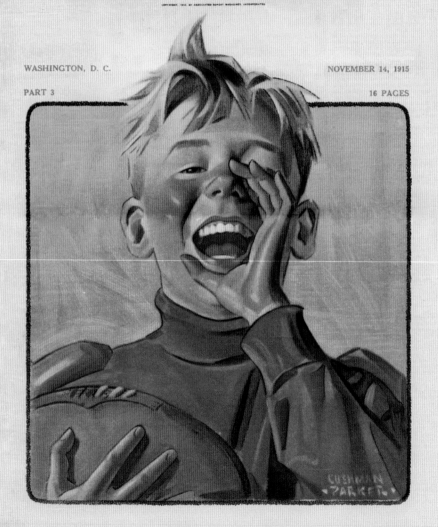

The Sunday Star
SUNDAY MAGAZINE

WASHINGTON, D. C.

PART 3

NOVEMBER 14, 1915

16 PAGES

A Thousand for Incidentals — *Holworthy Hall*

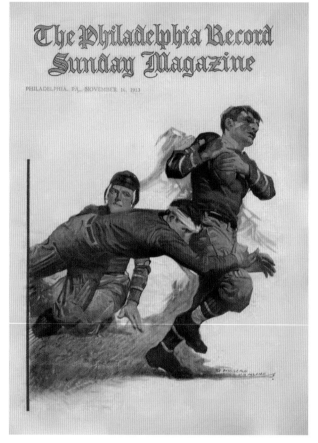

PLATE 135. Cushman Parker. Cover for *Washington Star*, November 14, 1915. Associated Sunday Magazines.

PLATE 136. Hibberd V. B. Kline. Cover for *Philadelphia Record*, November 16, 1913. *Illustrated Sunday Magazine*.

PLATE 137. Will Grefe. *The Goal*. Associated Sunday Magazines, November 19, 1905.

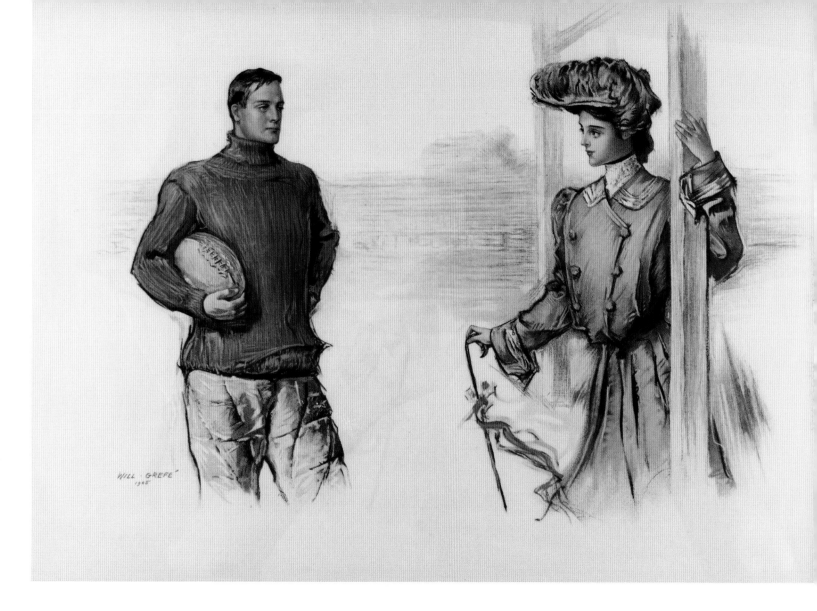

4

HOWARD GILES, GEORGE BELLOWS, AND THE ILLUSTRATED FOOTBALL STORY

IN NOVEMBER 1903 *Leslie's Monthly Magazine* published a six-page portfolio of paintings by Howard Giles titled "Our College Education." The six full-page halftones, apparently from watercolors, documented without text the course of a football game.[1] It begins with a portrait of the Harvard team captain and a few teammates in the background (plate 138), followed by *The Gladiators of 1903* from Yale coming onto the field (plate 139). After *The Opening Play* (plate 140), the first scoring attempt, a field goal, is *Missed!* (plate 141), but a successful running play leaves *Four Yards to Go* (plate 142). Finally comes a touchdown for *The Winning Points* (plate 143).

The entire series might have been mildly satiric—a football game constituted a college education?—but the indi-vidual illustrations convey no irony. The images also have non-ironic captions. With the gladiators from Yale comes the famous line from their Roman ancestors: "*Ave Alma Mater. Morituri te Salutant!*" (Hail, Alma Mater. We Who Are About to Die Salute You!) Given the absence of graphic violence in the images that follow, these handsome young collegians are metaphorical gladiators only, courageous rather than barbaric. *The Opening Play* illustrates the tech-nique of "'blocking' while the half-back catches the kick-off." The *Missed!* kick is "a goal try but too far to the right." *Four Yards to Go* illustrates one of the era's mass-momentum plays in which a pair of blockers lead the ball carrier into the line, "driving a tandem play through the tackle." Finally, *The Winning Points* are scored when the runner is "dragged over

the line for a touchdown" with a tackler clinging to his ankle but unable to stop him. This is a complete football story in five acts, told entirely through pictures: 1) dreams of glory, 2) engaging the adversary, 3) early setback, 4) determined comeback, 5) final triumph. That basic plot still plays out in most of the football movies made today.

Both technical skill and knowledge of the game are evident in these six paintings. The balanced composition of each, the rendering of foreground and background, and the details of football action are all quite effective. The tangle of bodies; the kicking, receiving, and blocking formations; even the final dragging of the runner across the line (a legal tactic) accurately represented football as it was played at the time. Giles's six illustrations look so natural—this is simply what football looked like in this era—that their artfulness can easily be missed. But someone had to figure out what to represent in a football game. Howard Giles was an early leader in working this out.

As American football developed over the 1880s and acquired increasing importance on college campuses and in the press, articles in magazines were often illustrated with simple line drawings. Improved technology and reduced costs of halftone reproduction launched a great age of magazine illustration in the 1890s.[2] Football fiction coincidentally began in the same decade, both in magazines for adults and in juvenile publications such as *St. Nicholas* (fig. 31) and *Harper's Young People*—including a story by Jesse Lynch Williams in the latter that was illustrated on the cover (plate 144). The major monthlies and weeklies were publishing illustrated football stories by the end of the decade. W. T. Smedley, the much-respected creator of numerous centerfolds for *Harper's Weekly* in the 1880s and early 1890s, illustrated a football story for *Harper's Monthly* in 1898 (fig. 32). That same year, Frederic Remington's illustration for *Collier's* (plate 32) accompanied a football story by Walter Camp. The *Saturday Evening Post's* first illustrated football story appeared a year later (fig. 33), and a story in *McClure's* in 1900 was illustrated by both Albert T. Reed (fig. 34) and Remington (whose two small line drawings—see fig. 6—added little more than Remington's celebrity-artist name). The illustrated football story was a recognizable subgenre of magazine fiction by the turn of the century.

The illustrated weeklies used small illustrations in these early years. (Remington's full page for *Collier's* was an exception, warranted by the artist's reputation, not Camp's story.) Full-page (usually 7 in. x 10 in.), more finely-detailed

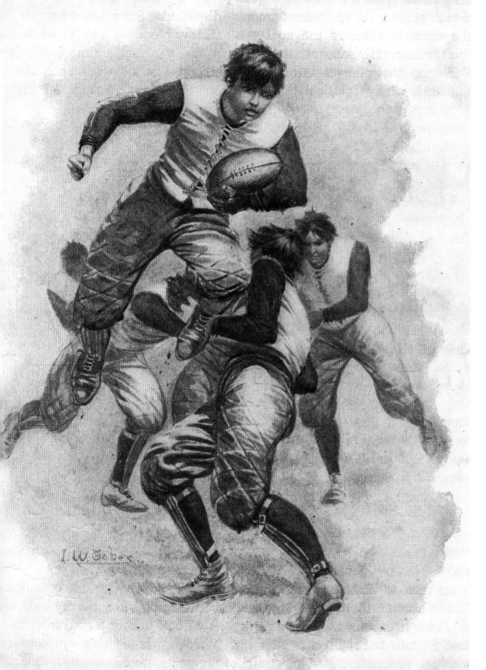

FIG. 31. I. W. Gaber. One of three illustrations for A. T. Dudley's "The Generous Game." *St. Nicholas*, November 1894.

FIG. 32. W. T. Smedley. Illustration for Jesse Lynch Williams's "The Girl and the Game." *Harper's Monthly*, December 1898.

FIG. 33. A. S. Keller. Illustration for Arthur Hobson Quinn's
"The Last Five Yards." *Saturday Evening Post*, October 28, 1899.

FIG. 34. Albert T. Reed. Illustration for Frederick Carrol
Baldy's "Confusion of Goods." *McClure's*, November 1900.

paintings were limited to the high-quality monthlies such as *Scribner's*, *Harper's*, and *The Century*. Typically an art editor would select the illustrator and send him the story three or four months in advance of publication (with less lead time for weekly magazines).[3] In choosing illustrators, art editors would be drawn to artists with proven expertise in the subject matter at hand, and Howard Giles emerged in the early 1900s as the illustrator-of-choice for football stories.

Born working-class in Newark in 1876, Giles pursued an early interest in drawing at the Art Students League in New York through the assistance of a family friend. His career as a commercial illustrator began around 1899 and was relatively brief, his most productive period ending around 1912 when he accepted the first of several teaching and lecturing positions at the New York School of Fine and Applied Art. (He eventually retired in 1934 as dean of fine arts at the Roerich Museum in New York.) But over the course of barely a decade in the early 1900s Giles produced a large and impressive body of football art. After breaking in with *Scribner's* and then the *Saturday Evening Post,* he sold his first football illustration to *Harper's Weekly* in November 1902 (plate 36).[4] Two full-page illustrations for a football story in *Leslie's Popular Monthly* in December (plate 145)

then led to the major commission for the paintings for "Our College Education" the following football season.

These nine full-page illustrations from 1902 and 1903 marked the beginning of a remarkable period for Giles as a football artist that also included:

three football poster covers for the *Illustrated Sporting News* in October and November 1903, followed by a fourth in October 1905 (plates 97 and 98);

a cover for *Leslie's Weekly* in October 1904 (plate 111);

six illustrations, two of them full-page, for a football story in *McClure's* in October 1904 (plate 146); along with three more (two small, one full-page) for another in *Leslie's Monthly* (plate 147);

one small and another full-page football illustration for a story in *Munsey's*, along with six small line drawings (two of them football-themed) for a story in *Everybody's*, in November 1905.

Following these four prolific years—five magazine covers and thirteen full-page plus nine smaller interior illustrations—Giles's pictorial cover for Walter Camp's

juvenile novel, *The Substitute* in 1908 (fig. 27), and four pen-and-ink drawings, one of them full page, for a football article in *Everybody's* in November 1911 (fig. 35) completed the largest body of football artwork produced by any artist. Giles also illustrated collegiate baseball and rowing stories, though not so frequently.[5] Later, while teaching in art schools, he achieved modest recognition for his watercolors and pastels.[6] All of this work has been forgotten, but Howard Giles's football illustrations deserve recognition as a major contribution to the emerging conventions of football art.

Giles's more fully-developed, full-page illustrations of football action appear to be consistently guided by a desire to capture the sport's fierce struggles but within formal balance and symmetry. Among the four action scenes from "Our College Education," in the last, *The Winning Points* (plate 143), the expressions on the players' faces come closest to upsetting the picture's formal balance. In *89–2–5* (plate 145), the quarterback's frantic look leaps out from the

FIG. 35. Howard Giles. Full-page illustration for James Hopper's "The Last Grind Before the Big Game." *Everybody's,* November 1911.

center of the image. The scene from "The Passing of the Vet" (plate 146) is the most crowded of these four illustrations, with figures threatening to burst through the frame. In each case the distribution of helmets, noseguards, and bandaged heads across the frame has the effect of both balancing the image and conveying the game's dangers.

The frontispiece for "The Lady and the Football" (plate 147) was unusual for Giles for its portrait rather than landscape orientation but also for its emphasis on facial expressions: the burning eyes of four players cupping the upright ball carrier with his strangely sorrowful look. The illustration for "The Knocker" (plate 148) was also unusual, but even here the intrusion of a dog on the football field (in a noncomic story) does not offset the seriousness of the flying and colliding bodies. Giles presented the violence of football most emphatically in his 1904 cover for *Leslie's Weekly* (plate 111), where he abandoned his usual wide angle for a tight focus on the ball carrier hurdling blockers and tacklers—the apex of action viewed from head-on. The single nose protector appears particularly vulpine here; the runner's cleated shoe looks like a weapon; his clenched fists and all of the players' fierce emotions register vividly in closeup. A common element that runs through all of these images is so obvious it might not seem notable: all of them clearly illustrate tales of physical challenge and determined effort. Football is yet again a test of physical and mental courage, not a mere game.

The typical magazine story had two or three illustrations, perhaps one or two small ones to establish characters, setting, and tone, along with a larger and more dramatic one that gave a glimpse of the climactic moment.[7] In the 1900s and 1910s artists rather than art editors usually determined what in the story to illustrate.[8] Formal portraits of the hero (such as those by John Sheridan [fig. 23]) were common early on but largely disappeared once they became so conventional that readers needed no visual reminder. The considerably more interesting climactic scenes of football action became somewhat stereotypical as well, but what they stereotyped is noteworthy, particularly the desperate struggle to score the winning touchdown in the closing seconds (plates 149 and 150). It was not the victory but the struggle, and sometimes the high cost, that distinguished football from other sports.

Over the winter of 1909–1910 *The Century* published seven full-page football illustrations for a series of articles by Walter Camp, five by Frank Leyendecker and two by N. C.

Wyeth, the future acclaimed illustrator of literary classics. Four of Leyendecker's drawings for the November 1909 and January 1910 issues (plates 151–154) portrayed football action; the fifth showed spectators in the stands. All are executed in the sharp-edged, angular style characteristic of the art of his more famous brother, Joseph (who did the cover for the November issue [plate 105]) rather than of Frank's own typically rounder lines. Wyeth's paintings for the February 1910 issue, a departure from his usual western subjects, offered a coach exhorting his players in the locker room and the winning captain carried triumphantly from the field (plates 155 and 156).[9] To varying degrees all of these images conveyed the same sense of intense combat that marked the artwork for football fiction—as did Wyeth's own first commission for book illustration, in 1904. *Boys of St. Timothy's*, the first of what became a series of school sports books by Arthur Stanwood Pier, included a color frontispiece by Wyeth (plate 157), along with Wyeth's illustrations of baseball, hockey, and tennis. At least one later edition in 1907 added a second full-page football illustration: a distraught mother telling her son on the field that he can no longer play the dangerous game. That one may have resonated with the artist as more than paid work. Wyeth's own mother had worried about her sons playing "the awful game" for their village team in the early 1900s.[10]

THE FOOTBALL ART OF GEORGE BELLOWS

In the 1910s a new football artist entered the field. George Bellows was already one of the most celebrated artists of the day, the youngest member of the so-called Ashcan School and creator of three stunning (and controversial) boxing paintings: *Club Fight* in 1907 and *Stag at Sharkey's* and *Both Members of This Club* in 1909. Bellows was himself an athlete—a star college baseball player at Ohio State and then a slick-fielding but weak-hitting semi-pro in New York during the time he was establishing himself as an artist. He also was personally drawn to sporting subjects in part for their affirmation of his masculinity as an "artist."[11] His undergraduate paintings of campus figures at Ohio State included a Gibson Girl–like cheerleader and a pair of football players possibly influenced by Howard Giles or John Sheridan (fig. 36). After his move to New York, a poster-style *Football Hero* (1905), which apparently was never exhibited or published, seems indebted to Penfield's 1901 *Collier's* cover.[12] In New York, as Bellows turned primarily

to easel painting, his interest in the labor and particularly the leisure of the immigrant working classes drew him to seedy boxing clubs rather than to, say, baseball or football fields, and he followed his great boxing canvases with large paintings of polo and tennis at the opposite extreme of the social spectrum.[13] Bellows's relative neglect of football and particularly baseball, the two most popular spectator sports of the day, is somewhat surprising.

One possible explanation is the distance of the spectators from the action in the football or baseball stadium. As is particularly evident in his boxing paintings, but also those of polo and tennis, Bellows's interest in spectator sports was at least as much in the spectator as in the sport. Boxing was the ideal subject for this, with its spectators crowding the small squared ring and nearly breaking through the ropes. Add the concentrated action—two boxers in a small space rather than baseball players scattered about a field or two dozen football players in a tangle—and the purely formal advantages of boxing seem obvious. With baseball or football, Bellows would have had to choose between sport or spectators, one or the other.[14]

But he did not neglect football altogether. In 1910, when Bellows produced his oil paintings of polo at Lakewood,

FIG. 36. George Bellows. Untitled. 26 in. x 17 in. Watercolor, with graphite and gouache. Painted while a student at Ohio State, 1903–1904. Courtesy of the Theta Delta Chapter of Beta Theta Pi Alumni Association and the Bellows Trust.

he also painted two pastels with sports themes: *Polo Game* (likely the source of one of the oil paintings) and *Football Game.* Both of these appeared in a January 1911 exhibition of "The Pastellists" at the Folsom Gallery in New York. The *New York Times* described Bellows's two paintings as "shortened notes of violent motion."[15] A reviewer in *Art and Progress* applauded them as "extraordinary examples of action in art . . . full of strength and power . . . as well as movement."[16] A year later, when Bellows began accepting commissions from popular magazines to supplement his income, these included a page of small football drawings for *The Delineator* and a handful of more fully developed ones for a football article in *Everybody's.*[17] Two more illustrations for a football story in *Everybody's* in 1918 completed Bellows's small—but remarkable—body of football art.

Following Bellows's untimely death in 1925, the *Football Game* of 1910 disappeared into private collections and was never reproduced. In 1966 a Bellows exhibition at the Gallery of Modern Art in New York included a 14⅜ in. x 23 in. pastel titled *Football*, which was lent by a major collector (but not reproduced in the catalog). It might be surmised that this is the *Football Game* of 1910. The pastel exhibited in 1966 then disappeared from the public record until its

showing in May 2016 in an exhibition of Bellows's sports paintings and drawings at the Cleveland Museum of Art, on loan from its current owner.[18] (This is the work included here as plate 158).

It is a strikingly original painting, with no apparent influence from the published football posters and illustrations of the era. Both realistic and abstract, it has ten identifiable figures, most of them faceless but three with visible expressions. The one just above the midpoint of the frame is the most fully realized and seems to be emitting a cry of anguish. Just above it, splashed with white paint, is what looks like a disembodied skeleton head, a startlingly macabre touch. To the left are the nose, mouth, and chin of a grimly determined tackler. The tackler and the ball carrier are launched toward a fierce collision, while the many faceless figures simply add momentum or fall by the wayside. The perspective is so close that the viewer feels almost part of the action, and the conventionally muted pastel colors are instead dark and bold, with their typically soft lines sharpened by smears of black. The overall effect is violent and explosive.

Bellows's drawings for *The Delineator* and particularly for *Everybody's* were quite different but produced similar effects. For *The Delineator*, the women's fashion magazine

once edited by Theodore Dreiser, he drew a page of caricatures (plate 159) which can be set alongside Kemble's football montage for *Life* in 1884 (plate 42), Remington's for *Harper's Weekly* in 1893 (plate 30), and Penfield's for *Collier's* in 1906 (plate 87). What emerges is not the evolution of a pictorial genre but snapshots of four artists' highly distinctive styles. Bellows's figures are simple sketches except for the banner drawings of fans and opposing teams at the top and bottom of the page. *The Delineator*'s interest was surely in Bellows—"the youngest member in the new school of American painters"—rather than in football. Following an ironic subtitle ("The Absorbing Chase of the Pigskin Through Our Halls of Learning"), the brief text declared football to be "a brutal game, and we all know it," and then went on to comment on the various figures. "The pretty girls on the bleachers with their fluttering banners and glowing chrysanthemums" could not make up for "our sons, bruised and bleeding, led from the field." As for the artist: "Mr. Bellows loves football as he loves every game of skill and strength and brute force—his drawings show that. But he is not deceived by the 'glory' of the field. He shows it to us as he sees it—brutal, forceful, requiring physical courage of the highest type, exciting the lowest kind of animosities."

Bellows's simple cartoonish figures don't quite justify this editorial judgment, which in fact more accurately describes his three mixed-media illustrations for a football article a month later in *Everybody's* (plates 160–162). Bellows's not-quite-faceless figures registering raw emotion rather than familiar humanity belong with his boxing paintings and lithographs in what Bellows scholar Charles Brock has called his "sustained meditation on human violence."[19] However typical for Bellows, the images brought something altogether new to football illustration. Readers of an article celebrating football heroes and heroics of the past must have been startled to see not the recognizable faces of John DeWitt of Princeton, Harold Weekes of Columbia, and Oliver Cutts of Harvard, but rather some anonymous caricatures assigned those names. The facial expressions of Weekes and Cutts (plates 161 and 162) are little more than blanks; DeWitt's (plate 160) conveys something beyond struggle or desperation, closer to the existential terror of Edvard Munch's *The Scream* than to the strain of a football game. Subordinate players are just masses of tangled bodies in carefully composed geometric piles, some with brutal slashes for facial features like those on the men at ringside in Bellows's great boxing paintings. According

to art historian Robert Conway, "Bellows's strength as a commercial illustrator was caricature." The people in his drawings were "simplified, mildly exaggerated, caricatures" in "complicated arrangements" that expressed "emotional validity" rather than visual realism.[20] The drawings for *Everybody's* sacrificed individual specificity for a more powerful generalized sense of football as a struggle of opposing brute forces and anonymous personal sacrifice. Bellows's fourth football drawing from 1912 (plate 163), never published but now held in the Smithsonian's Hirshhorn Museum, is in the same style. Like the 1910 pastel, its generic title, *The Football Game*, makes explicit what the drawings for *Everybody's* suggest: that Bellows was not illustrating specific scenes or individual athletic feats but exploring the essential nature of this American sport. Artist and subject were perfectly matched here. Bellows's already well-worked-out style was the ultimate contribution to football's developing aesthetic of excess.

Bellows's modernist, nonrepresentational drawings were unprecedented among football illustrations in popular magazines. Like Howard Giles, Bellows created tension between formal symmetry and football's extreme nature, but his football drawings sharply tipped the balance toward extremity.

Their radical break from convention in a popular magazine was surely made possible not by any editorial interest in edgier football art but by Bellows's stature in the art world. They nonetheless seem to have changed more conventional football illustration, or pushed it more explicitly along a path that it had been following.

Whether other artists were influenced by Bellows or simply continued striving for novelty within the prevailing conventions, football illustrations after 1912 were sometimes subtly and sometimes dramatically different from earlier ones.[21] Illustrations by Sidney H. Riesenberg, Hibberd V. B. Kline, and Hawthorne Howland, for example, tended more toward distortion and exaggeration than those of Howard Giles and others earlier in the century. They recall the wood engravings of the 1880s but their distortions were now fully intentional, for effect. The expression on a Riesenberg runner in 1916 (plate 164) evokes not just extreme effort—like the Kinneys' 1903 illustration for *Harper's Weekly* (plate 37)—but something closer to terror, as if at the prospect of being dragged by demons into hell, not merely tackled short of the goal line. The lone black player in Kline's illustration in 1918 (a striking anomaly itself) looks more like a martyr at the stake than an athlete in competition (fig. 37).

(Kline's football covers after 1912 also became more expressionistic, à la Bellows.) Howland's more realistic image for an article in *Scribner's* (plate 165) confirms, by contrast, his conscious decision to distort the figures when illustrating the melodramatic plots of football fiction (plates 166 and 167).[22] Like Penfield, Leyendecker, and Kline, Howland was another artist whose nonfootball illustrations were more conventional and less expressionistic.

Everybody's commissioned a second group of football illustrations from Bellows for a story in November 1918: a drawing of the training room at halftime and another of two opposing masses composed in a symmetrical pyramid (plates 168 and 169). Symmetry trumps intensity in the scene of football action, or, rather, intensity emerges not from specific faces but from the symmetry of the two masses of nearly faceless players grimly straining against each other. The pyramidal arrangement calls to mind the two boxers straining against each other in Bellows's *Both Members of This Club*. It also belonged to football art, as seen in G. C. Widney's painting for the *Chicago Tribune* in 1900 (plate 131) and Howland's illustration for a 1916 story (plate 166). It became another convention, adopted by numerous future artists as a way to find visual order within the brute

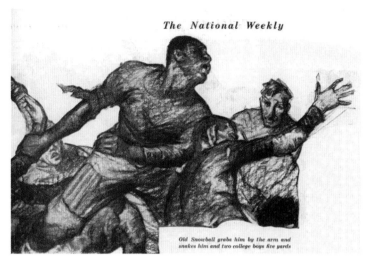

The National Weekly

Old Snowball grabs him by the arm and snakes him and two college boys five yards

FIG. 37. Hibberd V. B. Kline. Detail from illustration for Guy W. Norton's "A Gentleman's Game." *Collier's*, November 16, 1918. Double-page illustration above the story's title.

force and massed bodies in a football game. This was football as violent pastoral.

As magazines began using larger illustrations in the late 1910s, which in itself made them more dramatic, the most interesting ones continued the trend toward exaggeration and distortion (plates 170 and 171). Over the entire period under discussion, illustrators consistently portrayed football

as fierce struggle. But the degrees of fierceness and struggle increased, and Bellows's illustrations for *Everybody's* in 1912 seem to mark a shift. After 1912, when a final round of significant rule changes seemed likely to solve the problem of excessive violence, college football was relatively free from major controversy until 1925, when Red Grange shocked the football world by turning professional. But "excess" must be continually ratcheted up in order to seem excessive. (This perennial challenge to football artists also points to the dilemma facing everyone today in trying to make football safer while still being football.) For football illustrations to carry the same punch, they had to keep pushing against the boundaries of convention. Bellows's use of caricature to capture the sport's "emotional validity" offered another way to do this.

FOOTBALL AS CRUSADE AND DARWINIAN STRUGGLE

The illustrator of magazine fiction, as one scholar has put it, "served not one but three masters—himself as an artist, the text, and his publisher, whose business was to reflect the public wants—and so it behooved him to have a style flexible enough to fit the texts he was given."[23] Bellows had the stature to dictate his own style. Other illustrators of football stories had to be more responsive to the texts at hand, and the texts they illustrated were often governed by their own aesthetic of excess.

The name James Hopper appears often in the captions to the artwork discussed in this chapter (plates 146, 150, 166, 168–69, and fig. 23). With his eleven football stories in popular magazines between 1904 and 1918 (seven in the *Saturday Evening Post*, including a three-part serial later published as a novel), plus at least seven more into the 1930s, it is only a slight exaggeration to say that Hopper invented the football story in popular magazines.[24] From 1904 through 1916 the *Post* published just two college football stories *not* written by Hopper (excluding George Fitch's comic tales of old Siwash).

Hopper was a star quarterback at the University of California from 1894 to 1898, and after graduation the occasional head coach at Cal and Nevada State (later the University of Nevada) while launching his writing career. (He was coaching at Cal in 1904 when his first three football stories appeared in national magazines.) Hopper was also a friend and admirer of Jack London, whom he first met as a college student. Whether his insider's knowledge of football or the

influence of London's Darwinian worldview—or both—most informed his fiction, Hopper wrote story after story with heroes who must fight tooth-and-claw in a football world ruled by the cunning and the strong.

The illustrations of Hopper's stories barely approximated his overwrought plots and prose. In "The Passing of the Vet," illustrated by Howard Giles (plate 146), Kelley, the team captain, enters the big game with a badly damaged leg, which the opposing linemen, like "a pack of wolves," target on every play. For a time Kelley fools them into attacking his good leg by having the trainer tape it (one of the scenes illustrated by Giles), but that ruse doesn't last. He also retaliates by gouging their faces with thumb guards, but to no effect, as "still they charged and charged with undiminishing fury." Beaten down but unyielding, Kelley cries out at one point, "You can't kill me, you can't kill me, you can't, you can't, you can't!" Finally, exhausted and desperate, Kelley makes the ultimate sacrifice—a bit of trickery at the expense of his sporting honor to get the ball back for his team—and then replaces himself with an eager freshman (also illustrated by Giles). The youngster goes on to win the game for his alma mater, while Kelley sits on the sidelines, ignored and forgotten (Giles again).

These are nineteen- and twenty-year-olds playing a sport sponsored by universities, but the plots and prose are out of gothic thrillers.

Hopper's stories in the 1910s were presented as contemporary, but they were always governed by the rules under which he played at Cal in the 1890s when a first down was five yards in three downs, and "strategy" was one line smash after another. To make football safer, universities legalized the forward pass in 1906, but James Hopper didn't. He never quite accepted what the narrator of one of his humorous football stories in 1917 calls "the quarter-back-running, forward-passing, piebald, effeminate, and illegitimate frivolity which is now played under the name of the grand old game."[25] Almost thirty years later he hadn't changed his mind. In 1945, a nearly seventy-year-old Hopper wrote a piece for the *Saturday Evening Post* titled "We Really Played Football in the Gay Nineties," in which he recalled the old-time game of "hammer, hammer, hammer," a game without trick plays or delays for incomplete passes, so unlike the gentler modern sport.[26]

In Hopper's basic morality play the hero is crushed and then rises to transcendent glory or inner peace by overcoming not just the brutal assaults of opponents but also some

sickness in his own spirit. In "The Redemption of Fullback Jones" (plate 150), "Ram-em-to-ell" Jones loses his position on the varsity team after going "inert and limp" (attention, Freud!) when he hits an unmoving wall of defenders who felt "like something hard, sickeningly hard, which hurt not only the body . . . but also the soul." Jones redeems himself in practice on the scrub team, sobbing with fierce determination while the coach rages as he throws his body into the varsity line again and again, to earn his chance to win the big game. In "The Long Try" (plate 166), Carr the star back sees his hope-filled senior season derailed by a reckless freshman who dislocates his shoulder in what was supposed to be a light practice, but after weeks of self-pity and isolation he sacrifices his shoulder for the sake of victory. "The Pony Trio," with its jocular tone, at first seems different but is more of the same. The coach, who is too much "scientist" and not enough "football man," puts his huge linemen in the varsity backfield and his lightweight backs on the scrub. But the three "pony backs" hold secret practices so that they are ready when called on to rescue the varsity in the big game. This is the scene illustrated by Bellows: the three 140-pounders becoming "one long iron-spined animal with six legs" (plate 169) that "sank into the

line like a rapier, and when it came out on the other side, it was still one, still strong on its six legs, and dragging tacklers along for several yards."

Titles like "The Redemption of Fullback Jones" and those of several other Hopper stories—"The Strength of the Weak," "The Idealist," "He Could Take It"—made explicit the hero's existential challenge, beyond mere physical battering. Football in Hopper's stories was a rite of initiation and a test of manhood—secular versions of baptism, wandering in the desert, and ultimate salvation. "The Idealist" (1905) and "The Freshman" (a 1911 three-part serial in the *Saturday Evening Post* published as a novel the next year) came right out of Greek myth and Fraser's *The Golden Bough*. In "The Idealist," the hero is a "knight" who undergoes a stern trial to defeat "the Avenging Red Whirl" (fig. 38). In "The Freshman" (fig. 39) the novice hero and his teammates depart for their first game like knights of old, "men marked with a consecration." In their isolation they seem to be "in a tunnel below the earth, out of which they could emerge into the sunlight and among their fellows again only after a struggle, arduous, long and painful." Football as rebirth from the Underworld. In the final moments before the game our freshman feels "a convulsive desire

at once to weep and kill; to kill, and, killing, sob on the piercing beauty of things." Football as mystical experience.

The theme of redemption belonged to sports stories generally; untried newcomers, lowly substitutes, disgraced stars, and washed-up veterans win most of the big games in popular fiction.[27] What made football different was the violent context in which this plot played out. The football substitute did not just star in the big game nor did the disgraced hero merely overcome his early blunder. He did it against fierce and brutal opponents who tested his "manliness," both physically and spiritually. Other writers, whether influenced by Hopper or following their own instincts, handled football in similar ways. The freshman fullback in Ralph D. Paine's 1908 story for *Red Book* (plate 149) is not just trying to make the team but is "working out his own salvation along with that of his comrades." In Guy Norton's "The Crisscross" (plate 164), an apparent prima donna proves he's the "gamest" of them all as he scores the winning touchdown despite a fearful pounding. In Octavus Roy Cohen's "Fair Play," football's Darwinian struggle is

FIG. 38. George Brehm. Illustration for James Hopper's "The Idealist." *Saturday Evening Post*, October 14, 1905.

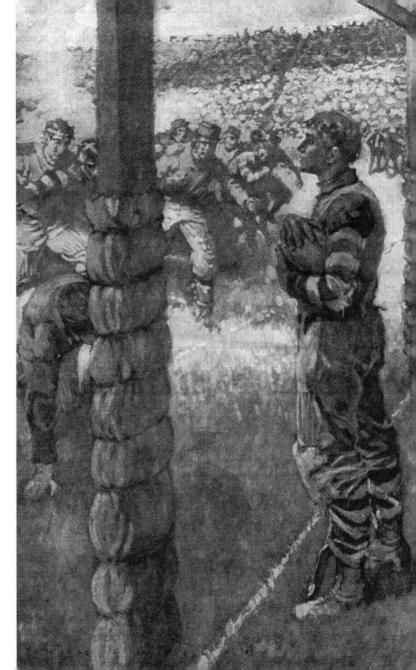

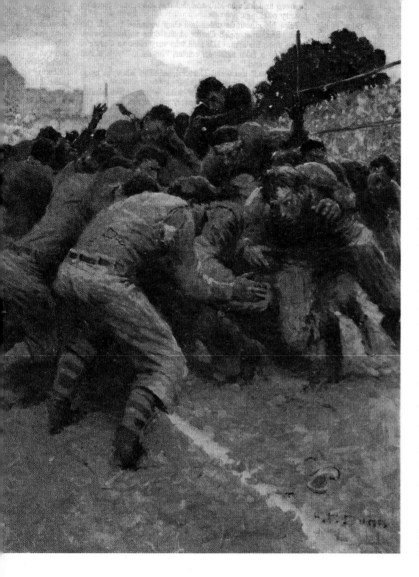

tempered, and justified, by redemptive sportsmanship. In the scene illustrated by Hawthorne Howland (plate 166), the hero has broken the jaw of an opponent who was illegally holding him, but he admits his foul to the referee and is disqualified from the game. In William Almon Wolff's "Time Enough, Damn You!" (plate 170), the hero erases a lifetime of shame from early bullying when he scores the winning touchdown by flinging himself suicidally into the arms of his gargantuan nemesis. In Wolff's "Right About Face" (plate 171), the cynical hero learns camaraderie and school spirit through fighting desperately alongside his teammates in a losing cause, as their fellow students roar support from the stands.

Whatever the artists' own stylistic preferences, such "texts" required illustrations that pushed beyond conventional realism. The recurrence of such stories suggests that the "wants of the public" invited illustrations that rendered football as more than a game. But football illustrators (and writers) also had a fourth "master": the game itself. Baseball was already the "national pastime." Football had a different

FIG. 39. Harvey T. Dunn. Illustration for James Hopper's "The Freshman." *Saturday Evening Post*, September 30, 1911.

role as the country's greatest sporting spectacle, but also, as Hopper put it bluntly in a 1909 story, as preparation for "the bigger game of Life."[28] Baseball was played by boys and men in every town in the country, and at the highest levels by skilled but barely educated professionals—grown men playing what was essentially a boys' game, for a paycheck. Football was played by schoolboys and college youths for alma mater and glory. Baseball was orderly, leisurely, and individualistic, requiring subtle skills. Football was chaotic and spectacular, requiring raw speed, brute force, and a cool head in the midst of chaos. Above all, while baseball was pastoral, football was violent, with a thin line separating necessary from unnecessary violence. From the wood engravers for *Harper's Weekly* to the cartoonists for *Puck, Life*, and *Judge*, to Edward Penfield, J. C. Leyendecker, and other cover artists, to Howard Giles, George Bellows, and other magazine illustrators, football continually challenged artists to find new ways not just to illustrate it but to illuminate it. They needed excessive styles to capture the sport's elemental excesses. The most uncanny of their illustrations seem balanced on a knife's-edge between horror and exultation, between football's most appalling dark side and its deepest appeal.

The persistence of an aesthetic of excess can be found in some of the most distinctive literary and visual football art down to our own day—say, the novels of Don DeLillo (*End Zone*) and Peter Gent (*North Dallas Forty*) or the prints and paintings of former pro linemen Ernie Barnes and Ed White (plate 172)[29]—and also in the stunning visual style of NFL Films, in the amped-up productions of *Sunday Night* and *Monday Night Football*, and even in the daily highlights on ESPN's *SportsCenter*. A sense that football's excesses demand a commensurate art was the collective discovery of illustrators and cartoonists during football's formative decades, and it became their chief legacy, both to future artists and to the broader culture of football.

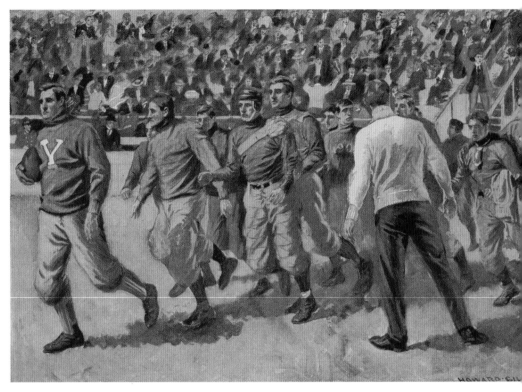

PLATE 138. Howard Giles. *Our College Education. Leslie's Monthly Magazine,* November 1903.

PLATE 139. Howard Giles. Title page for "Our College Education," *The Gladiators of 1903. Leslie's Monthly Magazine,* November 1903.

PLATE 140. Howard Giles. *The Opening Play. Leslie's Monthly Magazine,* November 1903.

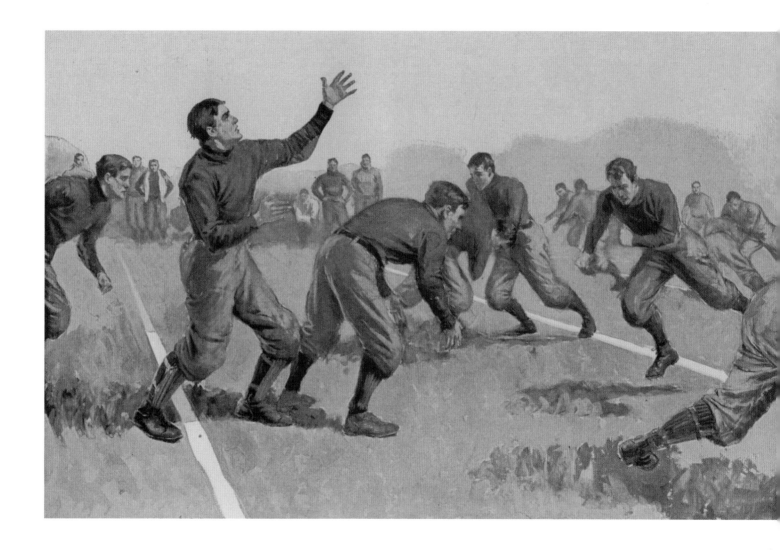

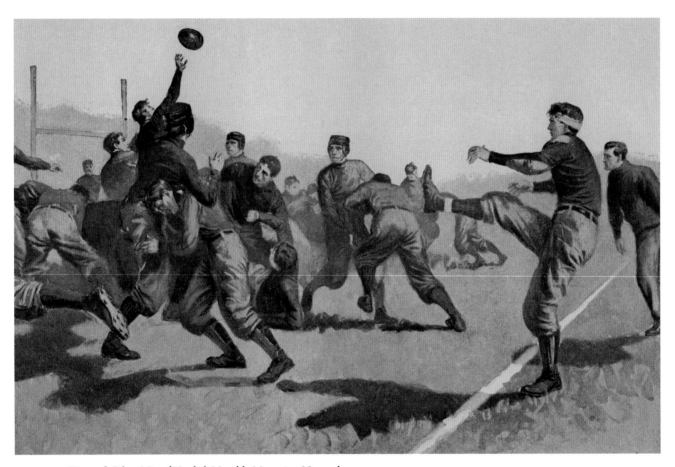

PLATE 141. Howard Giles. *Missed! Leslie's Monthly Magazine*, November 1903.

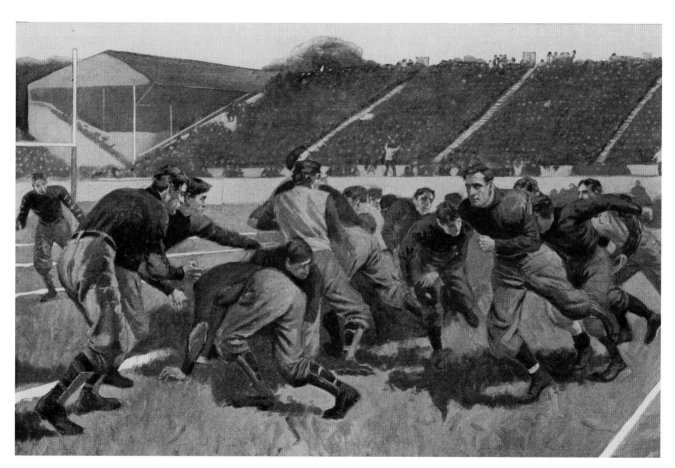

PLATE 142. Howard Giles. *Four Yards to Go. Leslie's Monthly Magazine,* November 1903.

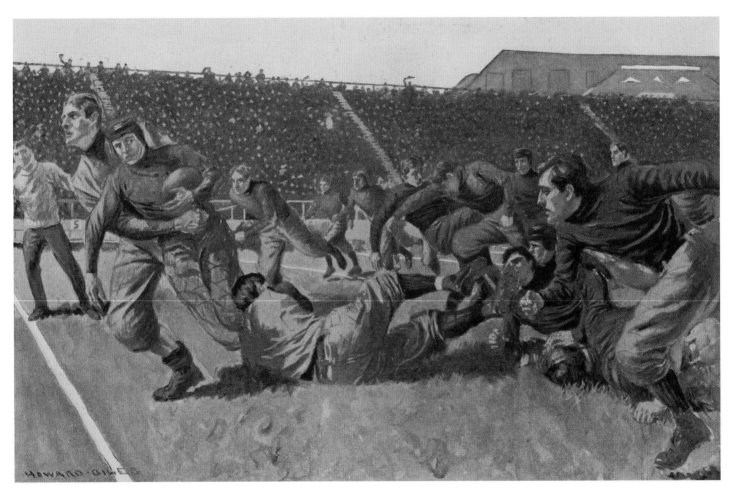

PLATE 143. Howard Giles. *The Winning Points. Leslie's Monthly Magazine,* November 1903.

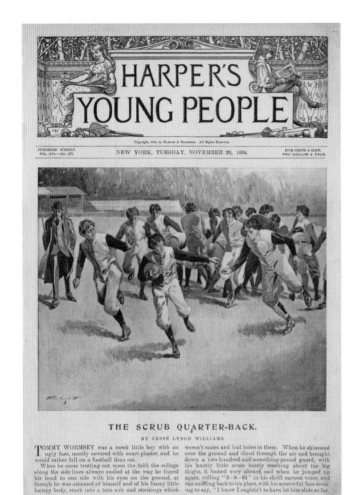

HARPER'S YOUNG PEOPLE

PUBLISHED WEEKLY.
VOL. XVI.—NO. 795.

Copyright, 1894, by Harper & Brothers. All Rights Reserved.

NEW YORK, TUESDAY, NOVEMBER 20, 1894.

FIVE CENTS A COPY.
TWO DOLLARS A YEAR.

THE SCRUB QUARTER-BACK.

BY JESSE LYNCH WILLIAMS.

TOMMY WORMSEY was a meek little boy with an ugly face, mostly covered with court-plaster, and he would rather fall on a football than eat.

When he came trotting out upon the field, the college along the side-lines always smiled at the way he tipped his head to one side with his eyes on the ground, as though he was ashamed of himself and of his funny little bumpy body, stuck into a torn suit and stockings which weren't mates and had holes in them. When he skimmed over the ground and dived through the air and brought down a two-hundred-and-something-pound guard, with his knotty little arms barely reaching about the big thighs, it looked very absurd, and when he jumped up again, yelling "3–9–64" in his shrill earnest voice, and ran sniffling back to his place, with his sorrowful face seeming to say, "I know I oughtn't to have let him slide so far.

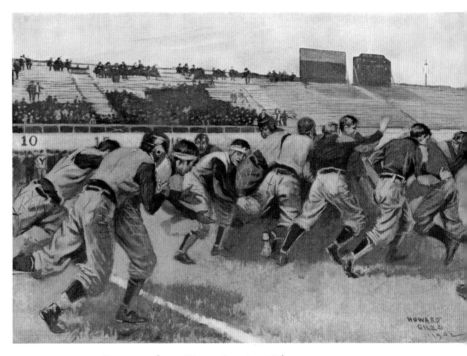

PLATE 144. Cover illustration (signed but indecipherable) for "The Scrub Quarterback" by Jesse Lynch Williams. *Harper's Young People,* November 20, 1894.

PLATE 145. Howard Giles. One of two full-page illustrations for Edwin Oviatt's "89–2–5." *Leslie's Popular Monthly,* December 1902. The other is a standing portrait of the hero.

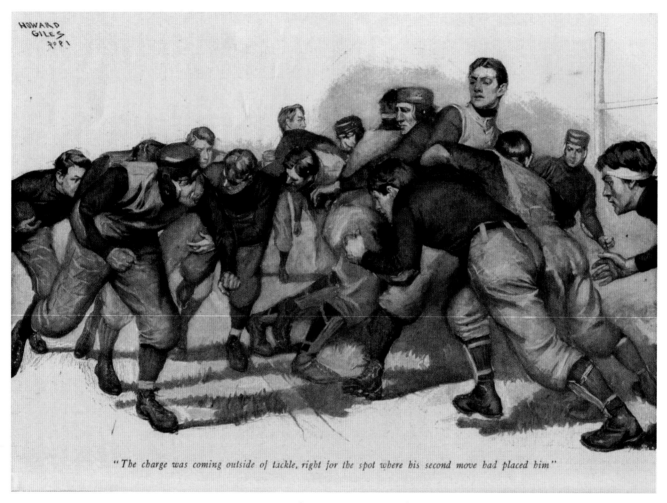

"*The charge was coming outside of tackle, right for the spot where his second move had placed him*"

PLATE 146. Howard Giles. One of two full-page illustrations (with four smaller ones) for James Hopper's "The Passing of the Vet." *McClure's*, November 1904.

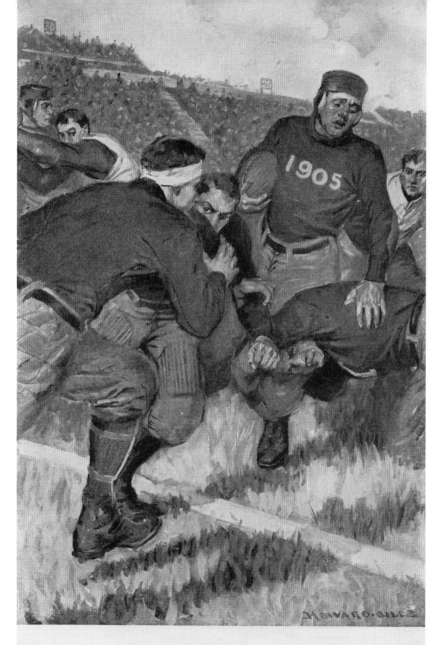

With a dive Billy Parker broke through.

PLATE 147. Howard Giles. Full-page frontispiece (with two smaller illustrations) for Edwin Oviatt's "The Lady and the Football." *Leslie's Popular Monthly*, November 1904.

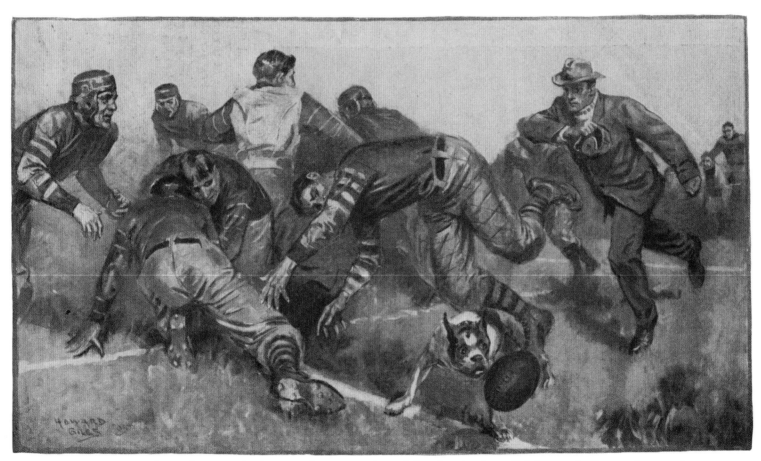

PLATE 148. Howard Giles. Full-page illustration (with one smaller one on title page) for Edward Boltwood's "The Knocker." *Munsey's*, November 1905.

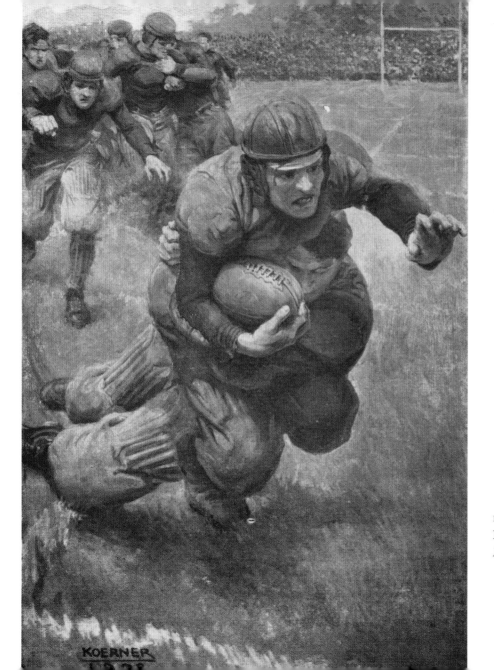

PLATE 149. W. H. D. Koerner. Illustration for Ralph D. Paine's "The Freshman Full-Back." *Red Book*, November 1908.

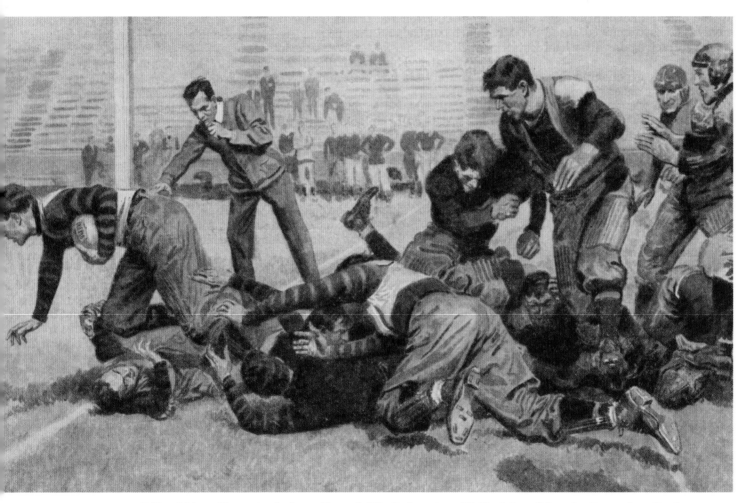

PLATE 150. F. Vaux Wilson. Illustration for James Hopper's "The Redemption of Fullback Jones." *Saturday Evening Post,* October 26, 1912.

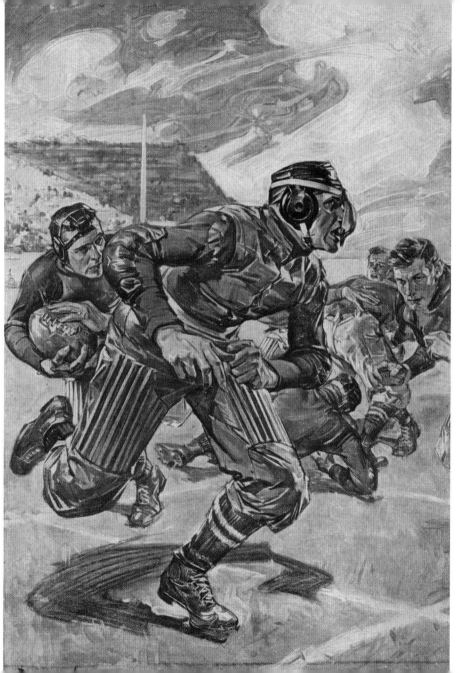

PLATE 151. Frank X. Leyendecker. *An End Run. The Century*, November 1909.

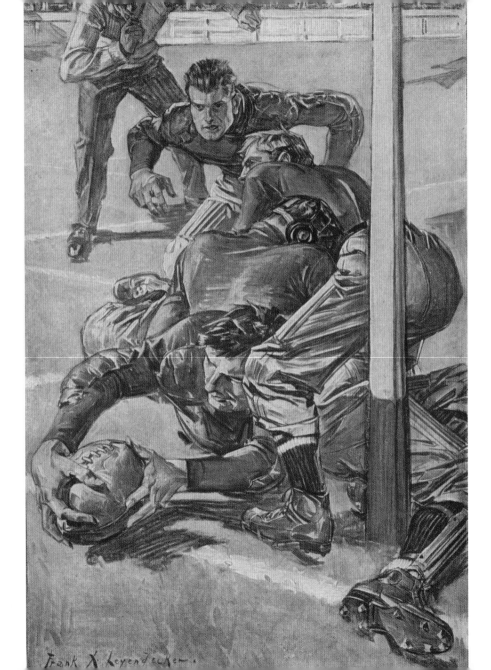

PLATE 152. Frank X. Leyendecker. *A Touch-Down. The Century,* November 1909.

PLATE 153. Frank X. Leyendecker. *The Quarter Back Passing the Ball. The Century,* January 1910.

PLATE 154. Frank X. Leyendecker. *Tackling the Dummy. The Century,* January 1910.

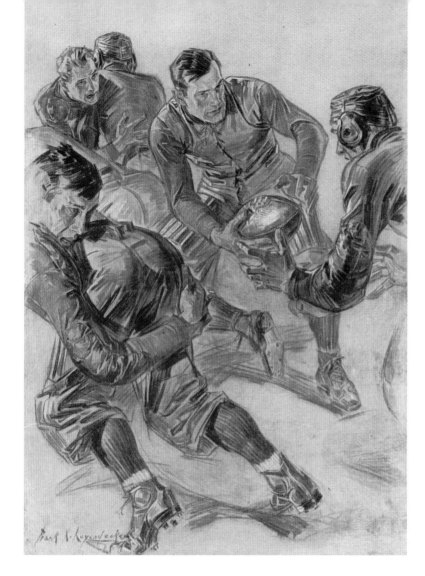

197

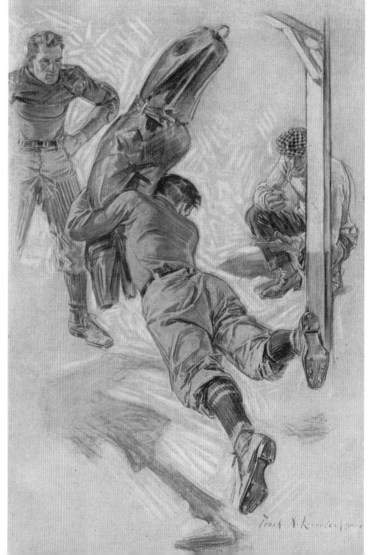

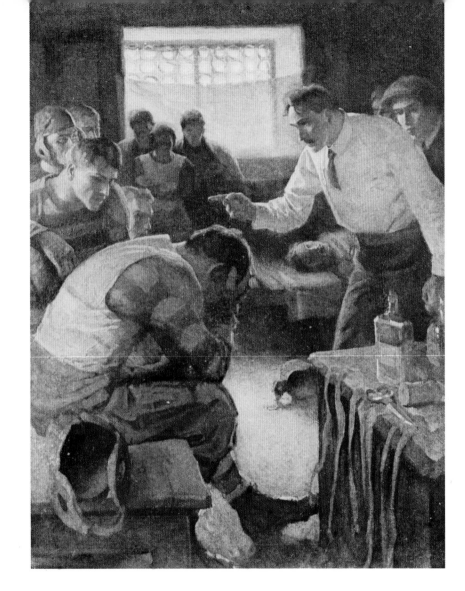

PLATE 155. N. C. Wyeth. *Between Halves—The Head Coach Braces Up the Team. The Century,* February 1910.

PLATE 156. N. C. Wyeth. *The Victorious Captain. The Century,* February 1910.

PLATE 157. N. C. Wyeth. Frontispiece for Arthur Stanwood Pier's *Boys of St. Timothy's,* 1904.

He received the ball, rushed forward, and sprang up and out, with all his might.

PLATE 158. George Bellows. *Football Game.* 1910. Private Collection.

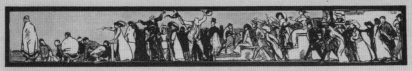

RAH! RAH! RAH! RAH! RAH! RAH! RAH! RAH! RAH!

THE ABSORBING CHASE OF THE PIGSKIN THROUGH OUR HALLS OF LEARNING

As Glimpsed by George Wesley Bellows, A. N. A.

THESE are not pretty pictures — we know they are not. He never did want to make pictures *pretty*, anyway. What this young American painter is after is *truth*, first, last and always. And hasn't this page from his sketch-book recorded truths about our national enthusiasm of football that all of us recognize?

It's a brutal game, and we all know it is. The pretty girls on the bleachers with their fluttering banners and glowing chrysanthemums can not make it less so. We see our sons, bruised and bleeding, led from the field, and we try to cure our apprehensive shivers with consciously attempting to increase our warm glow of pride—trying to be *glad* John is on the team, in spite of our firm conviction that the risk to his safety makes the honor a doubtful one.

Mr. Bellows loves football as he loves every game of skill and strength and brute force—his drawings show that. But he is not deceived by the "glory" of the field. He shows it to us as he sees it— brutal, forceful, requiring physical courage of the highest type, exciting the lowest kind of animosities.

Are we wrong in our estimate of "the most perfectly learned lesson in our colleges"? Or are there more who believe as we do, when we cheer for the team, that we could be more spontaneously enthusiastic, more sincere in our college cheering, if we saw a game which went more to the swift and the clever than to big muscles and mere endurance?

'Way down deep in our secret souls, aren't we Americans just a bit ashamed of the "Chase of the Pigskin"? And just between you and me—behind my hand, so no Englishman can hear—would we not be glad to see our "Halls of Learning" evolve a better game? In the meantime, quite apart from that question, let's take off our hats to Mr. Bellows and the way he has interpreted the spirit of the game, and let us acknowledge that his leadership of the younger school of American painters has been well earned.

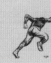
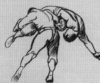

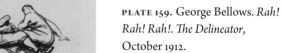
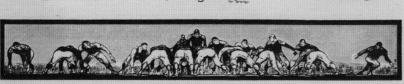

PLATE 159. George Bellows. *Rah! Rah! Rah!*. *The Delineator*, October 1912.

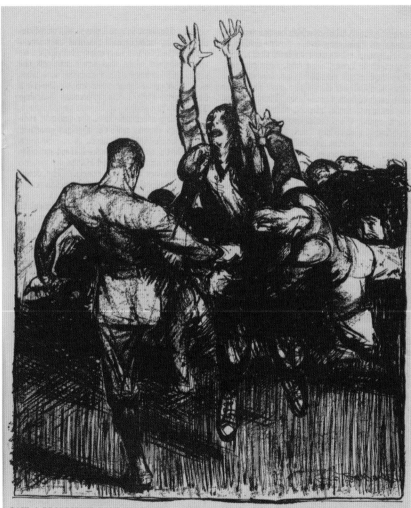

PAST A PROTECTING BACK HE SWEEPS; PAST ANOTHER, BEATING DOWN, PLUNGING—A GIANT
SHOOTING THROUGH SPACE—A THUMP—DE WITT'S CHEST CRASHING INTO
THE BALL HAS DRIVEN IT FAR BEHIND.

PLATE 160. George Bellows. Illustration for Edward Lyell Fox's "Hold 'Em!" *Everybody's*, November 1912.

PLATE 161. George Bellows. Crayon, charcoal, India ink, and collage. Illustration for Edward Lyell Fox's "Hold 'Em!" *Everybody's*, November 1912. The original now in the Mead Art Museum, Amherst College.

PLATE 162. George Bellows. India ink and crayon. Illustration for Edward Lyell Fox's "Hold 'Em!" *Everybody's*, November 1912.

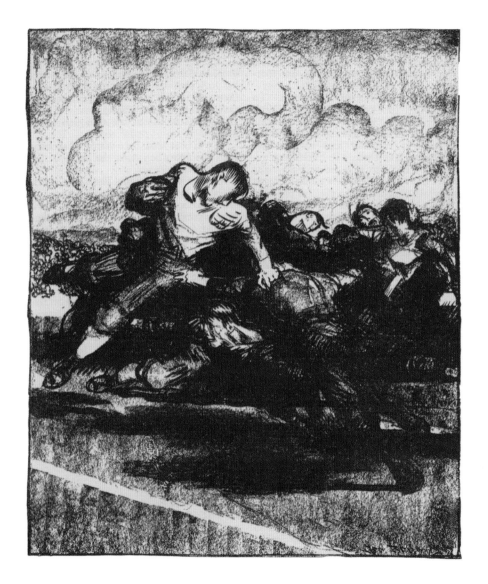

203

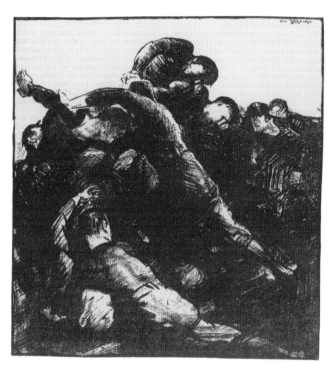

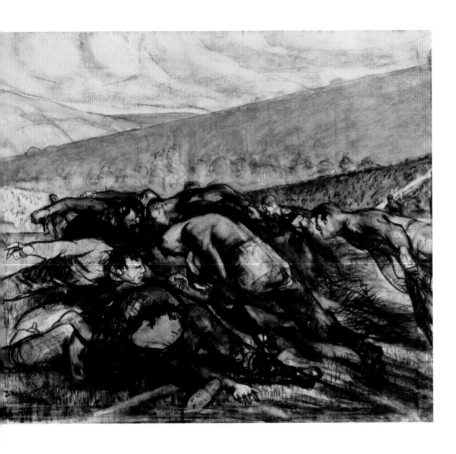

PLATE 163. George Bellows. *The Football Game.* Charcoal and wash. 1912. Hirshhorn Museum and Sculpture Garden, Smithsonian Institution, Gift of Joseph H. Hirshhorn, 1966. Photograph by Lee Stalsworth. Courtesy of the Bellows Trust.

PLATE 164. Sidney Riesenberg. Illustration for Guy W. Norton's "The Crisscross." *Collier's*, November 18, 1916.

PLATE 165. Hawthorne Howland. *A Critical Moment in the Game. Sunset*, November 1914.

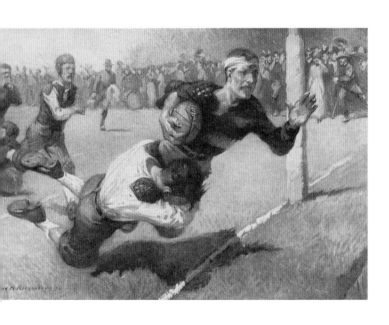

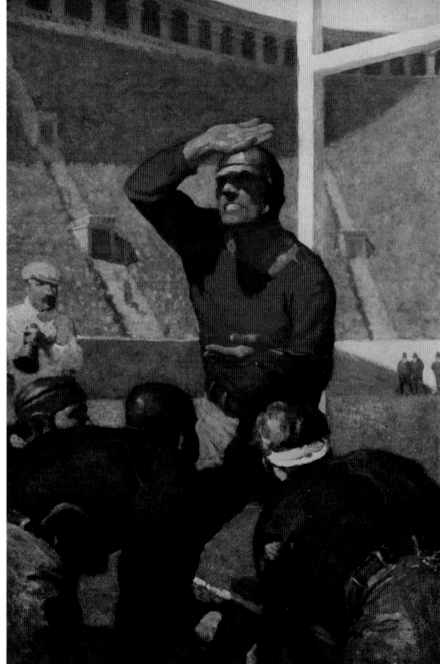

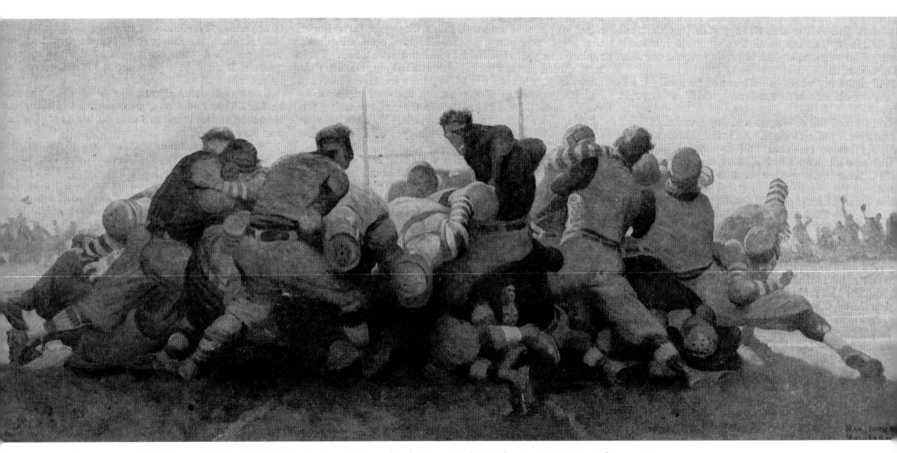

PLATE 166. Hawthorne Howland. Illustration for James Hopper's "The Long Try." *Saturday Evening Post*, October 7, 1916.

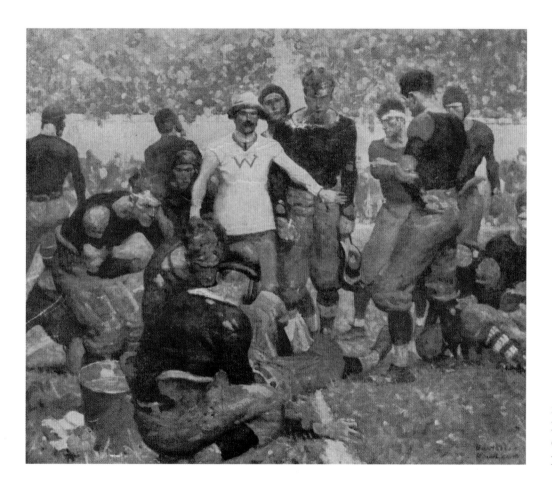

PLATE 167. Hawthorne Howland. Illustration for Octavus Roy Cohen's "Fair Play." *Collier's,* November 24, 1917.

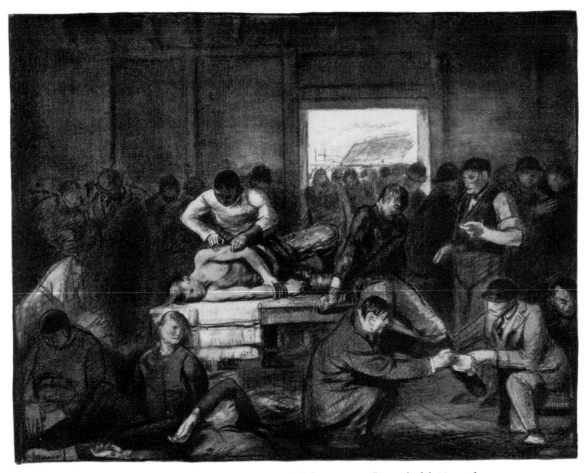

PLATE 168. George Bellows. Illustration for James Hopper's "The Pony Trio." *Everybody's,* November 1918.

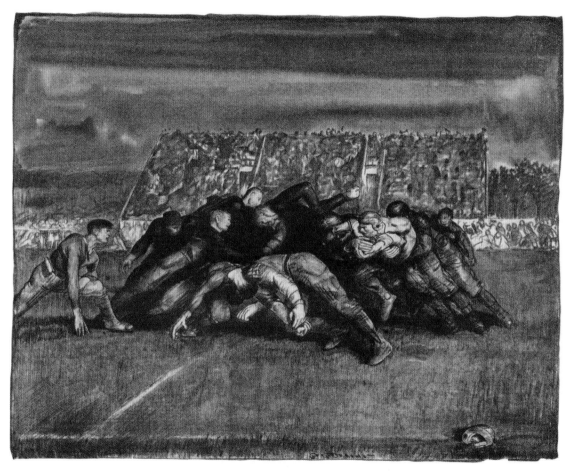

PLATE 169. George Bellows. A second illustration for James Hopper's "The Pony Trio." *Everybody's,* November 1918.

PLATE 170. William Kemp Starrett. Illustration for William Almon Wolff's "Time Enough, Damn You!" *Leslie's*, November 6, 1920.

PLATE 171. Sidney H. Riesenberg. Illustration for William Almon Wolff's "Right About Face." *Collier's*, September 30, 1922.

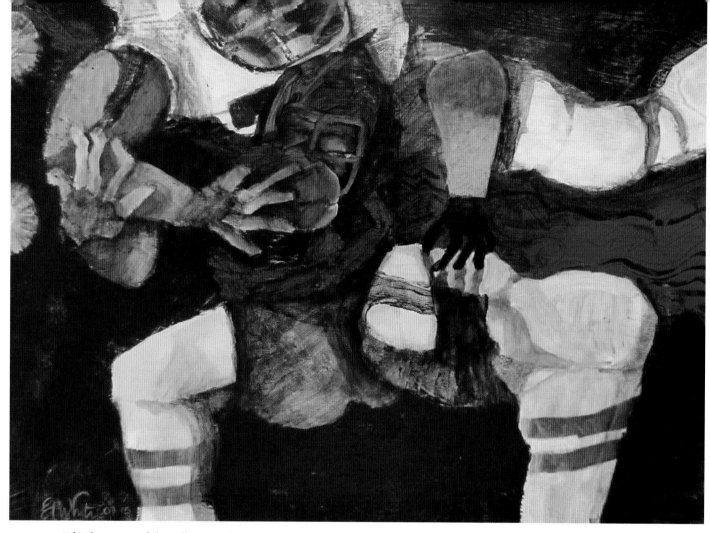

PLATE 172. Ed White. *Around the Ball*. 2014. Ed Art White.com.

211

NOTES

INTRODUCTION

1. Davis, *Football*, 35–37.
2. Hughes and Rawlins, "Recollections of American Universities."
3. Having portrayed the students facing off at the onset of Bloody Monday, Homer made another drawing in 1858 of the violent action that followed, likely for offer to *Harper's* or *Ballou's Pictorial* but it was never engraved nor published and apparently was reproduced only once, in the magazine *Auction*, October 1970. It is in a private collection. See Tatham, *Winslow Homer and the Pictorial Press*, 70.

1. THE BEGINNINGS OF AMERICAN FOOTBALL ART

1. Game of Foot-Ball.
2. Mott, *History of American Magazines, 1850–1865*, 43–45; Brown, *Beyond the Lines*, 18–24.
3. Mott, *History of American Magazines, 1850–1865*, 460. On *Leslie's*, see Brown, *Beyond the Lines*. *Harper's Weekly* has received no comparable book-length scholarly treatment.
4. See, for example, *Gleason's Pictorial and Drawing Room Companion* for May 17, 1851 (trotting); for October 3, 1851 (yachting regatta); for October 25, 1851 (horse race); for November 22, 1851 (clipper ship race); for January 22, 1853 (skating); for November 26, 1853 (trotting); for January 28, 1854 (sleigh racing); and for September 9, 1854 (trotting).
5. See January 29, 1853 (for cock-fighting); April 23, 1853 (for bull and bear fighting on the cover); and November 19, 1853 (for several pages of Japanese wrestling and martial arts).
6. See November 28, 1857, and January 29, 1859, as well as July 3, 1858 (Class Day at Harvard) and June 4, 1859 (cricket), also by Homer.

7. Brown, *Beyond the Lines*, 38; Wattous, *American Printmaking*, 20; Ivins, *Prints and Visual Communication*, 99.

8. *Leslie's* published full- or double-page illustrations on March 17 and 24, April 14 and 28, and May 5, then a cover and a double-page illustration as well as a four-page foldout of the fight itself on May 12, followed by two more pages of sketches on May 19 (in addition to a full-page illustration of a championship bout in 1788).

9. Mott, *History of American Magazines, 1850–1865*, 458.

10. Nast's drawings appeared weekly from April 7 through May 12; the "Extra" is dated only by the month: May 1860.

11. *Harper's Weekly*, May 5, 1860.

12. Training of Modern Gladiators.

13. Stern, *Purple Passage*, 109. Stern's biography focuses mostly on Mrs. Leslie's social life.

14. Wattous, *American Printmaking*, 20–26; Jussim, *Visual Communication and the Graphic Arts*, 85; Mott, *History of American Magazines, 1865–1885*, 187–90).

15. Woodward, "Decline of Wood-Engraving."

16. Jussim, *Visual Communication and the Graphic Arts*, 85; Elzea, *Golden Age of American Illustration*, 14.

17. Woodward, "Decline of Wood-Engraving," 58.

18. Merrill, *Wood Engraving and Wood Engravers*, 11. Merrill describes his experiences as an engraver for *Harper's Weekly*.

19. Smith, "Thure de Thulstrup."

20. Camp, "American Game of Foot-Ball."

21. See, for example, *Harper's Weekly* for September 30, 1871 (rowing regatta by Thomas Nast); July 6, 1991 (horse race by Thulstrup); and September 2, 1893 (tennis by Charles Howard Johnson).

22. Weitenkampf, *American Graphic Art*, 224.

23. All three are included in the five-volume *Grove Encyclopedia of American Art*, edited by Joan Marter, though Frost's entry is very brief—by implication, that of a minor artist.

24. Davis, "Day with the Yale Team."

25. Camp, *Football Facts and Figures*, 180. On Camp's motives, see Smith, *Sports and Freedom*, 92–93.

26. Seelye, "Remington the Writer," 239–41; Nemerov, *Frederic Remington and Turn-of-the-Century America*, 54–62.

27. Brown, *Beyond the Lines*, 39.

28. Harris, "Iconography and Intellectual History."

29. Larkin, *Art and Life in America*, 254–55.

30. Merrill, *Wood Engraving and Wood Engravers*, 8.

31. Hassrick, *Frederic Remington*, 24; Rogers, *World Worth While*, 164–65.

32. Remington's painting, now in the Yale University Art Gallery, has a title, *Touchdown, Yale vs. Princeton, Thanksgiving Day, Nov. 27, 1890, Yale 32, Princeton 0*, that had to have been

attached well after the fact. Whether Remington painted it from a new sketch or from memories of his own playing days, his subject was certainly not the Yale-Princeton game of 1890, which was played in Eastern Park, Brooklyn, before twenty-five thousand spectators (in grandstands, not lining the field) a mere two days before the date of the issue of *Harper's Weekly* in which the engraving appeared.

33. Gorn, "Wicked World," 12.

34. Michaelis, *N. C. Wyeth*, 35.

35. Not included among the plates are unsigned illustrations for December 10, 1887 (double-page) and November 19, 1892 (single-page), each a cluster of small drawings.

2. THE ART OF THE FOOTBALL CARTOON

1. Caspar Whitney's columns in *Harper's Weekly* in the 1890s were filled with reports and accusations regarding "professionalism" on college teams, even in prep schools. Exeter in 1893 fielded a team for the annual match with Andover that included a twenty-nine-year-old lineman and a twenty-four-year-old "well-known professional athlete" named "Pouch" Donovan who had performed with Barnum's circus in 1891 and 1892. ("Amateur Sport," December 2, 1893). Regarding Harvard's, Yale's, and Princeton's constant wrangling over the eligibility of each other's players,

Whitney declared, "We had rather see football forbidden by the university faculties than pained by the exhibition of our college boys, sons of gentlemen, resorting to the intrigues of unprincipled professionals." "Amateur Sport," November 4, 1893. Versions of this sentiment were a refrain in Whitney's columns in the 1890s.

2. Murrell, *History of American Graphic Humor, 1865–1885*, 85–105; Mott, *History of American Magazines*, 520–32 (on *Puck*) and 552–56 (on *Judge*). On chromolithography, see Marzio, *The Democratic Art*.

3. Martin, "E. W. Kemble"; Nadell, *Enter the New Negroes*, 18. *The Churchman* (December 4, 1897, 749) called *The Blackberries and Their Adventures* an "exceedingly comical book." To *The Literary Era* (December 1897, 421), it was "a series of highly amusing drawings." *The Dial* (December 16, 1897), the literary journal founded by Ralph Waldo Emerson, noted its "amusing pickaninies [who] indulge in various sports."

4. In the cartoon, John L. Sullivan represents the view of Richard Kyle Fox, publisher of the notorious *National Police Gazette*, who waged a campaign in his weekly paper to legalize prizefighting that included repeatedly pointing out the hypocrisy of the elites' support for football while condemning prizefights. (Fox also publicly feuded with

Sullivan, but on personal grounds.) The sensationalistic daily press made much of the similarity between the two sports, pushing defenders of football to distinguish their sport explicitly from prizefighting. See for example, "Future of Football"; Richards, "Football Situation," and "Football."

5. For other political-football covers and centerfolds, see *Judge*, December 2, 1893; *Life*, November 23, 1899; *Puck*, September 17, 1905; *Judge*, October 12, 1907; and *Puck*, November 10, 1909.

6. The *New York Herald* reported on postgame revels on November 27, 1891, November 25, 2892, and November 30, 1893. The *New York Times* of November 15, 1896, explained the cancellation of these Thanksgiving Day games: "The game used to be played on Thanksgiving Day, but owing to the fun the students used to have after the game and the scrapes that some of them got into it was deemed advisable to change the day of playing, and now the contestants meet the Saturday before Thanksgiving Day, and the students, by order of the Faculty, have to be back within their college precincts at a set time that day unless they can furnish written requests from their parents asking leave of absence."

7. For more Thanksgiving cartoons, see *Life*, November 26, 1891; *Puck*, November 29, 1893; and *Puck*, November 20, 1912.

8. Boskin, *Sambo*, 128.

9. Gambone, *Life on the Press*, 53–58, 115–19. For Blackville cartoons with sports themes (by Sol Eytinge) see *Harper's Weekly*, August 25, 1877 (rowing); July 37, 1878 (baseball); and February 1, 1879 (pedestrianism). No football.

10. Le Beau, *Currier & Ives*, 231–44; Peters, *Currier & Ives*, 23; Murrell, *History of American Graphic Humor*, 105; Boskin, *Sambo*, 126.

11. The 1942 collection by Peters included fourteen Darktown prints on four plates (of a total of 192). None were included in the massive 1979 collection by Rawls, *Great Book of Currier & Ives' America*. Darktown had gone the way of the coon song.

12. E. W. Kemble's Blackberries and his inhabitants of Possumville (in sketches for *Leslie's Weekly* in 1905) cycled, golfed, and played polo, but not football. Eytinge's Blackville cartoons for *Harper's Weekly* included baseball and rowing, but no football. *Puck*'s Cullerville apparently didn't go in for sports.

13. For Zimmerman's similar racist football cartoons, see *Judge* for December 1, 1894, October 29, 1898, and October 21, 1899.

14. Other football cartoons by Flagg appeared in *Life* for November 23, 1904, and October 4, 1906.

15. Bond, "Strange Career of William Henry Lewis."

16. Camp, "Eleven Greatest Football Players of America." It goes without saying that Lewis's alignment with the accommodationist Washington, a shift from his earlier more radical integrationist politics that caused a bitter rift with his activist colleagues, was a crucial decision for Lewis that would not have mattered to Flagg and the editors at *Life*.

17. Bernstein, *Football*, 72–73; Bond, "Jim Crow at Play," 493–94; and Lindholm, "William Clarence Matthews."

18. Downey, *Portrait of an Era*, 97.

19. On the Gibson Girl see Downey, *Portrait of an Era*, 184–211; Hastedt, "Charles Dana Gibson," 129–36; and Kitch, *Girl on the Magazine Cover*, 37–55.

20. Bulloch, "Charles Dana Gibson."

21. See also *Puck*, November 30, 1892 (Charles J. Taylor); *Life*, November 18, 1897 (Otho Cushing); *Puck*, December 20, 1899 (Frank A. Nankivell); *Puck*, January 9, 1901 (Nankivell); *Life*, December 5, 1907; *Life*, November 2, 1911 (Orson Lowell); and *Life*, November 7, 1912 (Ralph Briggs Fuller).

22. The following account comes from Blackbeard, *R. F. Outcault's "The Yellow Kid."*

23. Berger, *Comic-Stripped American*, 27.

24. Zurier, *Picturing the City*, 221, 225.

25. Zurier, *Picturing the City*, 225.

26. Gambone, *Life on the Press*, 33–38, 130–76.

27. Outcault and Luks also portrayed the gangs in Hogan's Alley and McFadden's Row at baseball, boxing, golf, tennis, cycling, and bowling. See R. F. Outcault's *The Yellow Kid* (with images) and Gambone, *Life on the Press* (for references only). Gambone also documents Luks's cartoon-like drawings of boxing, baseball, polo, and wrestling for *Vanity Fair* in the 1910s and 1920s.

28. The caption reads: The captain—"De reason we so shuah ter win is bekase, dis bein' feet-ball, we got de advantage ob habin' de feet." His friend—"Yais, suh; yo got de avantage ob lookin' like de wild men from Borneo, so dem white kids gwine ter git skeered so bad dey cain't play—dat's what." Outcault also drew a six-panel cartoon of the Yellow Kid boxing a comical "coon." See "The Yellow Kid's Great Fight," *New York Journal*, December 20, 1896, reproduced in Blackbeard, *R. F. Outcault's "The Yellow Kid."*

29. Zurier, *Picturing the City*, 225.

30. On Outcault's invention of the comic strip, see Blackbeard, *R. F. Outcault's "The Yellow Kid,"* 68.

31. Zurier, *Picturing the City*, chaps. 6 and 7.

32. Gambone, *Life on the Press*, 20–25.

33. Perlman, *Painters of the Ashcan School*, 89.

34. The painting was reproduced in black and white in *Vanity Fair* (January 1934) shortly after Luks's death, but otherwise it seems to have disappeared.

35. See Zurier, Snyder, and Mecklenburg, *Metropolitan Lives*.

36. See Corbett, "Life in the Ring"; Curry, "Life of Leisure"; and Doezema, *George Bellows and Urban America*, 67–122.

37. Bellows sketched two versions of a baseball crowd in 1906, one of which ended up published as *The Great American Game* in *Harper's Weekly* (May 2, 1914). The Bellows scholar Charles Morgan also reproduced an undated and apparently unpublished drawing in lithographic crayon of a baseball player in a locker room, *Sweeney, the Idol of the Fans, Had Hit a Home Run*, from the Fogg Museum at Harvard. Finally, a small oil painting from 1908 in a private collection, *The Baseball Game*, was apparently a wedding gift from Bellows to friends. See Morgan, *Drawings of George Bellows*; and Zoss, Bowman, and Bowman, *Diamonds in the Rough*, 238–39.

38. Durant, "Sucker."

39. See also, for example, *May-Day in New York's Central Park* (May 4, 1907); *A Spring Morning in Washington Square, New York* (April 16, 1910); *Far From the Fresh Air Farm* (July 8, 1911); *The Day Before Christmas on Madison Square* (December 14, 1912), and *A White Christmas* (December 13, 1913); all in *Collier's*.

40. A crowded football scene also appears on the October 1916 cover of *Boys' Life*, and Glackens (or Outcault) may have influenced the great cartoonist John Held Jr.'s trademark crowds of small round-faced stick figures in various settings. Among Held's many football cartoons, the cover of the program for the Yale-Army game in 1929 (October 26), with the opposing teams deployed on either side of the river "No Man's Land," is an example. Illustrations by John Groth for an article on football in *Collier's* (November 2, 1946) and a cover by Stan and Jan Berentstain for *Collier's* (October 29, 1949) are direct descendants from Outcault and Glackens, while *New Yorker* covers by Charles E. Martin (November 9, 1973) and Dean Victor (September 22, 1975) can be viewed as reimaginings of the tradition.

41. See Becker, *Comic Art in America*, 246–61; and McCrory, "Sports Cartoons in Context."

3. FOOTBALL POSTER ART

1. Price, *Poster Design*; Cirker and Cirker, *Golden Age of the Poster*; Margolin, *American Poster Renaissance*; Keay, *American Posters of the Turn of the Century*; Gibson, *Designed to Persuade*; and Irwin, "Edward Penfield." The quotation is from Price, 215.

2. On posters as art and commerce, see Bogart, *Advertising, Artists, and the Borders of Art*, chap. 2 ("Posters versus Billboards"), 79–124.

3. See contents page for December 1896 issue. Like Gould, Carqueville made his reputation with posters for *Lippincott's*, but he lived in Chicago and was available to the editors of the new magazine.

4. Reproduced in Blackbeard, *Yellow Kid*, plate 105.

5. Gibson, *Designed to Persuade*, 22.

6. "John E. Sheridan, Illustrator, Dies." The collection in the Library of Congress includes Sheridan's 1902 Cornell rowing poster, 1902 Columbia poster, and 1905 poster ad for a Penn-Georgetown baseball game, in addition to Sheridan's Princeton football poster. In *Poster Design* (1913), Price included Sheridan with Penfield, Gould, and Leyendecker among notable American poster artists.

7. Holdings in the Library of Congress include football posters from 1902 and 1903 by Bristow Adams (Illinois, Navy, Brown, Ohio), H. G. Laskey (Princeton, Brown), and Mae Goodelle Chaffee (Syracuse)—a lone woman in this male-dominated field. A 1902 Columbia poster by Sheridan has a college student in his dorm room with a football poster on the wall behind him—a bit of either self-advertising or self-aware humor.

8. Sheridan's later work included two football covers, one for Associated Sunday Magazines (see plate 132), the other for the *Saturday Evening Post* (November 19, 1932), both featuring classically handsome football heroes unchanged from his early posters and illustrations.

9. Posters titled *Tackled* and *The Team*, and two 43-inch-wide banner posters, *The Forward Pass* and *Goal from Field*, survive only in private collections, with information about them, as far as I can determine, limited to online auction results. See http://www.auctionguide.com/lot/4-hibberd-vb-kline-football-posters/140/94/. Kline also produced chromolithographic banner posters of other sports, including baseball (*Two Men Out*), rowing (*The Last Mile*), and track (*High Hurdles*).

10. Eskilson, *Graphic Design*, 54.

11. Rayburn, *Football Nation*, 77. Earl Christy's College Girl series in these years included postcards representing schools ranging from Harvard, Yale, Princeton, Penn, Cornell, Columbia, and West Point in the East to Michigan and Chicago in the Midwest to Stanford on the West Coast. Many of these postcards are available for sale on eBay today.

12. Penfield's sports covers for *Collier's* included baseball (April 28, 1902; April 17, 1915), golf (August 8, 1903; Sep-

tember 13, 1908; June 8, 1912; October 2, 1915), tennis (July 13, 1907; July 18, 1914; July 29, 1916), lacrosse (May 15, 1909), rowing (June 11, 1910), and polo (November 12, 1910).

13. Mott, *History of American Magazines, 1885–1905*, 453–56. Mott identifies "two great eras" for *Collier's*, the first ending with Robert Collier's death in 1918 and the sale of the magazine to the Crowell Publishing Company, the second under the editorial guidance of William L. Chenery from 1924 to 1943 (479). Tebbel and Zuckerman in *Magazine in America* call the first two decades of the twentieth century the magazine's "golden period" (69).

14. Price, *Poster Design*, 222.

15. In his memoirs, Norman Rockwell recalled seeing Leyendecker's "sports posters, which had titles like 'Rushing the line' and 'The Kickoff' and which college boys framed and hung about their rooms." Rockwell, *My Adventures as an Illustrator*, 167.

16. His sports covers for *Collier's* included baseball (May 25, 1907; October 9, 1915; October 24, 1916; April 14, 1917), track and field (June 4, 1904; June 9, 1906), women's golf (August 18, 1906; August 17, 1907); and rowing (June 24, 1916). For the *Saturday Evening Post* he painted a baseball cover (May 15, 1909), a rowing cover (June 29, 1907), and a golf cover (March 13, 1920). His cover subjects for *Popu-lar Magazine* included hockey (February 1909), baseball (April 10, 1910), and rowing (July 25, 1910).

17. The term "apex of action" comes from an account of the innovation by a Japanese film editor, Yoshio Kishi, when editing highlight reels for NFL Films in its early years in the 1960s. Kishi, who had never seen a football game, grasped that a film showing only the apex of action rather than the entire play as it unfolded was more dramatic, an insight that revolutionized highlight films, as NFL Films revolutionized football filmmaking in general. Kishi received credit for his innovation in volume 2 of *Lost Treasures of NFL Films* (a DVD about its own early years), but mention of him was omitted from most print tributes as the company began receiving attention for its contributions to the art of film.

18. Jordan, "Buying Football Victories."

19. *N. W. Ayer & Son's*, 1908; *N. W. Ayer & Son*, 1920; Tebbel and Zuckerman, *Magazine in America*, 155.

20. Cohn, *Creating America*, 65.

21. Giles's other covers appeared on issues for November 7 and 28, 1903. Football covers by other artists appeared on issues for October 3, 1903; November 21, 1903; October 15, 1904; November 19, 1904; and December 2, 1905—the last one (in addition to Giles's 1905 cover) under a new title,

Illustrated Outdoor News. In 1905 five of the seven football covers were photographs instead of paintings.

22. Discovered on eBay.

23. The key offensive players were the fullback who kicked and the ends who covered the punts. Offensive strategy dictated punting whenever the team had the ball in its own territory, not close to midfield, even on first or second down. Teams punted back and forth, dozens of times each game. The objective was to gain a few yards with each exchange of punts until getting the ball in the opposing team's territory provided an opportunity to attempt to score. The heroes in several short stories from these years were courageous punters getting the ball away time after time in the face of a fierce rush and increasing exhaustion, then seizing the opportunity to strike for the winning touchdown. Field goals (drop-kicked) counted more than touchdowns until 1904, then counted the same as touchdowns until 1909. The current rule awarding six points for a touchdown and three for a field goal was instituted in 1912. Drop-kicking for field goals remained a valued skill into the 1930s.

24. Dean, "J. C. Leyendecker," 202–3. Dean specifically cites the football poster for Penn in marking Leyendecker's new style.

25. *Popular* published rising authors who went on to write for the better-paying magazines but also the work of established writers and artists unable to place it elsewhere. In 1909 its circulation was 300,000, compared to 531,000 for *Collier's* and 865,000 for the *Saturday Evening Post* (*N. W. Ayer & Son's American Newspaper Annual,* 1909). It hit its peak in 1911 with more than 400,000 and was still over 300,000 in 1920. See Reynolds, *Fiction Factory,* 144 (for peak circulation numbers); and the Ayer directory for 1920.

26. Leyendecker also did baseball covers for *Popular* in 1909 (May), in 1910 (March 1 and May 1), and in 1911 (May 1); a swimming cover for *Popular* in 1909 (August); and a rowing cover in 1910 (July 15); plus a nonsports cover in 1910 (March 1).

27. Dean, "J. C. Leyendecker," p. 204. The one exception I've found is an artist named Frederick Lowenheim, whose baseball cover for Street & Smith's juvenile magazine *Top-Notch* in 1924 (May 15) is so obviously an imitation of Leyendecker (down to the signature) that on first glance it can easily be mistaken for his.

28. Examples include *Collier's* covers in 1924 (October 25) and 1927 (November 12), and *Post* covers in 1925 (November 21, by Norman Rockwell), 1926 (October 16 and November 13), 1927 (November 12), and 1930 (October 18).

29. The most obvious examples are a cover by V. E. Pyles for the *American Legion Weekly* (November 28, 1924) and two by E. M. Jackson, one for *Collier's* (October 18, 1930) and the other for the *Saturday Evening Post* (November 27, 1931).

30. Kitch, *Girl on the Magazine Cover*, 70.

31. In developing his own style Rockwell learned from Leyendecker, whom he idolized as a young artist. Rockwell's football cover for the *Post* (November 21, 1925) was a new take on Leyendecker's rough-and-tumble kid. His covers in 1938 (November 19) and particularly 1952 (October 21) exaggerate the homely gangliness of his high school football players but are meant to symbolize their ordinariness, or ordinary American-ness, rather than transcendent strength or power.

32. Details on the 1909 cover from an eBay sale of the 1909 poster. The original paintings for several of Leyendecker's football covers, typically oil on canvas (20 to 22 in. by 26 to 30 in.) survive in private collections. Leyendecker was among the major illustrators who could demand ownership of the originals—typically the publisher held them for other possible uses before discarding them. On his death he left them to his sister and longtime partner, who sold some of them at yard sales for between fifty cents and seven dollars. A year after he died someone found a large number of his original paintings, along with sketches and other items, in the attic of his studio in New Rochelle, New York. Some were donated to the New York Public Library and some were given away to friends, while the rest were exhibited by the Society of Illustrators and then sold to society members. Near the end of her life, Leyendecker's sister, Mary, gave several paintings to the Haggin Museum in Stockton, California (including some baseball but no football). Later still, the National Museum of American Illustration in Newport, Rhode Island, acquired a large number of Leyendecker paintings but then subsequently sold them. (In response to a request by a colleague of mine to borrow some of these paintings for an exhibition of football art, the director of the museum in 2014 explained that all had been sold.) All of the football paintings today are apparently held in private collections. This account comes from Cutler and Cutler, *J. C. Leyendecker*, 52, 235–40. For reproductions of eight football paintings that became magazine covers, see Cutler and Cutler's book.

33. In addition to the 1919–20 style book and the 1921 ad, Leyendecker's football heroes appeared in Kuppenheimer ads in 1912 (September 14 *Saturday Evening Post*); 1919 (October 18 *Saturday Evening Post*, an image from the style book);

1927 (double-page, October 29 *Saturday Evening Post*); and in the company's stylebooks for 1913–14 (football hero with ball cradled in arm on the cover) and 1920–21 (front and back covers making a two-panel illustration of furious football action, along with a double-page interior illustration of a kicker watched by two well-dressed young men).

34. Cutler and Cutler, in *J. C. Leyendecker*, 73–74, claim that Leyendecker deserves credit for conceiving this strategy of creating a "brand" and then convincing the agency for which he created his Arrow Collar ads. Whether he was in fact the father of modern branding, Leyendecker's ads for Arrow Collars, Kuppenheimer suits, and other commercial products are among the earliest and most impressive examples.

35. The most obvious examples are two football covers by E. M. Jackson, one for *Collier's* (October 18, 1930) and the other for the *Saturday Evening Post* (November 27, 1931). Both have Leyendecker's signature torn jersey.

36. *Saturday Evening Post*, October 18, 1919 (Cushman Parker); *Collier's*, September 13, 1919 (R. C.). The latter was remarkably simple and uninteresting, an anomaly among the magazine's dozens of football covers.

37. Football was not common on the covers of women's magazines but it also appeared on *The Housekeeper* (October 1903); *Fashions* (November 1903); and *McCall's* (October 1907); in addition to a full-page illustration in *Vogue* (November 1902).

38. *American Boy* was the leading boys' magazine into the 1920s, with a circulation of 250,000 in 1920 when *Boys' Life's* was 45,000, trailing even *St. Nicholas's* 67,000 and *The Boys' Magazine's* with 80,000. (*Youth's Companion*, for girls and boys, had a circulation of 332,000. It did not adopt pictorial covers until the 1920s and then merged with *American Boy* in 1929.) See the Ayer directory for 1920. As the official publication of the Boy Scouts of America, of course, *Boys' Life* surpassed all of them and lives on (with pictorial covers only through the 1950s). One early cover of *Boys' Life* (October 1913) was by Norman Rockwell, who also served as art editor—at the age of nineteen. The cover showing a boy in his football suit sitting on a wooden crate, looking at a diagram of a play, did not exploit the dramatic possibilities of the poster style.

39. *Around the End* was part of a portfolio titled "College Sport," along with paintings of baseball, rowing, and cross-country running, published in the May 1910 issue of *Outing* and sold separately as prints. An advertisement for the portfolio in the April 1910 issue noted Kline's "national reputation for interpreting the college spirit," presumably

based on his sports posters. His football cover for *Outing* followed in October. Kline's cover for *Popular Magazine* from November 15, 1912, not reproduced here, was of a male cheerleader.

40. Other football covers in *Popular Magazine*: November 1903; November 1904; November 1906; November 15, 1913; November 23, 1914; October 7, 1916; and November 20, 1918. In *Top-Notch*: October 1, 1910; October 15, 1915; October 1, 1916; October 15, 1917; November 15, 1918; October 1, 1919; and November 1, 1920.

41. In 1926 Kline gave up commercial art to return to Syracuse University, where he created a curriculum in illustration in the College of Fine Arts, teaching and serving as department chair until retiring in 1951. See the obituaries and tribute in the *Syracuse Post-Standard* of October 28, 1959—with confirmation and corrections provided to me in emails by Stephanie James, chair of the Department of Art at Syracuse, and reference archivist Mary M. O'Brien.

42. *Philadelphia Inquirer*, November 21, 1897. See http;//hdl.library.upenn.edu/1017/d/archives/20130807069. This was already a "now famous picture" according to the ad for it on November 14.

43. The *Tribune*'s ads announcing "Football" (on November 18 and November 24) described Widney as "a remark-ably clever artist, who has studied under some of the best instructors in this country and abroad" and who "painted this picture especially for *The Chicago Tribune*. The picture shows two of the best 'elevens' in action on the 'gridiron.' Mr. Widney devoted a great deal of time watching the noted games recently played in this city, and his painting is a complete success." Widney went on to a career as a cover artist and illustrator for the *Saturday Evening Post* and other magazines, including George Fitch's Siwash stories for the *Post*. Art supplements, including several drawings by Charles Dana Gibson, were sufficiently common as late as 1912 to be disparaged in *The Outlook* for too many "atrocities committed in the name of art by newspaper color supplements," as opposed to the truly "praiseworthy" and "genuine art" such as a recent suite of paintings in the *New York Times*. (See "True Newspaper Art.") Perhaps there were other football prints in this period besides these two, whether "atrocious" or "praiseworthy."

44. Little has been written about the Sunday magazines. My overview draws on a conference paper by Moore and Gabrielle, "American Sunday Newspaper Magazine"; Homestead, "Associated Sunday Magazines"; and Platnick, "Sunday Magazine." I have constructed some details,

including the existence of United Sunday Newspaper Magazines, from ads and listings in the annual Ayer directories.

45. It appeared first as *The Monthly Magazine Section* in 1911, becoming *Semi-monthly* in 1913. A *Family Magazine Section* was published in 1912–1913, then finally the *National Sunday Magazine* in 1914–1916. (I tracked this through Ayer directories and ads.)

46. Mott, *American Journalism*, 585.

47. In 1915, Hearst's *American Sunday Magazine* had a circulation of 2.2 million; *National Sunday Magazine*, 2.2 million; United Sunday Newspaper Magazines, 2.1 million; Associated Sunday Magazines, 1.53 million; and *Illustrated Sunday Magazine*, 1.33 million. For comparison, the *Saturday Evening Post*'s was 1.95 million and *Collier's* was 642,000. *N. W. Ayer & Son's*, 1188–89.

48. Platnick, "Sunday Magazine."

49. Additional poster-style football covers include: Associated Sunday Magazines for November 18, 1906, by J. J. Gould (see *New-York Tribune*) and November 22, 1914 by Hawthorne Howland; and the *Illustrated Sunday Magazine* for November 1, 1908 (see the *Pittsburgh Gazette-Times*). The Howland cover (as well as the Sheridan) are reproduced in *Football Nation*, compiled from the collections of the Library of Congress. (Howland was another regular illustrator of football, as described in chap. 4.) I have found no football covers for *National Sunday Magazine*. Football covers for the *St. Louis Globe-Democrat* (September 24, 1905, and November 10, 1912) and the *San Francisco Call* (November 13, 1910) do not seem to have been syndicated. The *St. Louis Post-Dispatch* (Pulitzer's United Sunday Newspaper Magazines) had a football cartoon cover (on November 10, 1912) before switching to poster covers in 1913, including a football cover by Harrison Fisher for November 9, 1913.

50. See the ad in the *Minneapolis Journal* of December 31, 1905.

51. Of ninety-seven painted football covers (excluding photographs, that is) of the *Post* and *Collier's* from the 1920s through the 1950s, the subjects of only sixteen could be described as football heroes or heroic action (seven from the *Post*, none after 1937; nine from *Collier's*). The rest illustrate some aspect of the game's spectacle or social world. By the 1940s the *Post* had shifted to the kind of storytelling covers associated with Norman Rockwell, J. C. Leyendecker's successor as the magazine's premier cover illustrator. The stories told by the *Post*'s football covers in the 1940s and 1950s tended to be domestic (showing mothers and sons) or linked to small-town or rural America and the "American Way of Life"—familiar postwar and Cold War scenes.

52. See, for example, *Collier's* covers for April 28, 1902 (baseball); July 11, 1903 (rowing); May 15, 1909 (lacrosse); and June 11, 1910 (rowing).

4. THE ILLUSTRATED FOOTBALL STORY

1. The original painting for "Missed!," which appears to be a watercolor, was sold at auction (it can be seen online at http://www.askart.com/Askart/artists/search/Artist Keywords.aspx?artist=22775). I have not located any of the other originals.

2. Larson, *American Illustration*, 20.

3. Larson, *American Illustration*, 25.

4. Single illustrations by Giles appeared in *Scribner's* in September 1899 and June 1900, then four in an article in July 1900, followed by another in June 1901. In 1902 he illustrated first a two-part and then an eleven-part serial for the *Saturday Evening Post* before selling his football painting to *Harper's Weekly*.

5. See Oviatt, "Atkinson No. 7"; and Balmer, "In the Winning of the Game."

6. See Ross, "Drawings by Howard Giles"; Gutman, "Howard Giles"; and "Howard Giles."

7. Larson, *American Illustration*, 26.

8. Larson, *American Illustration*, 25. According to Larson, before 1900 and after 1920 art editors assumed more responsibility in selecting which scenes to illustrate.

9. Wyeth achieved fame and wealth but took little satisfaction from all of this commercial work, despite wide praise for its artistry. See Podmaniczky, "N. C. Wyeth."

10. Michaelis, *N. C. Wyeth*, 109. Most fatalities in fact did occur in such "sandlot" football rather than better supervised school games.

11. Doezema, *Bellows and Urban America*, 69–77.

12. "Football Hero" from 1905 (pen, ink, and crayon with pencil and collage), held in a private collection and apparently never published, can be viewed online (http://www.georgebellows.com/gallery/artwork/217/football—hero—recto—fresh—verso). The cheerleader (gouache on paper) from 1903–4, along with his undergraduate football players, are reproduced in Haverstock, *George Bellows*, 22–24.

13. *Polo Game* (1910), *Crowd at the Polo Game* (1910), *Polo at Lakewood* (1910), *Tennis Tournament* (*Tennis at Newport*) (1919), *Tennis at Newport* (1920), and *Tennis Tournament* (1920).

14. Bellows's two baseball drawings, both satiric, were of a scrawny baseball hero in the dressing room (*Sweeney, the*

Idol of the Fans, Had Hit a Home Run) and rabid fans at a baseball game, with players barely in the frame, apparently in a brawl (*The Great American Game*, published in *Harper's Weekly*, May 2, 1914, a revision of a simpler 1906 drawing titled *Kill the Umpire*). No baseball action.

15. "First Exhibition of 'The Pastellists.'"
16. Gallatin, "The Pastellists."
17. Conway, "American Life," 219.
18. This collector purchased it from the Hirschl & Adler Galleries in New York, which had acquired it from the estate of C. Ruxton Love Jr., who had lent it for the 1966 exhibition. The current owner, who wishes to remain anonymous, purchased it with the understanding that it was titled *Football* and dated August 1912. It seems unlikely that Bellows did a second pastel—he painted only a handful of pastels over his entire career—at the same time he was doing his commissioned football drawings for *The Delineator* and *Everybody's*. But my conjectures could be wrong; Bellows could have painted two football pastels, with the one reproduced here properly titled *Football* and dated 1912, and the *Football Game* from 1910 still missing.
19. Brock, "George Bellows," 8.
20. Conway, "Distinction Between Fancy and Imagination," 24–25.
21. *Everybody's* ranked high among the major monthly magazines of its day with a circulation in 1912 of 632,000, well behind the *Saturday Evening Post's* 1.7 million but more than 100,000 higher than *Collier's* and trailing only *Cosmopolitan* among the major monthlies. (*The Delineator's* 930,000 was third among women's magazines.) The artists who illustrated football stories for the major weekly and monthly magazines surely knew each other's work. Anyone hoping for commissions from the *Saturday Evening Post* or *Scribner's* had to know what the magazines were publishing. When an artist of the stature of George Bellows entered the field, everyone must have taken special note.
22. In addition to these two stories, Howland illustrated James Hopper's "Pee Wee Peters," for *Saturday Evening Post*, November 20, 1915; and painted a cover for Associated Sunday Magazines (November 22, 1914). Riesenberg did numerous football covers and illustrations for football stories into the 1930s.
23. Elzea, *Golden Age of American Illustration*, 8.
24. Other Hopper stories not represented by illustrations reproduced here include: "The Strength of the Weak;

The Story of the Full-back Who Got Used to It," *Saturday Evening Post*, October 22, 1904 (illustrated by Clarence F. Underwood); "The Boy Who Lost Weight," *Saturday Evening Post*, October 9, 1909 (illustrated by Fred C. Yohn); "Pee Wee Peters," *Saturday Evening Post*, November 20, 1915 (illustrated by Hawthorne Howland); "Weight Above the Eyes," *Collier's*, November 17, 1917 (illustrated by C. Le Roy Baldridge); "Kelly, Cordier, Donner and Kent!" *Popular Magazine*, November 7, 1923; "Father and Son," *Saturday Evening Post*, October 25, 1924 (illustrated by James H. Crank); "The Boy Who Ran the Wrong Way," *Popular Magazine*, February 20, 1926; "The Long Try," *Pictorial Review*, November 1925 (illustrated by Hibberd V. B. Kline); "'My Quarterback,'" *Collier's*, November 28, 1931 (illustrated by C. C. Beall); and "He Could Take It," *American Magazine*, November 1933 (illustrated by Harvey Dunn).

25. Hopper, "Weight Above the Eyes."

26. Hopper, "We Really Played Football."

27. Hopper himself wrote two baseball stories for the *Saturday Evening Post* in these years. Both "The Last Throw" (October 5, 1912) and "The Spitter" (September 20, 1913) are about over-the-hill pitchers getting one last chance through the help of a young boy (crippled, in one case).

Redemption is sentimental and modest, not melodramatic and heroic.

28. Hopper, "Boy Who Lost Weight."

29. Barnes played for three teams in the old American Football League from 1960 through 1964; White, for the Minnesota Vikings and San Diego Chargers of the NFL from 1969 through 1985. Barnes's football prints are reproduced in his book, *From Pads to Palette*. A selection of White's football paintings can be seen on his website (edwhiteart.com).

BIBLIOGRAPHY

PUBLISHED SOURCES

Balmer, Edward. "In the Winning of the Game." *American Magazine*, May 1906.

Barnes, Ernie. *From Pads to Palette*. Waco TX: WRS, 1995.

Becker, Stephen. *Comic Art in America*. New York: Simon and Schuster, 1959.

Berger, Asa Arthur. *The Comic-Stripped American: What Dick Tracy, Blondie, Daddy Warbucks, and Charlie Brown Tell Us About Ourselves*. Baltimore: Penguin, 1973.

Bernstein, Mark F. *Football: The Ivy League Origins of an American Obsession*. Philadelphia: University of Pennsylvania Press, 2001.

Blackbeard, Bill. "The Yellow Kid and the Yellow Decade." In *R. F. Outcault's "The Yellow Kid": A Centennial Celebration of the Kid Who Started the Comics*, 16–136. Northampton MA: Kitchen Sink, 1995.

Bogart, Michele H. *Advertising, Artists, and the Borders of Art*. Chicago: University of Chicago Press, 1995.

Bond, Gregory. "Jim Crow at Play: Race, Manliness, and the Color Line in American Sports, 1876–1916." Ph.D. dissertation, University of Wisconsin, 2008.

———. "The Strange Career of William Henry Lewis." In *Out of the Shadows: A Biographical History of African American Athletes*, ed. David K. Wiggins, 39–57. Little Rock: University of Arkansas Press, 2006.

Boskin, Joseph. *Sambo: The Rise and Demise of an American Jester*. New York: Oxford University Press, 1986.

Brock, Charles. "George Bellows: An Unfinished Life." In *George Bellows*, 7–27. Washington DC: National Gallery of Art, 2012.

Brown, Joshua. *Beyond the Lines: Pictorial Reporting, Everyday Life, and the Crisis of Gilded Age America*. Berkeley: University of California Press, 2002.

Bulloch, J. M. "Charles Dana Gibson." *Studio International* 8 (June–September 1896): 75–81.

Camp, Walter. "The American Game of Foot-Ball." *Harper's Weekly*, November 10, 1888.

———. "The Eleven Greatest Football Players of America." *Independent*, October 20, 1904.

———, compiler. *Football Facts and Figures: A Symposium of Expert Opinions on the Game's Place in American Athletics.* New York: Harper & Brothers, 1894.

Cirker, Hayward and Blanche, eds. *The Golden Age of the Poster.* New York: Dover, 1971.

Cohn, Jan. *Creating America: George Horace Lorimer and the "Saturday Evening Post."* Pittsburgh: University of Pittsburgh Press, 1989.

Conway, Robert. "'A Distinction Between Fancy and Imagination': Learning from the Drawings of George Bellows." In *The Powerful Hand of George Bellows: Drawings from the Boston Public Library*, 21–39. New York: Trust for Museum Exhibitions, 2007.

———. "American Life: Drawing, Illustration, and Lithography, 1912–1924." In *George Bellows*, 213–23. Washington DC: National Gallery of Art, 2012.

Corbett, David Peters. "Life in the Ring: Boxing, 1907–1909," In *George Bellows*, 71–83. Washington DC: National Gallery of Art, 2012.

Curry, David Park. "Life of Leisure: Polo, Parks, and Tennis, 1910–1920." In *George Bellows*, 131–55. Washington DC: National Gallery of Art, 2012.

Cutler, Laurence S., Judy Goffman Cutler, and the National Museum of American Illustration. *J. C. Leyendecker: American Imagist.* New York: Harry N. Abrams, 2008.

Davis, Parke H. *Football: The American Intercollegiate Game.* New York: Charles Scribner's Sons, 1911.

Davis, Richard Harding. "A Day with the Yale Team." *Harper's Weekly*, November 18, 1893.

Dean, Susan Thach. "J. C. Leyendecker." In *American Book and Magazine Illustrators to 1920*, ed. Steven E. Smith, Catherine A. Hastedt, and Donald H. Dyal. Detroit: Gale Research, 1998.

Doezema, Marianne. *George Bellows and Urban America.* New Haven: Yale University Press, 1992.

Downey, Fairfax. *Portrait of an Era as Drawn by C. D. Gibson: A Biography.* New York: Charles Scribner's Sons, 1936.

Durant, H. R. "A Sucker." *Cosmopolitan*, May 1905.

Elzea, Rowland. Introduction to the catalog for *The Golden Age of American Illustration, 1880–1914*, Delaware Art Museum, September 14–October 15, 1972.

Eskilson, Stephen J. *Graphic Design: A New History.* New Haven: Yale University Press, 2007.

"First Exhibition of 'The Pastellists' Suggests the Revival of a Charming Form of Eighteenth-Century Art." *New York Times* magazine section, January 15, 1911, 15.

"Football." *Independent*, December 5, 1901.

"The Future of Football." *Nation*, November 20, 1890.

Gallatin, A. E. "The Pastellists." *Art and Progress* 2, no. 5 (March 1911): 142–44.

Gambone, Robert L. *Life on the Press: The Popular Art and Illustration of George Luks.* Jackson: University of Mississippi Press, 2009.

"A Game of Foot-Ball." *Harper's Weekly*, December 7, 1878.

George Bellows. Washington DC: National Gallery of Art, 2012.

George Bellows: Paintings, Drawings, Lithographs. New York: The Gallery of Modern Art, including the Huntington Hartford Collection, March 15 through May 1, 1966.

Gibson, David. *Designed to Persuade: The Graphic Art of Edward Penfield.* Yonkers NY: Hudson River Museum, 1984.

The Golden Age of American Illustration: 1880–1914. Delaware Art Museum, September 14–October 15, 1972.

Gorn, Elliott J. "The Wicked World: The *National Police Gazette* and Gilded-Age America." *Media Studies Journal* 6 (Winter 1992): 1–15.

Gutman, Walter. "Howard Giles." *Art in America*, April 1929, 142–50.

Harris, Neil. "Iconography and Intellectual History: The Half-Tone Effect." In *New Directions in American Intellectual History*, ed. John Higham and Paul K. Conkin, 196–211. Baltimore: Johns Hopkins University Press, 1979.

Hassrick, Peter H. *Frederic Remington: Paintings, Drawings, and Sculpture in the Amon Carter Museum and the Sid W. Richardson Foundation Collections.* New York: Abrams, 1973.

Hastedt, Catherine A. "Charles Dana Gibson." In *American Book and Magazine Illustrators to 1920*, ed. Steven E. Smith, Catherine A. Hastedt, and Donald H. Dyal, 129–36. Detroit: Gale Research, 1998.

Haverstock, Mary Sayre. *George Bellows: An Artist in Action.* London: Merrell, 2007.

Homestead, Melissa. "Associated Sunday Magazines and the Origins of Every Week," Center for Digital Research in the Humanities, University of Nebraska–Lincoln, online at everyweek.unl.edu/view?docId=AssoicatedSunday Magazines.html.

Hopper, James. "The Boy Who Lost Weight." *Saturday Evening Post*, October 9, 1909.

Hopper, James. "We Really Played Football in the Gay Nineties." *Saturday Evening Post*, October 13, 1945.

Hopper, James. "Weight Above the Eyes." *Collier's*, November 17, 1917.

"Howard Giles," In *Paintings and Sculpture in the Collection of the National Academy of Design*, vol. 1, 1826–1925, ed. David B. Dearinger, 226–27. New York: Hudson Hills, 2004.

Hughes, Thomas, and W. D. Rawlins. "Recollections of American Universities." *Every Saturday*, May 20, 1871.

Irwin, Margaret A. "Edward Penfield." In *American Book and Magazine Illustrators to 1920*, ed. Steven E. Smith, Catherine A. Hastedt, and Donald H. Dyal, 243–49. Detroit: Gale Research, 1998.

Ivins, William M., Jr. *Prints and Visual Communication*. London: Routledge & Kegan Paul, 1953.

"John E. Sheridan, Illustrator, Dies." *New York Times*, July 5, 1948, 16.

Jordan, Edward S. "Buying Football Victories." *Collier's*, November 11, 18, and 25, and December 2, 1905.

Jussim, Estelle. *Visual Communication and the Graphic Arts: Photographic Technologies in the Nineteenth Century*. New York: R. R. Bowker, 1974.

Keay, Carolyn. *American Posters of the Turn of the Century*. New York: St. Martin's, 1975.

Kitch, Carolyn. *The Girl on the Magazine Cover: The Origins of Visual Stereotypes in American Mass Media*. Chapel Hill: University of North Carolina Press, 2001.

Larkin, Oliver W. *Art and Life in America*. New York: Rinehart, 1949.

Larson, Judy L. *American Illustration 1890–1925: Romance, Adventure, and Suspense*. Calgary: Glenbow-Alberta Institute, 1986.

Le Beau, Bryan F. *Currier & Ives: America Imagined*. Washington DC: Smithsonian Institution Press, 2001.

Lindholm, Karl. "William Clarence Matthews: 'The Jackie Robinson of His Day.'" In *The Cooperstown Symposium on Baseball and American Culture 1997 (Jackie Robinson)*, ed. Peter M. Rutkoff, 25–42. Jefferson NC: McFarland, 1997.

Margolin, Victor. *American Poster Renaissance*. New York: Watson-Guptill, 1975.

Marter, Joan, ed. *Grove Encyclopedia of American Art*. New York: Oxford University Press, 2011.

Marzio, Peter C. *The Democratic Art: Pictures for America, Chromolithography 1840–1900*. Boston: David R. Godine, 1979.

Martin, Francis, Jr. "E. W. Kemble." In *American Book and Magazine Illustrators to 1920*, ed. Steven E. Smith, Catherine A. Hastedt, and Donald H. Dyal, 182–90. Detroit: Gale Research, 1998.

McCrory, Amy. "Sports Cartoons in Context: TAD Dorgan and Multi-Genre Cartooning in Early Twentieth-Century Newspapers." *American Periodicals* 18, no. 1 (2008): 45–68.

Merrill, Hiram Campbell. *Wood Engraving and Wood Engravers*. Boston: Society of Printers, 1937.

Michaelis, David. *N. C. Wyeth: A Biography.* New York: Alfred A. Knopf, 1999.

Moore, Paul S., and Sandra Gabrielle. "The American Sunday Newspaper Magazine: An Intermedial History, 1893–1910," *Mapping the Magazine 3* (Cardiff University, 2011), online at http://www.cardiff.ac.uk/jomec/resources/mtm2011/Moore_Gabriele.pdf.

Morgan, Charles H. *The Drawings of George Bellows.* Alhambra CA: Borden, 1973.

Mott, Frank Luther. *A History of American Magazines, 1850–1865.* Cambridge MA: Harvard University Press, 1938.

——. *A History of American Magazines, 1865–1885.* Cambridge MA: Harvard University Press, 1938.

——. *A History of American Magazines, vol. 4: 1885–1905.* Cambridge MA: The Belknap Press of Harvard University Press, 1957.

——. *American Journalism, a History: 1690–1960,* 3rd ed. New York: Macmillan, 1962.

Murrell, William. *A History of American Graphic Humor.* New York: Macmillan, 1938.

N. W. Ayer & Son's American Newspaper Annual. Philadelphia: N. W. Ayer & Son, 1908.

——. Philadelphia: N. W. Ayer & Son, 1909.

——. Philadelphia: N. W. Ayer & Son, 1915.

——. Philadelphia: N. W. Ayer & Son, 1920.

Nadell, Martha Jane. *Enter the New Negroes: Images of Race in American Culture.* Cambridge MA: Harvard University Press, 2004.

Nemerov, Alexander. *Frederic Remington and Turn-of-the-Century America.* New Haven: Yale University Press, 1995.

Oviatt, Edwin. "Atkinson No. 7." *Leslie's Popular Monthly,* June 1903.

Perlman, Bernard B. *Painters of the Ashcan School: The Immortal Eight.* New York: Dover, 1979.

Peters, Harry T. *Currier & Ives: Printmakers to the American People.* Garden City NY: Doubleday Doran, 1942.

Platnick, Norm. "The 'Sunday Magazine,'" online at www.enchantmenthink.com/sunday.php.

Podmaniczky, Christine B. "N. C. Wyeth." In *American Book and Magazine Illustrators to 1920,* ed. Steven E. Smith, Catherine A. Hastedt, and Donald H. Dyal, 368–78. Detroit: Gale Research, 1998.

Price, Charles Matlack. *Poster Design: A Critical Study of the Development of the Poster in Continental Europe, England, and America.* New York: George W. Bricka, 1913.

R. F. Outcault's "The Yellow Kid": A Centennial Celebration of the Kid Who Started the Comics. Northampton MA: Kitchen Sink, 1995.

Rawls, Walton. *The Great Book of Currier & Ives' America*. New York: Abbeville, 1991.

Rayburn, Susan. *Football Nation: Four Hundred Years of America's Game, from the Library of Congress*. New York: Abrams, 2013.

Reynolds, Quentin. *The Fiction Factory, or From Pulp Row to Quality Street*. New York: Random House, 1955.

Richards, Eugene Lamb. "The Football Situation." *Popular Science Monthly*, October 1894.

Rockwell, Norman. *My Adventures as an Illustrator*. New York: Harry N. Abrams, 1988.

Rogers, W. A. *A World Worth While: A Record of "Auld Acquaintance."* New York: Harper & Brothers, 1922.

Ross, Denman W. "Drawings by Howard Giles." *Notes (Fogg Art Museum)*, June 1926: 82–84.

Seelye, John. "Remington the Writer." In *Frederic Remington: The Masterworks*, ed. Michael Edward Shapiro and Peter H. Hassrick, 239–41. New York: Harry N. Abrams, 1988.

Smith, Ronald A. *Sports and Freedom: The Rise of Big-Time College Athletics*. New York: Oxford University Press, 1988.

Smith, Steven A. "Thure de Thulstrup." In *American Book and Magazine Illustrators to 1920*, ed. Steven E. Smith, Catherine A. Hastedt, and Donald H. Dyal, 352–59. Detroit: Gale Research, 1998.

Smith, Steven E., Catherine A. Hastedt, and Donald H. Dyal, eds. *American Book and Magazine Illustrators to 1920*. Detroit: Gale Research, 1998.

Stern, Madeleine B. *Purple Passage: The Life of Mrs. Frank Leslie*. Norman: University of Oklahoma Press, 1953.

Tatham, David. *Winslow Homer and the Pictorial Press*. Syracuse NY: Syracuse University Press, 2003.

Tebbel, John, and Mary Ellen Zuckerman. *The Magazine in America, 1741–1990*. New York: Oxford University Press, 1991.

"The Training of Modern Gladiators—Some Details of a Demoralizing 'Profession' Illustrated." *Frank Leslie's Weekly*, September 1, 1892.

"True Newspaper Art." *Outlook*, April 6, 1912.

Wattous, James. *American Printmaking: A Century of American Printmaking 1880–1980*. Madison: University of Wisconsin Press, 1984.

Weitenkampf, Frank. *American Graphic Art*. New York: Henry Holt, 1912.

Whitney, Caspar. "Amateur Sport." *Harper's Weekly*, December 2, 1893.

———. "Amateur Sport." *Harper's Weekly*, November 4, 1893.

Woodward, David. "The Decline of Wood-Engraving in Nineteenth-Century America." *Journal of the Printing Historical Society* 10 (1974–75): 57–83.

Zoss, Joel, John Bowman, and John Stewart Bowman. *Diamonds in the Rough: The Untold History of Baseball*. Lincoln: University of Nebraska Press, 2004.

Zurier, Rebecca. *Picturing the City: Urban Vision and the Ashcan School*. Berkeley: University of California Press, 2006.

Zurier, Rebecca, Robert W. Snyder, and Virginia M. Mecklenburg, *Metropolitan Lives: The Ashcan Arts and Their New York*. New York: W. W. Norton, 1995.

INDEX